Francesco Bonami Nancy Spector Barbara Vanderlinden Massimiliano Gioni

Maurizio
Cattelan

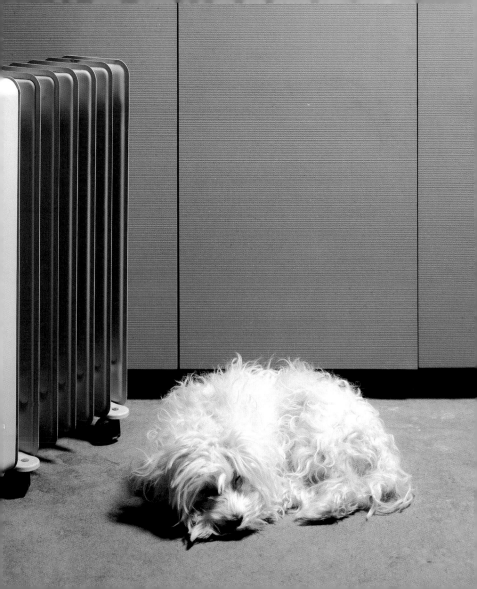

Contents

Interview Nancy Spector in conversation with Maurizio Cattelan, page 6. Survey

Francesco Bonami Static on the Line: The Impossible Work of Maurizio Cattelan, page 38. Focus

Barbara Vanderlinden Untitled, Manifesta 2, page 90. Artist's Choice Philip Roth

Portnoy's Complaint (extract), 1969, page 100. ... Or Not to Be: A Collection of Suicide Notes (extracts), 1997, page 106. Artist's Writings Maurizio Cattelan Face to Face: Interview with Giacinto Di Pietrantonio (extract), 1988, page 112. Incursions: Interview with Emanuela De Cecco and Roberto Pinto (extract), 1994, page 116. Statements, 1999, page 124. Interview with Robert Nickas (extract), 1999, page 128. I Want to Be Famous – Strategies for Succesful Living: Interview with Barbara Casavecchia, 1999, page 132. Blown Away – Blown to Pieces: Conversation with Massimiliano Gioni and Jens Hoffmann, 1999, page 140. The Wrong Gallery, 2002, page 144. Free For All – Interview with Alma Ruiz, 2002, page 148. Update Massimiliano Gioni Maurizio Cattelan – Rebel with a Pose, page 158. Chronology page 192 & Bibliography, List of Illustrations, page 209.

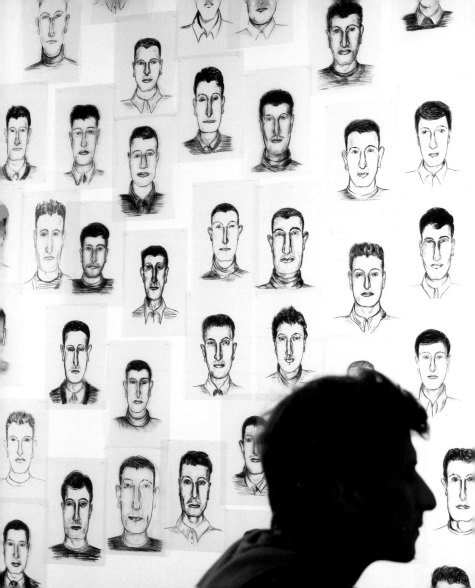

Interview Nancy Spector in conversation with Maurizio Cattelan, page 6.

Untitled (detail)
1995
Black and white
photograph mounted
on aluminium
20 × 25 cm

Nancy Spector Maurizio, I sense a certain reluctance about being interviewed.

> Maurizio Cattelan **My issue is not with the principle of the interview. Rather, I don't think I have anything interesting to say. When I read other interviews, there are always parts that strike me, and I ask myself, 'Why don't I just take this section since it's so interesting? I certainly can't do any better on my own.' The idea then is to reorganize something already there, re-present something that already exists. I'd be happy to do this now. We just have to think about which interviews we like and which ones we can use.**

Spector I find it strange then that you asked me to interview you for your monograph if it were going to be a cut-and-paste operation. I know that the artist's interview is a fundamental component of this book series so the editors must have discussed this process with you. What were you thinking initially?

> Cattelan **Well, they reviewed a list of names with me and I selected yours, since your office is close to my apartment. It's a matter of convenience.**

Spector I'm going to ignore that remark. Does this mean that earlier published interviews with you are borrowed from other sources, pilfered from other artists? For instance, what about the interview conducted by Giacinto Di Pietrantonio in which you discuss your education in Paris?[1] Does this mean that you never studied film theory with Roland Barthes, Michel Foucault, Jean François Lyotard and Gilles Deleuze, as you claimed? I did think your chronology was a bit suspect. If we do decide to proceed

with this strategy, I have to admit that I'll be concerned. I'm liable for the truth of my statements as well as yours.

Cattelan But, you see, the truth is not out there. It's just the moment that you claim something as your own. This is my truth; that is yours. Besides, if we use other materials, you will still have the opportunity to observe how I work, and I will have the opportunity to learn more about other people.

Spector Are there other artists whose work intrigues you enough that you want to adopt it as your own?

Cattelan The problem with that question is that I am not an artist. I really don't consider myself an artist. I make art, but it's a job. I fell into this by chance. Someone once told me that it was a very profitable profession, that you could travel a lot and meet a lot of girls. But this is all false; there is no money, no travel, no girls. Only work. I don't really mind it, however. In fact, I can't imagine any other option. There is, at least, a certain amount of respect. This is one profession in which I can be a little bit stupid, and people will say, 'Oh, you are so stupid; thank you, thank you for being so stupid.'

Spector What you are describing is a classic characteristic of the clown, the court jester who entertains through calculated buffoonery. Your self-derision or exaggerated humility, whether ironic or not, aligns your project with a tradition of clowning which has particular resonance in Italian culture, with its emphasis on the fine line between tragedy and comedy. The curator Laura Hoptman has placed your work in a trajectory that includes *commedia dell'arte*, Pirandello, Dario Fo and Roberto Benigni. To that I would add the character of Auguste from Federico Fellini's film *The Clowns*, the quintessential underachiever and self-styled hack with a painted smile and real tears.

Federico Fellini
The Clowns
1971
92 mins, colour
Production still

Cattelan The tears are very real. Sometimes I don't feel comfortable with myself. I think that maybe I don't know myself very well but then I realize that I know myself all too well. Problems can seem very dark and the solutions are very far away. Sometimes I feel that I have to take a break from my life, a break from being me. That's when I go to the movies, where I don't have to think about things. It gives me eighty-eight minutes to escape from myself, whether I'm laughing or crying.

Spector Does this stem from your relationship to your art?

Cattelan No, the work sustains me. When I come up with something, the work is extremely exciting for me for at least two or three months. Such a joy!

Spector So what's making you happy now?

Cattelan A fakir and a football team. For Harald Szeemann's Venice Biennale (1999), I'm planning to show a fakir – a mystic capable of unbelievable acts of endurance. He will be buried in the ground with only his hands showing

Untitled
1999
Granite, MDF, steel,
2700 hand-carved
letters
220 × 300 × 60 cm

SCOTLAND v ENGLAND 2-1	CZECHOSLOVAKIA v ENGLAND 2-1
SCOTLAND v ENGLAND 3-0	HUNGARY v ENGLAND 2-1
ENGLAND v SCOTLAND 1-3	SCOTLAND v ENGLAND 2-0
SCOTLAND v ENGLAND 7-2	ENGLAND v WALES 1-2
SCOTLAND v ENGLAND 5-4	AUSTRIA v ENGLAND 2-1
ENGLAND v SCOTLAND 1-6	BELGIUM v ENGLAND 3-2
ENGLAND v WALES 0-1	WALES v ENGLAND 2-1
SCOTLAND v ENGLAND 5-1	SCOTLAND v ENGLAND 3-1
ENGLAND v WALES 3-5	ENGLAND v SCOTLAND 0-1
ENGLAND v SCOTLAND 2-3	SWITZERLAND v ENGLAND 2-1
SCOTLAND v ENGLAND 1-0	WALES v ENGLAND 4-2
ENGLAND v SCOTLAND 2-3	YUGOSLAVIA v ENGLAND 2 1
ENGLAND v SCOTLAND 2-3	SWITZERLAND v ENGLAND 1-0
SCOTLAND v ENGLAND 2-1	ENGLAND v SCOTLAND 1-3
ENGLAND v SCOTLAND 1-2	SWEDEN v ENGLAND 3-1
SCOTLAND v ENGLAND 4-1	ENGLAND v REPUBLIC of IRELAND 0
ENGLAND v SCOTLAND 1-2	SPAIN v ENGLAND 1-0
SCOTLAND v ENGLAND 2-1	ENGLAND v UNITED STATES 0-1
SCOTLAND v ENGLAND 2-0	ENGLAND v SCOTLAND 2-3
IRELAND v ENGLAND 2-1	ENGLAND v HUNGARY 3-6
SCOTLAND v ENGLAND 3-1	ENGLAND v URUGUAY 1-2
ENGLAND v IRELAND 0-3	HUNGARY v ENGLAND 7-1
ENGLAND v WALES 1-2	URUGUAY v ENGLAND 4-2
ENGLAND v SCOTLAND 0-3	YUGOSLAVIA v ENGLAND 1-0
ENGLAND v SCOTLAND 0-1	WALES v ENGLAND 2-1
IRELAND v ENGLAND 2-1	FRANCE v ENGLAND 1-0
ENGLAND v WALES 1-2	PORTUGAL v ENGLAND 3-1
SCOTLAND v ENGLAND 2-0	ENGLAND v IRELAND 2-3
ENGLAND v SCOTLAND 0-1	ENGLAND v USSR 0-1
ENGLAND v WALES 1-3	YUGOSLAVIA v ENGLAND 5-0
ENGLAND v WALES 1-2	BRAZIL v ENGLAND 2-0
IRELAND v ENGLAND 2-0	MEXICO v ENGLAND 2-1
ENGLAND v SCOTLAND 1-5	PERU v ENGLAND 4-1
SCOTLAND v ENGLAND 1-0	ENGLAND v SWEDEN 2-3
SPAIN v ENGLAND 4-3	HUNGARY v ENGLAND 2-0
SCOTLAND v ENGLAND 2-0	SPAIN v ENGLAND 3-0
FRANCE v ENGLAND 5-2	AUSTRIA v ENGLAND 3-1
SCOTLAND v ENGLAND 2-1	BRAZIL v ENGLAND 3-1
ENGLAND v WALES 1-2	ENGLAND v HUNGARY 1-2

SCOTLAND v ENGLAND 2-0
FRANCE v ENGLAND 5-2
ENGLAND v SCOTLAND 1-2
ENGLAND v ARGENTINA 0-1
BRAZIL v ENGLAND 5-1
SCOTLAND v ENGLAND 1-0
ENGLAND v AUSTRIA 2-3
ENGLAND v SCOTLAND 2-3
WEST GERMANY v ENGLAND 1-0
ENGLAND v YUGOSLAVIA 0-1
BRAZIL v ENGLAND 2-1
ENGLAND v BRAZIL 0-1
ENGLAND v WEST GERMANY 2-3
ENGLAND v WEST GERMANY 1-3
ENGLAND v IRELAND 0-1
ITALY v ENGLAND 2-0
ENGLAND v ITALY 0-1
POLAND v ENGLAND 2-0
SCOTLAND v ENGLAND 2-0
CZECHOSLOVAKIA v ENGLAND 2-1
ENGLAND v BRAZIL 0-1
ITALY v ENGLAND 2-0
SCOTLAND v ENGLAND 2-1
ENGLAND v HUNGARY 0-2
ENGLAND v SCOTLAND 1-2
ENGLAND v WALES 0-1
WEST GERMANY v ENGLAND 2-1
AUSTRIA v ENGLAND 4-3
ITALY v ENGLAND 1-0
ROMANIA v ENGLAND 2-1
ENGLAND v WALES 1-4
ENGLAND v BRAZIL 0-1
NORWAY v ENGLAND 2-1
ENGLAND v SCOTLAND 0-1
ENGLAND v SPAIN 1-2
SWITZERLAND v ENGLAND 2-1
ENGLAND v WEST GERMANY 1-2
ENGLAND v DENMARK 0-1
FRANCE v ENGLAND 2-0

ENGLAND v USSR 0-2
URUGUAY v ENGLAND 2-0
ENGLAND v WALES 0-1
ITALY v ENGLAND 2-1
MEXICO v ENGLAND 1-0
SCOTLAND v ENGLAND 1-0
ARGENTINA v ENGLAND 2-1
ENGLAND v PORTUGAL 0-1
SWEDEN v ENGLAND 1-0
WEST GERMANY v ENGLAND 3-1
ENGLAND v HUNGARY 1-3
REPUBLIC of IRELAND v ENGLAND 1-0
USSR v ENGLAND 3-1
ENGLAND v WEST GERMANY 3-4
ITALY v ENGLAND 2-1
ENGLAND v URUGUAY 1-2
ENGLAND v GERMANY 0-1
SPAIN v ENGLAND 1-0
SWEDEN v ENGLAND 2-1
ENGLAND v GERMANY 1-2
ENGLAND v HUNGARY 0-2
NORWAY v ENGLAND 2-0
UNITED STATES v ENGLAND 2-0
ENGLAND v BRAZIL 1-3
ENGLAND v GERMANY 5-6
ENGLAND v BRAZIL 0-1
ENGLAND v ITALY 0-1
ENGLAND v BELGIUM 3-4
ENGLAND v ARGENTINA 3-4
CHILE v ENGLAND 2-0
ENGLAND v ROMANIA 1-2

in a gesture of prayer or meditation. And for my show in London at Anthony d'Offay Gallery (1999), I created a big untitled granite plaque, similar to the Vietnam War Memorial in Washington, DC. Carved into it are all the defeats of England's national football team. I guess it's a piece which talks about pride, missed opportunities and death, in a certain way.

Spector The memorial reference could also relate to the fact that there has been so much violence associated with the game in Britain.

Cattelan **And also the violence that will be associated with this show!**

Spector Are you expecting the audience to be upset by your monument to failure?

Cattelan **Generally I try not to expect anything. But I'm afraid some people will get upset. First, because I'm Italian; second, because football is one of the two or three subjects that you can't touch; and, last but not least, because they think it's a stupid idea. People want artists to come up with brilliant ideas, and the wall is not that brilliant. It's a monument to my failure as well.**

Spector With both the fakir and the football memorial you are treading on sacred territory.

Cattelan **Not really. It's like pointing a gun at an ambulance or insulting your own mother. It's considered outrageous, but it seems like everyone does such things once in a while.**

Spector Your work is highly context-specific, in that it speaks directly to a particular culture in a particular time and space. Or, to use a militaristic metaphor, it is like a missile aimed at the heart of a specific cultural practice or belief.

Cattelan **Not necessarily. I really just take advantage of the exhibition situation. Because I don't have a studio, I use shows as a means to get work produced. Every commitment to exhibit becomes a challenge for me. If I don't have any commitments, I don't do anything. In some ways I'm lazy. I use my head only if I really have to. My creative process, as they say, usually starts with a phone call. I call a gallery, ask for an exhibition date, and only then do I start thinking of a project. I send the description to the gallerist. He or she phones back, we discuss it a bit. After all this, I start looking for people to produce the work. I never touch the work myself; it's out of my hands. Of course, I would prefer to have a kind of unmediated representation, but this is not possible, given my process. The meaning of the work is really out of my control. I prefer to borrow someone else's interpretation. After all, you shouldn't be interviewing me. You could ask different people to come up with an interpretation of my work. They would know better.**

Spector That would be one approach, but it avoids any culpability for the work on your part. However, it is helpful to think of the objects and actions that you put out

into the world as narrative devices, as triggers for stories that might differ from viewer to viewer.

Cattelan **Yes, this is more interesting, maybe. I like all the little stories behind the work. They make it more alive. I like faces and legends more than I like artworks. In 1998 I did a project on the campus of the University of Wisconsin, Milwaukee, for its Institute of Visual Arts. The project engendered a long story, almost a novel. When I arrived there, first I wanted to show a series of films. I wanted to steal these films from the cinema at the university. But something went wrong with the equipment so I had to come up with a new idea in a couple of days. I decided to build a sculpture out of rags and old clothes; it was an effigy of a homeless man –** *Kenneth* **(1998). I left the poor guy near one of the campus buildings. The next morning it turns out that someone had stuck a sign on my sculpture, complaining about the tuition increase at the university. The homeless had become a kind of symbol in a struggle I knew nothing about.**

After that, neighbours started to complain about my piece, until eventually someone stole the sculpture, leaving only its shoes. So the police took over the situation; there were officers looking for a missing sculpture. A perfect plot, isn't it? The police found two different sculptures and neither of them were mine. The next day a new sculpture pops up, carrying a sign saying something like, 'We don't need an Italian to teach us what art is.'

Actually when I first made this piece, in Italy – *Andreas e Mattia* **(1996) – I received some really different reactions. It was another story but with the same cast of characters: a policeman, some neighbours, a homeless man. Some people were upset and called the police to complain that no one was taking care of this poor, old person on the street. So they went to check on his condition and started shaking him, saying, 'Hey, hey, wake up. It's time to go.' And when he didn't move, they thought, 'My God, he's dead.'**

At times I like the idea of taking these stories a step further and creating

Kenneth
1998
Stuffed cloth figure,
clothing
Lifesize
Installation, Institute
of Visual Arts,
University of Wisconsin,
Milwaukee

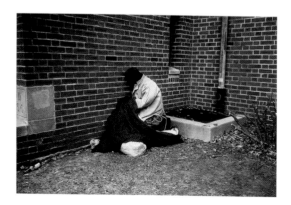

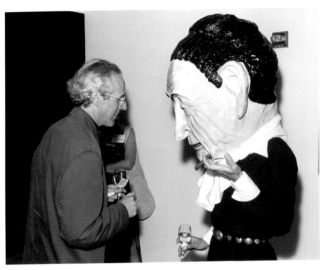

a sequel. I have actually been thinking about a work I could do in Buenos Aires which would involve installing ten to twenty fake beggars around the city in the early morning and then gathering them at the end of the day in order to collect the money they received.

Spector Your work provokes such stories to unfold. While you claim that your art is not necessarily context-specific, I would say that it addresses certain situations by intervening and becoming a deliberately provocative presence, an irritant that refocuses one's perception. How else would you describe the fun-house version of Georgia O'Keeffe (*Georgia on My Mind*, 1997) – complete with bulbous head and exaggerated features – which attended the opening of the second SITE Santa Fe, just blocks away from the new museum devoted to her work? Or the masked character of Pablo Picasso (*Untitled*, 1998), doyen of high Modernism that he is, greeting visitors to The Museum of Modern Art like a mascot for some theme park or sports arena?

Cattelan **Oh my God, no, no. I don't think so. I don't think of the work as intentionally provocative. What other works do you consider provocative?**

Spector What about the time you had your gallerist Emmanuel Perrotin wear a giant rabbit costume that doubled as an immense, flesh-coloured phallus for the duration of your exhibition in 1995 – a work that you called punningly *Errotin, le vrai lapin*, meaning 'Errotin, a true rabbit'? Tell me you weren't poking fun at the artist/dealer relationship or critiquing the erotic cycle of distribution and consumption that is inherent to the gallery system.

opposite, Georgia on My Mind
1997
Papier mâché mask, clothing, cigar
Mask, 80 × 80 × 50 cm
With David A. Ross at exhibition opening, 'Truce: Echoes of Art in an Age of Endless Conclusions', SITE Santa Fe, New Mexico

Georgia on My Mind
1997
Ink, pencil on paper
100 × 80 cm
Pre-production drawing, with Umberto Manfrin

below, Errotin, le vrai lapin
1994
Costume
h. approx. 220 cm
Worn by Emmanuel Perrotin at Galerie Emmanuel Perrotin, Paris

Cattelan Actually, I think that piece lacks any provocation; it has a zero degree of subversiveness. It's just a comment on the private life of this dealer. It was a game played between two people; that's all. It was fantastic because he was willing to go along with it; he laughed with me. It is very well known in Paris that he is a perpetual womanizer. So nobody thought for a second that it was a provocation. It was nice of him to allow himself to be presented in this ironic manner. However, I guess if you saw the performance from the outside, it could seem provocative. The viewer might feel that he or she is being treated like an arsehole or that the gallery is a place where some kind of bizarre theatre takes place. There is always this tension in my work, between my intentions and reality, between what I wanted and what people end up thinking.

In terms of the Picasso piece at MoMA, I felt that there was simply something missing at the museum. I didn't understand why they didn't embrace a more visible means of marketing and promotion. They shouldn't be ashamed. I think it's something that we will be seeing more of in years to come. What does it mean to be a cultural institution? Don't they want more visitors or do they just want to be boring? In any case, they are already selling coffee mugs, T-shirts, calendars and posters. I don't think it's such a sin. The Picasso figure was very popular; lots of people were taking pictures of themselves with him, as in the photos you take standing next to Disneyland characters like Mickey Mouse. It shows that people always want a different kind of memory of this place, a more personal memory. If the Picasso figure did anything, it was to promote the museum as a friendly place. *Georgia on My Mind* was a much smaller gesture, a rehearsal in a way. I don't usually repeat the same work twice, but the situation called for it. However, this work wasn't perfect. The head was made in the carnival tradition and it was meant to be playful, but in Santa Fe the figure became a ghost.

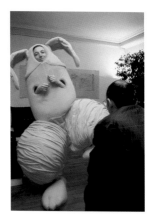
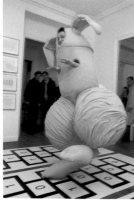
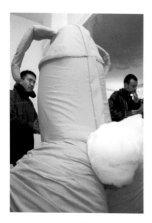

Spector Wasn't your contribution to Sonsbeek 93 in the Netherlands rejected because the work was considered too incendiary?

Cattelan That's true. But again, the intention was not to irritate. For this exhibition, I proposed using the entire city as a chemical experiment about fear. I had gone to Amsterdam on my way to Sonsbeek and while there I had casually eaten some cake, without knowing that it had been laced with some drug. For one day I was completely out of it. The experience was so surreal and intense that I thought afterwards, 'Yes, this is what I want to do for the Sonsbeek exhibition.' I wanted to alter people's perception of the city in this total, all-encompassing way. But at first I didn't know how I could accomplish this without using a drug, without lacing a cake for all to eat. Then I realized I could cover the entire city with a poster campaign and

Tarzan & Jane
1993
Costumes
00 × 00 cm
Worn by Umberto
Raucci and Carlo
Santamaria, Galleria
Raucci/Santamaria,
Naples

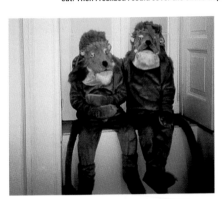

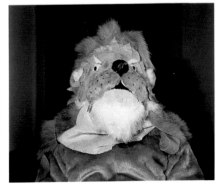

decided to use one that advertised an underground meeting of neo-Nazi skinheads during the week of the opening. I thought this was perfect because the neo-Nazi reference would create a fiction of a fiction, as long as nobody knew that it wasn't for real. I had this kind of experience in Amsterdam and thought it would be interesting to emulate it in some way for a large number of people.

The opening of the show was scheduled to include a visit from the Queen, so there was already a massive police presence, which might have made the whole thing more believable, more hallucinatory. So everything was perfect. But the curator didn't like the idea of neo-Nazis. She thought it was too strong a comment about the Second World War and about the atrocities that they hadn't experienced there directly. She said that I had no right to use those symbols. It was too presumptuous. In a way, she was right. But in another way, it was an overreaction. Nevertheless, they kicked me out.

Spector You must have been aware of the political implications of invoking neo-Nazism and, by extension, the Holocaust, in such a context even if you were, as you claim, just trying to create an altered reality. Even the most sincere attempts to mine the Nazi past through humour are met with scepticism and anger. Think of the recent objections to Roberto Benigni's Holocaust film, *La vita è bella (Life Is Beautiful,* 1997) on the grounds that such subject matter cannot be treated lightly. I am citing this example in particular because you are often compared to Benigni, Italian satirist that you are.

Roberto Benigni
La vita è bella (Life Is Beautiful)
1997
122 mins., colour
Film still

Cattelan I'm not really sure satire is the key to my work. Comedians manipulate and make fun of reality, whereas I actually think that reality is far more provocative than my art. You should walk on the street and see real beggars, not my fake ones. You should witness a real skinhead rally. I just take it; I'm always borrowing pieces – crumbs really – of everyday reality. If you think my work is very provocative, it means that reality is extremely provocative, and we just don't react to it. Maybe we no longer pay attention to the way we live in the world. We are increasingly … how do you say, 'don't feel any pain?' … we are anaesthetized.

Spector So, to some extent you see yourself as a chronicler of society's ills. Such was the traditional role of the fool, the town clown or village idiot, who through the hilarity of his gestures provided an inverted and ironic mirror for contemporary culture. Is this what you had in mind when you exhibited the rubble from an explosion in Milan as your artwork?

Cattelan This work (*Lullaby*, 1994) was for my exhibition in London at the Laure Genillard Gallery in 1994; a version was also made for a group show at the Musée d'Art Moderne de la Ville de Paris (1994). The year before in Italy we had had a wave of Mafia-related terrorism. The Mafia, or whatever it was, singled out three characteristic cultural venues to bomb. One was in Rome, at a historic church, another in Florence, at the Palazzo Uffizi museum, and the third was in Milan, at the Padiglione d'Arte Contemporanea (Contemporary Art Pavilion). The bombing in Milan had

fatalities; five people were killed in the explosion. At the time, I was really shocked: it was so well orchestrated.

It was the first time that I was exhibiting outside of Italy so I thought, 'Why don't I bring something from my country as a snapshot?' What could that be? I decided to bring rubble from the explosion as this snapshot of my country. I packed it in two different ways, like an official shipment. The rubble for Paris was loaded onto a pallet and wrapped in plastic; the London ship-ment was in a big, blue industrial bag. It looked like a huge laundry bag. It was like a laundry grave: it made me think of the kinds of bags hospitals have to use to transport contaminated laundry. The reaction to this work was immediate and unpleasant. It received strong attacks from the Italian press, who claimed I was looking into the garbage bins of our bad history, or something like that.

Tourists
1997
Taxidermized pigeons
Lifesize
Installation, XLVII
Venice Biennale, above
works by Ettore
Spalletti

Spector James Joyce described history as a nightmare from which he was trying to awake. All your work seems like an effort to break away from the burden of history, a never-ending escape. Just think of your participation in the 1997 Venice Biennale, organized by Germano Celant. Some of the father figures of Italian contemporary art – Mario Merz, Guilio Paolini and Gilberto Zorio – were in the main international exhibition, while Enzo Cucchi, Ettore Spalletti and yourself were representing the second and third generations in the Italian pavilion. The whole enterprise made me think of Harold Bloom's book *The Anxiety of Influence*, in which he filters the literary canon through the Oedipus complex, claiming that each generation of authors must annihilate its fathers.

Cattelan **Oh, that's important. We have to kill the father – otherwise we have to lick his feet.**

Spector Which did you do in Venice?

Cattelan **A little of both, it was in-between. I tried to make my fathers laugh, while taking away some of the space devoted to them. Or maybe I was over-reacting because I am afraid of big machinery like the Biennale. Venice was always a nightmare for me, even the first time I went there. There is so much pressure, especially because I'm Italian. In the end, it's just a big fair. It's like a big window where all the people come to stare.**

Spector The first time was in 1993 when you were in Francesco Bonami's section of the Aperto. You sold your space to a perfume company for their advertisement?

Cattelan **Yes, but that wasn't very premeditated, nor was I in it for the money. I just didn't know what to do; like that Beck lyric, ' I'm a loser baby, so why don't you kill me?' It was such a big space and I was so young and inexperienced. Francesco was brave, in a way, to let me do it. Actually, I'm sure he didn't like it. I didn't like the work either. But it saved my arse. In the end, I was probably looking for something more formal and poetic.**

Spector Were you making a pointed commentary on the commercialization of the art world and the proliferation of these immense international exhibitions with your intervention?

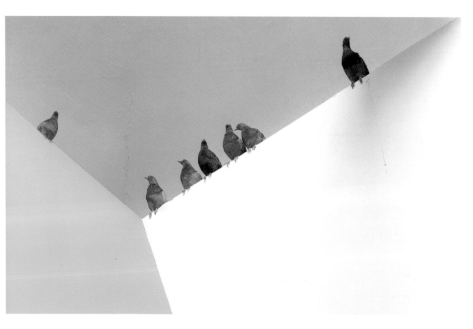

Cattelan No, not at all, but this is what people thought I was doing. I was just thinking about what Venice was for me at the time and I just tried to make this clear. The 1997 Biennale was, for me, very exciting. And I think Germano Celant's idea of mixing generations was the best solution to the Italian problem. Ultimately, the struggle for me was that there always seemed to be another room to do. Everyone thought this would make me happy; every day they would say, 'Here is another 200 square metres for you.' I thought, 'Are you crazy?' What could I do? Instead of feeling empowered in a situation, I felt like all the energy was being drained out of me. It was as if they wanted me to *buy* the space this time. I had got away with it once in 1993, but for the 1997 Biennale they really wanted me to sit down and do something.

Spector How did you arrive at your solution for filling the galleries with stuffed pigeons, which seemed at the time to be a very audacious, yet humorous, gesture?

Cattelan I had gone to see the pavilion in Venice about a month before the opening of the exhibition. The inside was a shambles and it was filled, really filled, with pigeons. For me as an Italian, it was like seeing something you're not supposed to see, like the dressing room of the Pope. But then again that is the situation in Venice, so I thought I should just present it as it

19 Interview

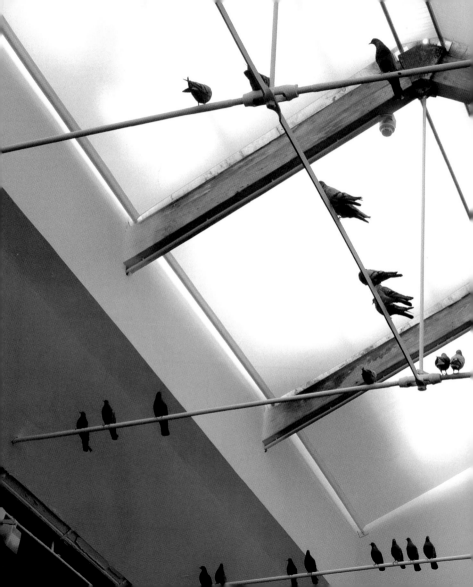

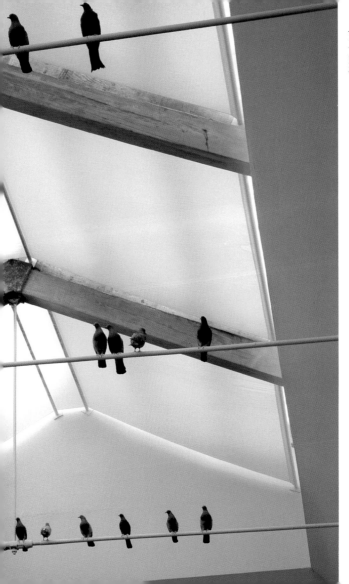

Tourists
1997
Taxidermized pigeons
Lifesize
Installation, XLVII
Venice Biennale

is, a normal situation. And of course, where there are pigeons, there is pigeon shit.

In the end, I thought that intervention was almost enough. I would have liked to place the birds all over the international exhibition, but there were limits. I guess if there was anything really provocative about this work it was in its relationship to time. Time doesn't affect this place; basically all the Biennales look the same. If I could, I would love to set up the same show twice in two consecutive Biennales. I think that no one would notice. So I installed the birds and the birdshit to prove that everything stands still in that place, that 'Time goes by so slowly' – that's another song.

Spector You have pointed out a few times that you don't like to repeat your work. Each installation, object or action seems to have its own reason for existing. Even so, it is possible to trace certain motifs or strategies that recur throughout the work, such as the use of stuffed animals or your recourse to theft. How do you decide when a work is complete, and that you don't need to revisit it?

Cattelan Well, certain pieces simply can't be repeated. Ideally, when I work on something new it should be really exciting for me. It's like with a new lover: the first time, it's okay, the second time a little better. But after two months, it's … Jesus! So the work is like this. I get struck by an image. It's something that hits my imagination and then the day after it's still in my imagination. It is keeping my imagination hooked. In the end, I can't reduce this image or forget it. So I start working. I begin by thinking of all the possibilities and then I try to clean the idea. I try to find a synthesis of the idea. This is the most difficult thing. It happens though, a few times at least, every ten years or so.

Spector What constitutes a successful work for you?

Cattelan I like it when the work becomes an image. I make a distinction between works that function as an idea or a project – like the soccer memorial wall for London – and those which get transformed into a memorable image. These are more readably repeatable, like the tree I made for Manifesta 2 in Luxemburg (*Untitled*), 1998). It started as something I just wanted to see; a huge clump of earth, a real piece of the earth, with a tree growing out of it, as if you could glimpse it from below the ground.

When I first thought of the piece, I imagined a more natural shape than what they constructed in Luxemburg. They made a cube out of the earth, and I found the cube too related to art – after all, I created this piece over the phone. But when I showed it again at the Castello di Rivoli, Turin, with a rounder, less rigid base, it worked much better for me. Since I don't have a studio, I have to work these things out in the public eye. Every time I produce a piece, I show it at the same time. I see the piece for the first time in the exhibition. That's when I assess the failure, if it's a failure.

When I arrived in Luxemburg, it was crazy. There were 2,000 kilos of earth on the second floor. There were structural problems, technical problems, organizational problems. Then, when it was done I thought, 'Okay, now we'll see what the result is. If I get another chance, I'll want to

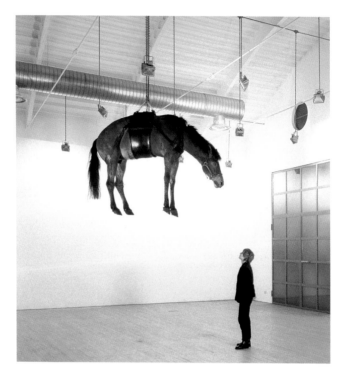

The Ballad of Trotsky
1996
Taxidermized horse,
leather saddlery, rope,
pulley
Lifesize
Installation, Galleria
Massimo De Carlo, Milan

Leo McCarey
Wrong Again (with Stan
Laurel and Oliver Hardy)
1929
20 mins., black and
white, silent
A horse instead of a
painting is delivered to
a rich man's house

make it better.' It's as if my exhibitions are my studio. I think that many pieces of mine are public failures. Some things could have been better, presented in a different way. For example, my horse suspended from the ceiling. The first time I showed it, as *The Ballad of Trotsky* in 1996, its legs were normal length. But the second one, *Novecento* (*1900*) from 1997, has very elongated legs, and I think it works much better. This piece functions very much as an image for me. The first one may have been lighter, but the second has this kind of energy to reach the ground, to participate in the place itself. So it was a necessary change. It was also, let's say, a more poignant, retrospective image (the twentieth century) to give a positive future.

Spector Your horse is just one in a string of works involving animals – embalmed animals which are uncanny in their lifelike appearance, comical yet depressing, if not unnerving. I've always thought the animals – from the sleeping dogs to the little

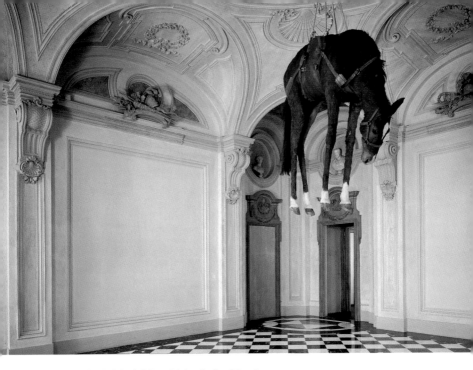

squirrel suicide to the mice in beach chairs – might be self-referential, maybe even surrogates for yourself. Is this true?

Cattelan Sure, those references show up in the work – in the animal pieces, in particular. There is the ostrich (*Untitled*) I did for the exhibition 'Fatto in Italia' ('Made in Italy') at the Institute of Contemporary Arts, London in 1997. His head was buried in the floor of the gallery; he was hiding from the exhibition. It was a sort of exercise – I was taking part in a show while trying to keep a distance from it, just like an ostrich, with his head buried in the ground and his arse sticking out. The show was okay, but it opened at the same time as that big 'Sensation' exhibition of young British artists at the Royal Academy. The differences in strategy between the British and Italian artists and curators were very noticeable. I felt as if we were the poor relatives. We were forced into this stereotype of Italian art, and I couldn't really deal with it. So I did the ostrich, but I also spray-painted a new exhibition title on the outside of the building: I wrote ' Bloody Wops' across the wall. I was trying to play with the role of the Italian immigrant; but more

Novecento (1900)
1997
Taxidermized horse,
leather saddlery, rope,
pulley
200.5 × 269 × 68.5 cm
Installation, Castello di
Rivoli, Museo d'Arte
Contemporanea, Turin

importantly I was making a point about curators and the absurdity of these kinds of shows, telling them more or less to wake up.

Spector How might *Bidibidobidiboo* (1996), the *noir*-ish suicide of the little stuffed squirrel in a kitchen, relate to you, if it does indeed relate to you?

Cattelan **Well, I really just thought that the squirrel was a nice animal, and as usual I had to make an exhibition. I had to do something I didn't want to do. So I started thinking about putting together two different worlds: the human world and the cartoon world. The squirrel reminded me of Chip and Dale, the two Disney chipmunks who were always playing with Donald Duck. I wanted to put this squirrel into a kitchen, but I didn't know which kind to use. I thought about something really shabby, and the first image that came to mind was my family's kitchen.**

The squirrel's kitchen is my parents' kitchen. I grew up in this kitchen. There is a nice story about it. Once my mother was ironing on the dining table and forgot she had left the iron on. It had been left face down on the Formica counter top. So the Formica had an iron mark burnt into it. My father was upset with her. How were we going to repair the table? He decided to cut off the part of the table with the burn mark, reducing the table by about 15 centimetres. So from that time on our family served all their meals on this shrunken table. That image has stayed with me forever. For the title, I thought about magic words like 'bibeddy bobbedy boo', which could transform something, make something better. That time, however, the magic didn't work.

I showed the piece in London at Laure Genillard's first gallery space, which was small and intimate. I really liked the idea of placing it on the floor in the room. I also liked the idea of seeing the piece while bending or kneeling on the floor. It added a kind of spirituality to the piece. You had to look at it as if you were praying.

Spector Do the titles of the stacked animal pieces – *Love Saves Life* (1995) and *Love Lasts Forever* (1997) – have any biographical meaning?

Cattelan **Not really. The earlier one with a stuffed rooster, cat, dog and donkey is based on a fairytale by the Brothers Grimm, 'The Bremen Town Musicians', in which the animals each escape an owner who was threatening to kill them because they were getting old and useless. They band together to travel to town and become musicians, but on the way they trick robbers out of their hideaway and take over the house to live out their days in freedom. I thought that this pointed towards a socialist moral about how we can put creativity and friendship together and win every battle.**

The second version came about almost three years later, when the curator Kasper König asked me to show the piece at Skulptur Projekte in Münster (1997). I didn't like the idea of exhibiting this piece again so I just thought about how time would have redefined the work. It seemed to me that after three years, the animals would have been reduced to skeletons, so this is what I showed: the same stack of animals – a rooster, a cat, a dog and a donkey, but as bones.

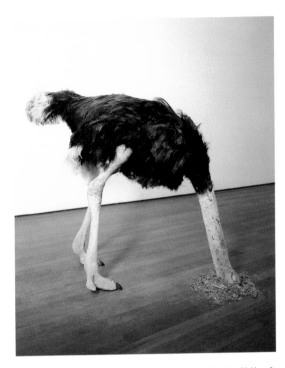

Spector I am struck by the morbid quality of the animal pieces. I'm also thinking of your sleeping dogs, which can sometimes be found curled up on the outer edges of your exhibition spaces. For a moment one could think they were real, but then something seems amiss. Before the realization sets in that this is actually an artwork (albeit a rather bleak one), one might think the dog is dead. Of course, you know this well. Why else call the sleeping dog in your Castello di Rivoli exhibition *Morto stecchito* (*Stone Dead*, 1997)?

Cattelan **My work can be divided into different categories. One is my early work, which was really about the impossibility of doing something. This is a threat that still gives shape to many of my actions and works. I guess it was really about my insecurity, about failure. We can have a chapter here called 'Failure'. Let's say that I just transformed something like failure into a work of art. A second category speaks about loss, about absence, about death. Even pieces like *Novecento* relate to this; it represents an energy that you can't utilize. It represents frozen energy. Animals are not so funny. I think**

right, **Untitled**
1997
3 taxidermized mice,
wood, plastic, fabric
toy deckchair and
umbrella
Mice, lifesize

above, **Untitled**
1998
Ink wash on paper
3 parts, 16.5 × 12.5 cm;
12 × 17.5 cm; 12 × 17.5
cm
Pre-production
drawing, with Umberto
Manfrin

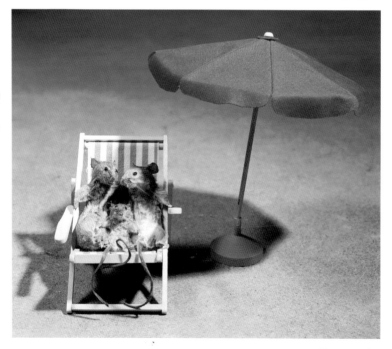

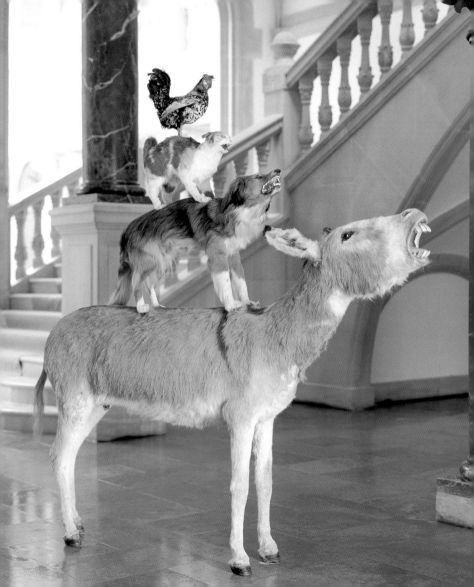

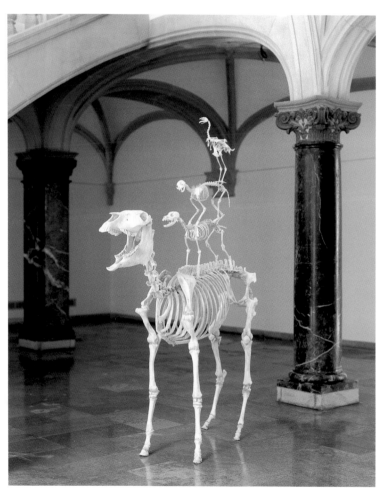

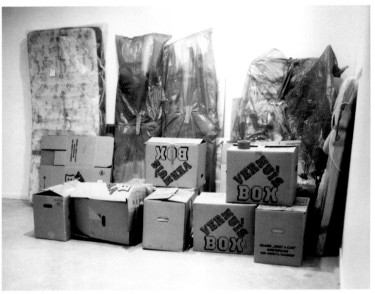

Another Fucking
Readymade
1996
Crated works from
stolen exhibition
Dimensions variable
Installation, 'Crap
Shoot', De Appel,
Amsterdam

they have a dark, morbid side. I'm actually finished with them. At the
moment, I'm working on a piece which is a dog's grave (*Piumino*, 1999) and
then the series will be over, unless I change my mind again, or I'm called to
do another show.

Spector As I mentioned before, another recurrent motif in your work is theft, from
actual larceny, like the time you stole the entire contents of an exhibition at Galerie
Bloom in Amsterdam to include in your show at De Appel (in a piece called *Another
Fucking Readymade*, 1996), to a kind of creative borrowing – like 'Moi-même, soi-
même', your exact replication of Carsten Höller's exhibition in Paris in 1997, when
your own show was happening in an adjacent space at the same time. Your
kleptomaniac tendencies have earned you comparisons in the press to fictional
characters like Zorro, the Artful Dodger and Robin Hood. Other critics see your blatant
appropriation of others' artworks as yet another postmodernist interrogation of
valuative concepts like originality and authorship, but with a mock serious twist.

Cattelan **Actually, we are stealing right now, here in your office.**

Spector How? What are we stealing?

Cattelan **Time. Aren't you supposed to be doing your office work?**

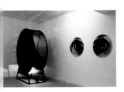

Installation, 'Moi-même, soi-même', Galerie Emmanuel Perrotin, Paris, 1997 (details)
above, l., **Untitled** (La roue)
1997
Steel, rubber, spotlight
238 × 205 × 87 cm
above, r. and right,
Untitled (Réflection dans ses yeux) (details)
1997
Black and white photographs, Perspex
Diptychs, area 80 × 206 cm each
Exact replicas of works and exhibition installation by Carsten Höller shown in adjacent gallery

Spector Well, I guess I'll have to have this time deducted from my pay.

Cattelan Once, a long time ago when I was in Italy, I was working as a cleaning person in a laundry, and they found me washing my own laundry at work. They said, 'What are you doing here?' And I said, 'Washing! Washing my laundry! It's my uniform! Where else am I going to do it?' They fired me. This was one of the first times that I got fired. Another time was when I was working in the church of Saint Anthony in Padua. I was working in the gift shop selling little figurines of Saint Anthony, postcards and so on. I was around thirteen at the time and was with a bunch of friends. So we were taking a break and laughing. I had drawn moustaches on the little statues. And when the priests found them, they came straight to me, they didn't even ask the other twenty kids who were working with me. Basically they knew it had to be Maurizio's fault. So they came up to me and said, 'Maurizio. Why!?'

Eventually, I learned to avoid being fired. By my third job, before they fired me, I fired myself.

Spector And where was this?

Cattelan In Italy. I worked in a morgue, and I was fed up with it. I found a doctor who was willing to help me. In Italy we have a system that if you are

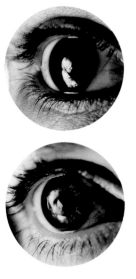

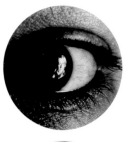

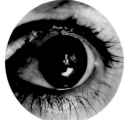

sick and can't work, your company has to pay your salary anyway. Not bad. I was paying the doctor, and he was giving me days off. I took about six months off; it was fantastic. I was so young and the work was horrible. It's not written anywhere that you have to work. It's not written that someone has to pay because you can't work or because you don't want to work. But that's life. I have always found a way to get things done. When I was working, I was also going to school at night so my days were often thirteen hours long. When I turned eighteen, I realized that you need time for friends, for girlfriends, you need to have a normal life. So basically I arrived at this line of work (making art) by escaping from other jobs. Art gave me my time back. And it is not so bad, but now I have to find ways to escape art.

Spector Didn't you work as a furniture designer early on?

Cattelan **Well, yes. At that point I had so much time on my hands I started to work for myself. I started to produce things for my apartment. It was something that I had never experienced before. It was a real adventure for me.**

Spector Why did you stop?

Cattelan **Because I didn't like it. No, because it became too serious. Companies were calling me, asking me to design things. I tried, but it was so difficult. I was making annoying furniture for annoying companies. I found the art world much more alluring. It was like a dream. From the outside, it was really something.**

Spector I see that your life of crime has deep roots. In many of your pieces you seem to glorify the persona of the burglar, like the time you exhibited actual safes that had been picked open by thieves (*-157,000,000*, 1992) or when you asked the police to make composite portraits of yourself from various descri-ptions given to them by friends and relatives (*Super noi* [*Super Us*], 1992).

Cattelan **That piece was really about how people around you perceive you in different ways than how you really are. So I was thinking about visualizing the idea of the self. The drawings really looked like me, but at the same time they were like cartoons. They were terrific. I don't know if it was a fluke.**

Spector Did you learn anything about yourself?

Cattelan **No, maybe I learned more about other people. You know, the works that you mention in reference to crime have other meanings for me. The piece with the safes was really about my love for certain cops and robbers movies, and, besides, I needed an object for an exhibition. Inside of everyone there is a little thief. So it was a romantic, sentimental piece. The safe is really a magic object. It is really a projection of our inner selves. It was certainly not a comment on the art world. The show of Carsten Höller's work was, from my point of view, more about parasitical relationships. My version of it was second generation, but at the same time, it was like giving**

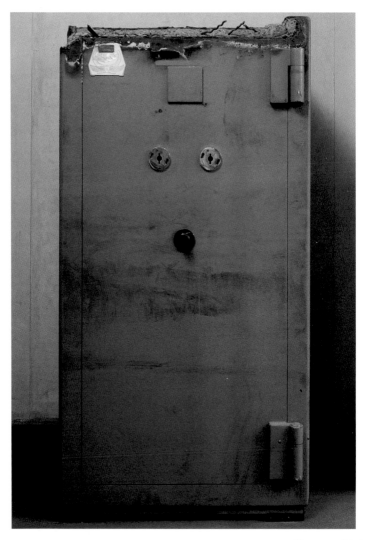

right and opposite,
-157.000.000
1992
Broken safes
Approx. 120 × 80 × 80
cm each
Installation,
'Ottovolante', Galleria
d'Arte Moderna e
Contemporanea,
Accademia Carrara,
Bergamo

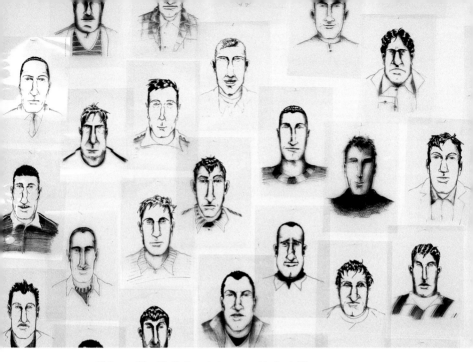

new life to something. Mostly, it was just a comment for fun, but it was a comment without major life lessons. The theft in Amsterdam (*Another Fucking Readymade*) was more of a survival tactic. De Appel had asked me to prepare a project in two weeks. It usually takes me six months to come up with something. I just followed the rule that I told you about before: I took the path of least resistance. It was the quickest and easiest thing to do. Afterwards, I realized that it was much more about switching one reality for another. For me, the idea of stealing was the least interesting part of the project.

Spector Your work exists in the interstices between objects and actions. It enters the art institution only to disrupt it, but that is only when you are not ignoring it entirely, working independently, inventing your own structures. Do you have an antagonistic relationship to the museum or the gallery system, or are you lovingly pointing out their contradictions from within?

Cattelan How can I contest the system if I'm totally inside it? I want benefits from this system. So it's like spitting in the hand of someone who pays your

Super Noi (Super Us)
(Detail)
1992
Photocopies on acetate
50 parts, 29.5 × 21 cm
each

salary. I'm not trying to be against institutions or museums. Maybe I'm just saying that we are all corrupted in a way; life itself is corrupted, and that's the way we like it. I'm just trying to get a slice of the pie, like everyone else.

In terms of the choice between actions and objects, this is getting difficult for me as I get more and more tied to galleries. There is always the pressure to produce things, to make objects. I mean I play the game because it is the only way to have a salary, but if they force you too much, you start to do things you shouldn't do.

Let's just say I try to find a balance between objects and actions, otherwise I will lose my mind or kill myself slowly. This is why curator Jens Hoffmann and I have founded the Caribbean Biennale. I'm raising money for it now. It will provide a vacation for all invited artists. It's very simple. It will be a show because you will have your list of artists. It will be a show because there are invitations. It will be a show because there will be advertisements. It will be a show because we will do a press conference. It will be a show because, in the end, it will also take a strong position against the proliferation of all the biennales and trienniales. And a vacation is a nice way to make such a comment.

It may seem like a joke, but it is really something quite serious. In a way, we are talking about morality – taking the responsibility for something, taking something that needs to be done into your own hands. Raising $50,000 is very serious. A joke may last for two minutes. This joke will cost me six months of working to raise the funds and organizing the whole thing. It's a huge commitment.

Spector You've undertaken such enterprises before, in which you assume the functions of the institution in order to help other artists. Your Caribbean Biennale reminds me of the Oblomov Foundation you formed in 1992 in order to subsidize an artist for an entire year, the only requirement being that this artist couldn't exhibit his or her work for the time period of the grant.

Cattelan Yes, it's very similar. But on that occasion, I was commenting on how a group of artists had become the 'usual suspects' by showing in every international exhibition. There must have been a photocopied list of artists who had been invited to the last three years of shows. Why bother with advertising? You don't need it. Everyone knows the list already.

This was a very early project for me, maybe too early. At that time, I really liked the idea of involving one hundred people, contacting each of them to raise funds for this grant. So I started to make a list of possible people who might help with this project. It was not so easy. You really have to have balls to make such calls to private people. So I spent four to five hours a day on the phone, saying 'Hi, do you know me?' Nobody knew me at that time. So it was really difficult to introduce myself quickly. I had to get their attention and then say, 'Could you please give me $100 for this project?' So I had to sell my position. It was another really hard job. Eventually I raised $10,000 to give to an artist for not showing any work for one whole year. The artist was selected by the donors; we even had a waiting list. But nobody accepted the grant.

Spector What did you do with the prize money?

> **Cattelan** Well, the other part of this story was that all the people were waiting for me to fuck up, to do nothing with the money, to keep it for myself. I had made a plaque with all the donors' names on it – the kind you see in museums – and I placed it outside the Brera Academy of Fine Arts in Milan. I went there early one morning with fake documents, and I fixed the plaque to the wall under some scaffolding. Those responsible for the place came and said, 'What are you doing?' I just claimed that a company had ordered me to post it. The plaque was there for a whole year. So every time I passed it, I would think, 'Hey, that's me.' It was very nice to have this piece on the wall. But the story needed an ending, so the money paid for my move to New York.

Spector It was a travel grant!

> **Cattelan** Yes, in the end.

Spector How is it that you always seem to get away unscathed from your escapades?

> **Cattelan** I just slide down the surface of things.

1 'Face to Face: Interview with Giacinto Di Pietrantonio', *Flash Art Italia*, No.143, Milan,
 April – May, 1988, pp 25-27. Extract reprinted in this volume, pp. 112-13

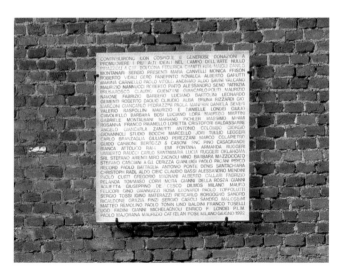

Oblomov Foundation
1992
Engraved glass
100 × 100 × 3 cm
Installation, Accademia
di Brera, Milan

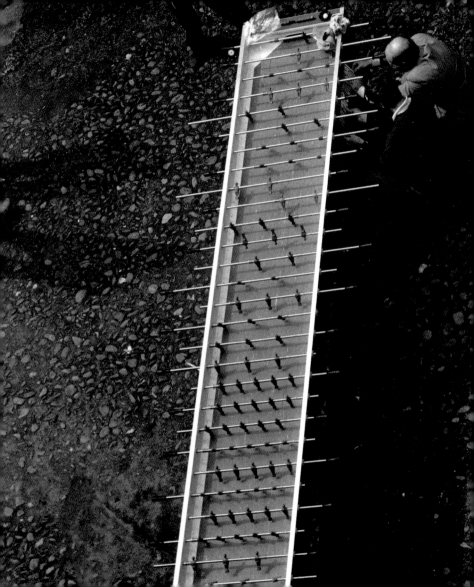

Survey

Francesco Bonami Static on the Line: The Impossible Work of Maurizio Cattelan, **page 38**.

Lucio Fontana
Concetto spatiale
(Spatial Concept)
1960
Oil on canvas
97 × 60 cm

Piero Manzoni
Line 20 metres long
1959
Ink on paper

I. *Il Ragazzo di Padova*

Maurizio Cattelan was born in Padua in 1960, the son of a truck driver and a cleaner. At this time, Italy was experiencing one of the most dramatic economic transformations of its history. Due to the country's rapid expansion of industrial production, there was a sudden rise in inflation; the buying power of average families was doubled, generating an intense social imbalance between the booming middle class and the low-income urban and agricultural classes. The poorer southern Italians were migrating to the industrialized metropolises of the North such as Turin and Milan; an equally marked imbalance arose between these growing urban centres and the parochial smaller towns of the North, such as Padua. Cattelan's family belonged to this proletarian, provincial underclass.

In Rome, the highly successful Cinecittá film studio was reflecting this situation, producing more motion pictures than Hollywood. Focusing on the economic transformation of the country, directors such as Federico Fellini (1920–93), Dino Risi (b.1917) and Pier Paolo Pasolini (1922–75) produced some of the most compelling films addressing post-war Italian culture. These reflected the tension between the desire to become a successful metropolitan beast and the attraction of remaining a comfortable provincial pet; the wish to improve one's social and economic reality, and the trauma of abandoning one's roots, friends and familiar environment by moving north. Fellini's *I Vitelloni* ('The loafers', 1953) and *La Strada* (*The Street*, 1954) express more than any other films of this period this melancholy dilemma faced by many Italians in the 1950s and 1960s.

At the time of Cattelan's birth, the Italian art movement Arte Povera, theorized by the Gramscian intellectual and critic Germano Celant in the late 1960s, had not yet emerged. The leading Italian artists of the early 1960s were Lucio Fontana, who expressed a revolutionary vision in his gestures against the traditional role of painting, experimenting with monochromes and slashed canvases; and Piero Manzoni, with his subversive, iconoclastic works, fusing art-making with everyday actions and commercial trans-actions. From these two figures, via a strange maze of ideas, Cattelan would eventually borrow both the gestures and the iconoclasm.

In the early 1970s, the provincial Catholic town of Padua was transformed into a subversive, left-wing centre by the arrival of students from other cities, who created organizations connected with the political movements which were developing in larger cities such as Rome and Milan. Padua was described later in the decade by economic theorists and philosophers at its university as the city of the 'Lotta Armata' ('Armed Struggle'). Although the outlawed terrorist group Brigate Rosse (Red Brigade) was not formed in Padua and its members lived mostly in hiding, other political groups used this university city as a base from which to subvert the dominant social order while maintaining an active, open presence. These groups became the public face for future full-time terrorists who would eventually be recruited by the Brigate Rosse. One of the most respected academic institutions in the country, the university was the interface between Padua and Italy as a whole,

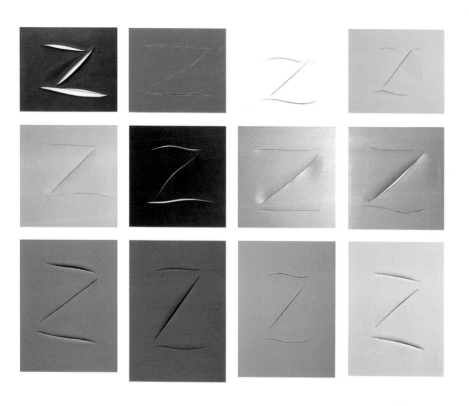

Untitled
1996
Acrylic on canvas
l. to r., from top left, 75
× 101.5 cm; 75 × 101.5
cm; 20 × 100 cm; 75 ×
101.5 cm; 35 × 27 cm;
35 × 27 cm; 35 × 27 cm;
35 × 27 cm; 101.5 × 75
cm; 103 × 75 cm; 101.5
× 75 cm; 101.5 × 75 cm

creating a place of dialogue for a generation that would eventually turn the nation inside out. Central to this process – distributing simple photocopied manifestos or scrawling subversive sentences in industrial paint on the city's walls – was Autonomia Operaia. This revolutionary group disseminated a far left ideology which was to influence the terrorism that devastated the Italian social order throughout the 1970s. It was in this context that Cattelan grew up, eventually becoming a subversive figure himself within the Italian contemporary art system.

A member of the lower working class, Cattelan was a social misfit as a child. At twelve he studied electronics, a popular field for working-class students who wished to escape the looming shadow of unemployment. There was no cultural stimulation at home, where existence was just above the level of literacy, focused on the effort of survival, the provision of a decent meal. Despite his mother's warnings, Cattelan spent

most of his time on the street. This was not so much an act of rebellion or anger as the manifestation of a precocious desire for the freedom which he would eventually achieve through his work.

Cattelan grew up with the unconscious desire to reverse the passive, fatalistic attitude of his parents. He shared the nightmare of his generation: fear of unending unemployment, a danger to be avoided at all costs. Unlike his friends, many of whom fell in with terrorist groups, he stayed away from political factions, concen-trating instead on working as hard as he could to escape the destiny that seemed to have been prepared for him since birth. While his generation experienced the utopia of collective living, devising slogans which proclaimed the end of private property (viewed as degenerate and counter-revolutionary), Cattelan shyly moved in the opposite direction, isolating himself while constantly searching for his own identity.

When he was seventeen Cattelan found an old photograph of his earliest school class in the garbage. This coincidence gave him the sense that he could rescue his image from the detritus of the past – an idea which forms the background of many of his future works. Constantly rewinding through the chronology of his life, Cattelan would recall fragments of his early school days, which later reappear in his art. It was this process of rewinding and fast-forwarding his memory that created a sense of displacement in his work, challenging and erasing the viewer's own memory. Cattelan's capacity for referring, through his own private and marginal experience, to a collective experience generates in the viewer

Angolo dei ricordi
(Memento corner)
1989
Perspex, brass slot,
postcards
150 × 45 × 37 cm
Installation, 'Metessi',
Galleria Carrieri, Rome

a subliminal recollection of similar events, traumas or simply awkward, still residual feelings. Central to this process was the moment when the artist failed his first Italian writing test. He experienced an epiphany, a revelatory moment when the curtain was raised once and for all on the reality around him, the realm of failures that must be faced or fought by each individual. Writing and its tools, such as the ballpoint pen with which he had once stabbed a school friend's hand, became a kind of obsession, which transmuted much later into some of his most poignant works.

In middle school he began to read several texts that were to accompany him along the path of his creative career. His favourite books included *The Sergeant of the Snow*, a diary by Mario Rigoni Stern, which narrated the painful retreat of the Italian army during the Russian campaign of the Second World War. Hermann Hesse and Italo Calvino were other authors whom he admired. However, he decided that mainstream magazines were better sources for ideas and slowly his research shifted away from literature. But the influence of Calvino and Rigoni Stern shaped the melancholia that often characterizes his works.

Cattelan started working at a very early age, while he was still in grammar school. He became an apprentice gardener and also sold holy effigies in the local parish, from which he was expelled when he drew a moustache on a sculpture of a saint. When he was eighteen, in 1978, he left his parental home to live with his girlfriend, taking with him only a shopping bag with his things.

1978 could be described as the most socially turbulent year in post-war Italy's history. Padua was at the centre of the student revolt known as the 77 Movement, led by siblings of the 1968 student generation, who had less ideological focus and more confused social goals than their prede-cessors. During this period, the 'Armed

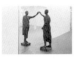

Enzo Cucchi
Per soluzione divina a
Gallignano (By Divine
Solution to Gallignano)
1980
Graphite on paper
200 × 200 cm

**Michelangelo
Pistoletto**
L'Etrusco (The Etruscan)
1976
Plaster, mirror
250 × 300 × 80 cm

Struggle' against the state was being theorized by the philosopher Toni Negri. Negri was later accused of having directly influenced a number of terrorist actions and was sentenced to a long prison term. Before the sentence was pronounced he was elected to the Italian parliament; to escape his sentence he fled to Paris where he lived in exile for many years. 1978 was also the year when Aldo Moro, the leader of the Christian Democrat party, was abducted and murdered. Moro had been the mind behind the *Compromesso Storico* (the 'Historical Compromise', 1978), an unprecedented political concept, which allowed the Italian Communist Party to form a government with the Christian Democrats, allying the left with the centre. This was viewed by some merely as a com-promise but by those who idealized the Italian Communist Party as an eternal party of opposition it was taken as a betrayal. The murder of Moro and the 77 Movement uprising changed Italy suddenly and dramatically, yet Cattelan, a postmodern drifter, stayed on the sidelines, miraculously avoiding any political involvement, although he toyed with the idea of robbing a bank.

In the art world's international arena, 1978 was the year when Italy's Arte Povera movement was superseded by the Transavanguardia (characterized by the return to figurative painting in the work of Sandro Chia, Enzo Cucchi, Francesco Clemente, Mimmo Paladino and Walter De Maria). The critical strategies of Germano Celant (the former champion of Arte Povera) became more power-based in their focus, and Achille Bonito Oliva took the curatorial lead in the hedonistic, market-driven practice which would dominate the 1980s.

Meanwhile, during the early 1980s, Cattelan was apprenticed to a nurse at a hospital, where he was assigned to deal with corpses in the morgue. He quit this job in 1985, the year in which he slowly started to consider becoming an artist, seeking in art an alternative to his proletarian fate. Cattelan's vague memory of his first experience of art in a gallery is of his visit to a show at a small gallery in Padua of mirror paintings by the Arte Povera artist Michelangelo Pistoletto. The work perplexed him so he asked for an explanation from the gallerist, who suggested he read the work of Carlo Giulio Argan, one of Italy's most renowned art historians. Argan's work opened the door of contemporary art to Cattelan and provided him with a sudden immersion in the world of images. The more he read, the more he developed an awareness of the power of images to exceed the content of texts. This basic reflection was the ground on which Cattelan began to work, attempting to create strong visual images that could communicate more than their textual equivalent or basis.

II. The Artist Outside

The years between the end of the 1970s and the mid 1980s were a hybrid zone for Italian contem-porary art. Young artists spent more time in the city squares and streets than in their studios. Their creativity was fragmented; everyone was trying everything, never settling in a particular place or style. Cattelan began to meet artists for the first time and made contact with the cult periodical *Frigidaire*, a counter-cultural publication based in Rome concerned with outsider art and cultural production. *Frigidaire*

assigned Cattelan to produce some computer-manipulated images and a series of comic strips. His idea of art was still blurred. He saw the art world idealistically, as a colourful place offering plenty of free time and attractive women.

In 1988 Italy began to enter its peculiar version of the 'yuppie' era. The new socialist government headed by Bettino Craxi – a kind of Italian version of the German Social Democratic party – led the country into a collective state of oblivion, temporarily erasing the previous, shattered decade of Italian history. In this new political and economic cultural ambience, where to be marginal now meant to be excluded from this social new wave, Cattelan was faced by his own incapacity to escape from the sidelines. He started work on some awkward designs for a series of anthropomorphic objects. Later, he began to design items of furniture such as the table *Cerberino*. Its name means colloquially 'little watchdog' but also refers to Cerberus, the mythological three-headed dog which guarded the gates of the underworld; the table is still commercially produced and sold in furniture stores. In 1989, at the Galleria Neon in Bologna, Cattelan presented his first series of works. These stood somewhere between art and design. One, for example, was a glass screen incorporating soil and plants titled *Cerniere* (*Hinges*). He had not yet defined his slow, inexorable move towards a rebellion against prevailing intellectual and cultural models. However, he did understand that the issue was not to divide the art world into good and bad artists but into 'very good ideas' and 'not so good ideas'.

Lessico familiare (*Family Syntax*, 1989),

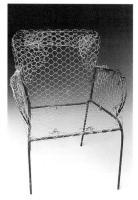

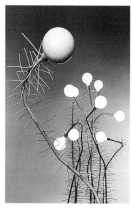

clockwise, from top l.,
Untitled
1988
Found metal armchair frame, chicken wire
Dimensions unknown

Trifidi (Trifids)
1988
Welded iron, light bulbs
Approx. h. 2 m

Punto di vista mobile
(Mobile Point of View)
1989
Cast iron, lacquered wood
40 × 33 × 30 cm

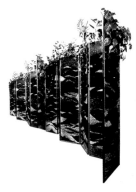

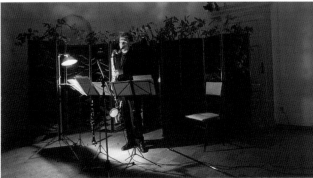

Cerniere (Hinges)
1989
Steel, glass, silicon,
earth, water, plants
1 m × 20 m (extended)
× 1 cm

above, right,
Installation, 'Paesaggi
Interni', Palazzo del
diavolo, Forlì, Italy

perhaps Cattelan's first real image, is a self-portrait. In a faux-rococo silver frame is a photograph of the half-naked artist, his hands positioned on his chest in the shape of a heart. The image is full of ambi-guity. Cattelan's desire to escape his working-class roots and reach the safe environment of the Italian middle class, without conceding his independence, frames him in this awkward position. The silver frame opens onto a world made up of conventions. This object, so common in an Italian bourgeois home, often displaying the prized wedding portrait, is here subverted. A wedding photograph usually creates an idealized ambience in which economics and love melt into a social achievement. On one level, Cattelan welcomes the viewer, with his hands forming a heart, but on another, he evokes a vulgar gesture comparable to the Anglo-Saxon 'finger' sign.

Remaining on the edge, Cattelan tended to avoid Italian exhibitions unless he was forced to attend them because he was participating. For this reason he would not visit the Venice Biennale until 1993 when he was officially invited to

participate in the Aperto section. He avoided reading articles in art magazines, only reading the Milan-based *Flash Art* – the unrivalled voice of Italian contemporary art – if he had to because it included a review of his own work. He visited only exhibi-tions in which he was participating, yet (with no logical explanation) attended Skulptur Projekte in Münster, the curator Kasper König's international presentation of contemporary sculpture, held every ten years in the small town of Münster, Germany. This self-imposed isolation helped to define Cattelan's identity as a contem-porary artist, yet to describe him at the beginning of the 1990s as an 'artist' would still be incorrect. It would be more appropriate to view him as an anthropologist intent on studying the origins of the artistic gesture within the social gesture. Walking around the city – by 1990 he had moved to Milan – was part of his 'field work'. He would focus on small acts of survival in this metropolitan context, finding them as intense as many art-works. A homeless man who washed his clothes and dried them on a tree in the middle of the winter, for example, provided an image strong

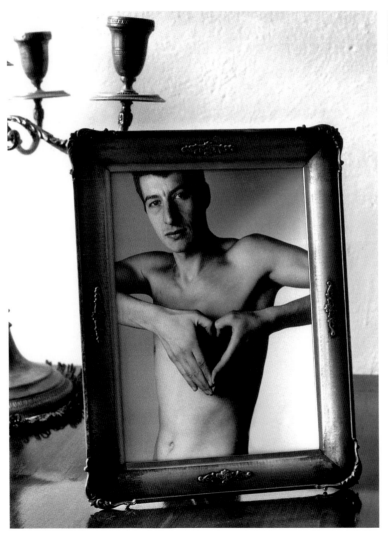

Lessico familiare
(Family Syntax)
1989
Black and white
photograph, silver
frame
Approx. 20 × 15 cm

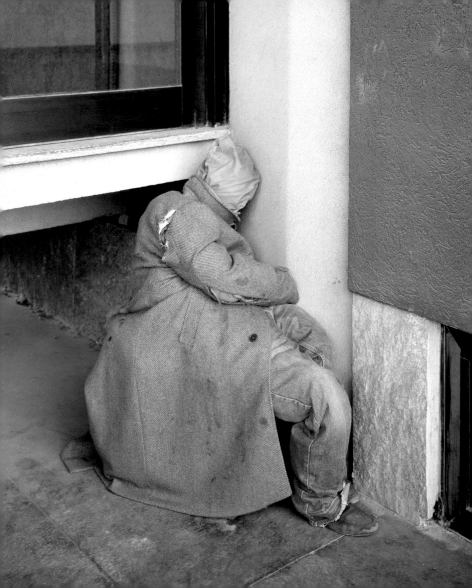

enough to generate a hypothetical art piece, later to evolve into actual works such as *Andreas e Mattia* (1996) and *Kenneth* (1998). During this period Cattelan was reflecting not only upon the role of the artist but on other social roles: on another occasion he followed a vagrant through the streets of the city in order to understand all of his movements and needs within the urban landscape – identifying with his emancipated condition.

Cattelan's relationship with art was beginning to be transformed, although he was not conscious-ly aware of this. Rejecting as obsolete the egocentric position of the conventional artist in search of a masterpiece, he believed he had to justify his artistic role like any other professional. The Italian art world had changed; the last fires of the Transavanguardia had been extinguished, although painting would remain the main obsession of Italian art critics and the world market. Cattelan surfaced in a relatively safe contemporary arena. His projects were structured as experiments, increasingly utilizing the strategies of the advertising world, presenting the idea of a work to a test group of the public before deciding whether to produce it and which form it should take. He believed that artistic ideas should not be autonomous; rather, to be effective an artwork should activate the social and cultural structures surrounding it in an urban environment.

In this respect, Cattelan was moving in a direction taken earlier by the Arte Povera artist and guru of the previous generation, Alighiero Boetti. Boetti was one of the few Italian artists who endorsed the idea of collaboration on and interpretation of artworks by those outside the art world. Cattelan became interested in Boetti's work at this time and at one point asked him to be a participant in an uncompleted project, in which various people were asked to add extra phrases to those listed in Jenny Holzer's work *Truisms* (1977–79). Boetti contributed the phrase 'Never write bullshit', affirming both his anarchic attitude – shared by Cattelan – and his moral stance, a source of both fascination and inse-curity for the younger artists who wished to emulate him. While in Boetti's work morality and anarchism combined to bolster its integrity, for Cattelan these same elements produced an internal struggle that led to a nervous creative energy on one hand and enervation and entropy on the other, shaping different qualities in his work.

Many years later, at Manifesta 2 in Luxemburg (1998), the second of a series of itinerant biennial exhibitions set up as an alternative to such institutions as Documenta and the Venice Biennale, Cattelan was to pay open homage to Boetti. In 1969–70, Boetti had worked on a proposal for a monument to agriculture, *Monumento all'agricoltura*, a tall sculptural column of soil in which a tree would be planted. For Manifesta 2, Cattelan presented in one of the rooms of the Casino Luxemburg an untitled work consisting of a large cube-like base of soil, sprouting a Mediterranean olive tree. With this work, Cattelan both acknowledged Boetti's legacy and stressed the power of images to transform the world, creating a monument to impossible feats. While Boetti's approach had been more idealistic, to the point where he deliberately left the work as an unrealized utopian project, for

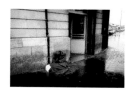

opposite, **Andreas e Mattia** (detail)
1996
Stuffed cloth figures, clothing
Lifesize
Installation, 'Campo 6: il villagio a spirale', exterior of Galleria Civica d'Arte Moderna e Contemporanea, Turin

above, Homeless person, Luxemburg, 1998
Photograph by the artist

Cattelan ideals are only useful on condition that they generate a visual reality. For Cattelan art continues to be an impossible feat where there is little room for ideals; an enterprise which is never completed and often fails; an endless effort to steal time from mortality. Cattelan's attitude is reminiscent of the key scene in Ingmar Bergman's film *The Seventh Seal* (1957) where a medieval knight engages in a game of chess with the figure of Death – a slow and complex process, which involves ever-decreasing strategies.

Cattelan's work has an idiosyncratic relationship with the Italian artistic movements that preceded him. He did not especially admire the works of the Arte Povera artists besides Boetti, although he appreciated their use of language: the way in which a word or phrase could be transformed into an artwork. Language was important for him in order to put in motion the chain of ideas that led to the formal construction of the work. Titles, when he uses them, often become a kind of base or pedestal where an idea can appear and become the work. The hierarchical relationship between title and work is never clear: which generates which is not a given. Once a work by Cattelan is completed, viewers are required to rediscover the connection between the title and the work's formal structure, a conjunction which is always displaced.

Cattelan's presence within Italian art is anomalous, his roots unclear. In spite of several attempts by curators to insert his production into official critical surveys, attempting to establish connections with earlier generations of Italian artists, Cattelan maintains his specificity and independence. He avoids Italian formalism, its obsession with 'high' materials such as stone, bronze or marble, and its anachronistic use of a poetic language which seems increasingly out of touch in the face of new technologies. He personifies a culture born too late to be part of the cultural revolution of the 1960s and too early to be lured by the aestheticization of media and communication developed in the 1980s. His Catholic upbringing and shrewdness helped him avoid the purist moralism pervasive in the Marxist culture of the 1970s. This shrewdness is at times seen as a weakness, arousing the accusation that he is a cynical one-liner, but his ambivalent aesthetic and conflicted attitude towards institutions, galleries and collectors helps save him from this charge.

An Italian artist who perhaps comes closest to his approach is Gino De Dominicis (b. 1947), yet such a comparison could be deceptive. De Dominicis was more isolated and, especially at the end of his life, more romantic. He produced aesthetic acts that were on the verge of absurdity in order to alienate the viewer, such as the work *Seconda possibilità d'immortalita (l'universo è immobile) (Second Possibility of Immortality [The Universe is Motionless])* shown at the Venice Biennale in 1972. Here De Dominicis presented a person affected by Down's syndrome, seated on a chair, who gazed at a beach ball and a rock placed before him. Cattelan gives the viewer more to grasp, the scandal never appears gratuitous, even when his message is a negative one. While De Dominicis played the role of the artist in an almost reactionary fashion, Cattelan is unable to conform to this obsolete idea.

This attitude was particularly evident in

Cattelan's 1997 show at the Wiener Secession in Vienna. Here the artist confronted what he perceived as the institution's lack of energy with the passive-aggressive work *Dynamo Secession*. In a dark basement room of the art institution two of its gallery attendants pedalled on bicycles propped in stands. Low-voltage light bulbs hung from the ceiling in several of the rooms of the basement, the source of their illumination being electric generators powered by the amount of energy the two members of staff put into their pedalling. The attendants were thus transformed into the artist's alter ego, capable of producing nothing but a feeble light in the world.

III. The Identity Thing

In the same year, veneration of famous artists from the past was parodied in the first of two works using giant masks (the second came in 1998 with his Picasso-masked figure in the entrance of The Museum of Modern Art, New York). The 1997 Biennial of Santa Fe was held

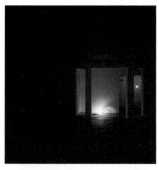
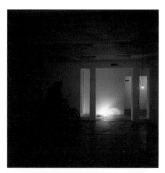
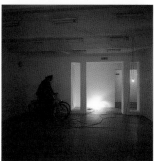
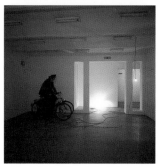

left and overleaf,
Dynamo Secession
1997
2 bicycles rigged to electricity generator, operated by museum guards
Dimensions variable
Installation, Wiener Secession, Vienna

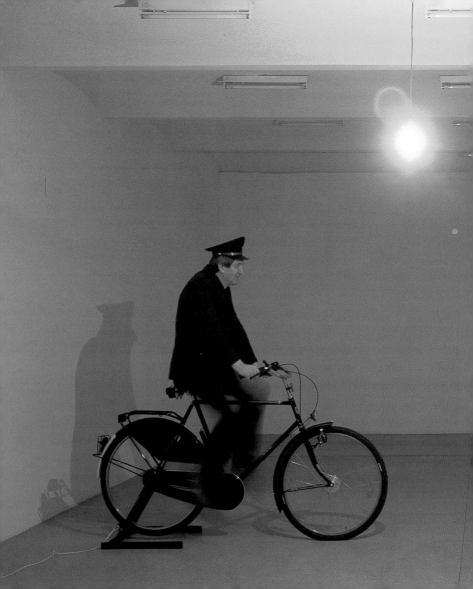

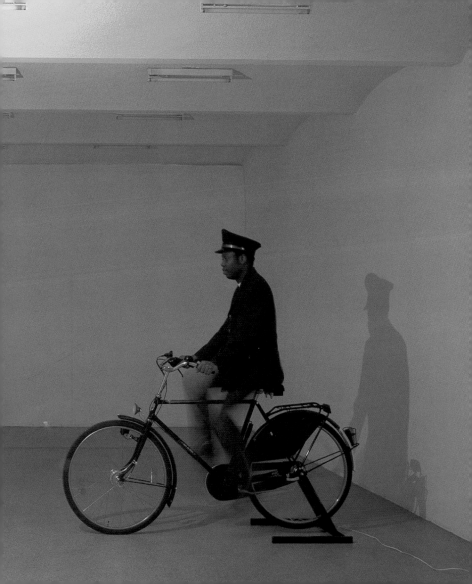

Stand abusivo (Illegal stand)
'Arte Fiera', Bologna, 1991

simultaneously with the city's grand opening of its new museum dedi-cated to Georgia O'Keeffe, an artist worshipped in the area like a goddess. For the Biennial, Cattelan therefore produced a huge papier mâché sculpture of O'Keeffe's head, entitled *Georgia on My Mind*. He took as his inspiration the large masks of famous contem-porary figures which are paraded annually through the streets of the small Tuscan town of Viareggio during its carnival – combined with the Mickey Mouse or Goofy masked figures who welcome visitors to Disneyland. A volunteer walked around the streets of Santa Fe wearing the mask and welcoming people, mocking the excessive local adulation of the artist.

The idea of the mask as a metaphor for the artist's identity is also used in *Spermini* (*Little Sperms*, 1997), many tiny masks of Cattelan's face, appearing like homemade clones. This was a revisited version of *Super noi* (*Super Us*, 1992), in which the idea of the self-portrait is stressed through the eye of the 'other'. Cattelan asked an expert in making police composite sketches, whom he had never met, to create fifty drawings of the artist based on descriptions by his friends

and acquaintances. With this work, Cattelan reversed the conventional idea of the self-portrait, defining his identity through other people's ideas and their relationships with him – at the same time turning himself into a kind of 'suspect'.

A similar approach to collaboration had informed the work *AC Forniture Sud* (*Southern Suppliers FC* [Football Club]), made in 1991. In this year, Italy was embarking on a new experience that would dramatically transform its social structure. At the start of the twentieth century, Italians had been among the largest groups to migrate to other countries. Now, at the end of the century, immigrants from North African and Eastern Europe were arriving in the country as refugees in increasing numbers. No specific laws existed to control the situation; racism, previously not an evident phenomenon in Italy, became a severe problem. Cattelan does not exploit social issues; he simply connects them with his ideas. In this work, which he showed at art events including the largest Italian art fair at Bologna, he combined football as an ancient passion and illegal immigration as a new

right, **Stadium**
1991
Wood, glass, metal, plastic
700 × 100 × 120 cm
Installation, 'Anni 90', Galleria d'Arte Moderna, Bologna

opposite, **AC Fornitore Sud** (Southern Suppliers FC)
1991
Colour photo collage
77 × 100 cm
Photograph of football team, managed by the artist

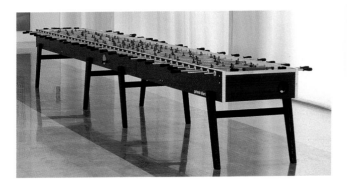

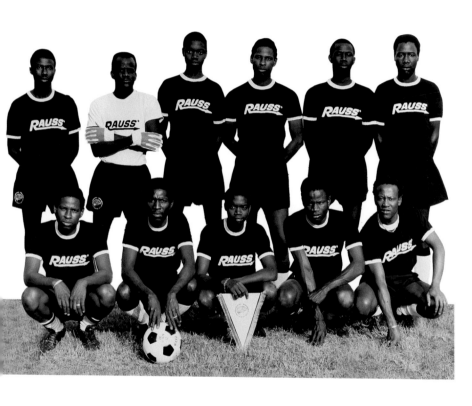

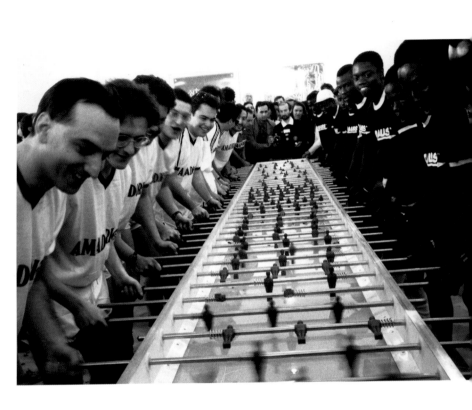

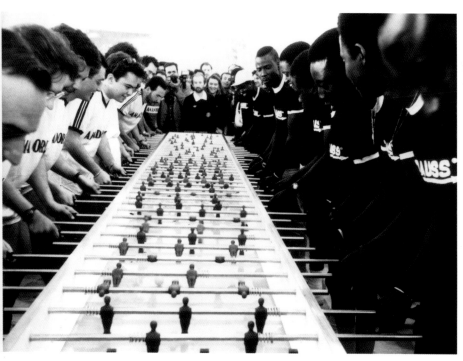

Stadium
1991
Wood, glass, metal,
plastic
700 × 100 × 120 cm
AC Fornitore Sud
(Southern Suppliers FC)
table football fixture

Untitled
1995
Ink on paper
29 × 21 cm
Prototype for lifesize
costume, Basilico Fine
Art, New York; pre-
production drawing,
with Umberto Manfrin

phenomenon. Incorporating his first major sculpture, it comprised an elongated table football game, played by twenty-two competitors – one team made up of North Africans, the other of Italians. Using collective action, performance and popular culture, it teetered on the verge of entertainment and social critique, aiming for a democratic new way to play the artist, whilst remaining central to the work as the coach and manager of the teams.

Andreas e Mattia (1996) also obliquely refers to the artist's own identity. Two stuffed cloth figures of homeless men, covered convincingly in clothing and blankets, the sculptures were placed along urban streets where one might expect to find real homeless people. The reaction of the average citizen to the homeless is ambivalent: a mixture of compassion and rejection, guilt and moral judgement. To Cattelan, their anonymous presence constitutes a point of reference in the urban environment, like a public sculpture. Without comparing himself on a social level with the homeless, he sees this work as mirroring the artist's position within the art world: a nuisance if unknown, a monument when successful.

Cattelan's expression of identity as an artist has also involved reversing traditional relation-ships with the gallerist. In 1995, at a new gallery, Basilico Fine Arts in New York, owned by Stefano Basilico, a former assistant of the legendary elder gallerist Ileana Sonnabend, Cattelan took on the role of psychoanalyst: he proposed that the dealer should wear a costume bearing Sonnabend's features, and with a tiny stuffed effigy of Basilico on the shoulders, for the duration of the show. It would appear as if

Sonnabend were carrying a little Stefano on her shoulders. In terms of the 'anxiety of influence' usually applied to artists, in this unrealized proposal Cattelan expressed as a sculptural concept the psychological legacy that he imagined Sonnabend must have imposed on the young dealer: a constant effort of comparison, even an Oedipus complex.

This work relates to an earlier project of 1995: for his show at Galerie Emmanuel Perrotin in Paris, Cattelan worked in collaboration with a cartoonist to design a costume which would communicate the true nature of his gallerist, a notorious womanizer. He considered a big rabbit with a large penis but finally, with the cartoonist's help, conceived a costume that was a big penis resembling a rabbit, which he named *Errotin, le vrai lapin*. Perrotin was obliged to wear the costume for the entire length of the exhibition. Entering the gallery, the viewer was thus welcomed not by a conventional gallerist but by his 'essential self'.

Although within the Italian art scene Cattelan stands out as a pure individualist, visual anarchist and independent creative spirit, he does share a communal relationship with a generation of international artists who have dragged the artistic process into the maze of the social. For Cattelan, design and advertising are as attractive as contemporary art. He sees all these aesthetic disciplines as tools of equal status, with which to extract the best from the aesthetic process. Rirkrit Tiravanija, Tobias Rehberger, Gabriel Orozco, Piotr Uklanski, Koo Jeong-a and Suchan Kinoshita all similarly blur the boundaries between art and life, creating a new terrain in

which the images of art and life upgrade each other in a continuous process. Their work is more experiential than simply visual. Like the 'stamp dealer', the main character in the novel *Il Serpente* (1966) by the Italian writer Luigi Malerba, these artists seem to say, 'I feel that I am in the centre of something, but I don't know what it is.' Compared with the 1970s generation, they do not feel the need to serve society, yet they believe that artistic practice is one of the fundamental elements which define the success of a society.

Ever since finding the old school photograph in the rubbish bin, Cattelan has maintained a dialogue with himself about his relationship with the world; he has never completely isolated himself to protect his identity. If he is remote he is not as much so as, for example, Emilio Prini, who disappeared from the public scene from the end of the 1960s onwards after having been one of the pivotal figures at the birth of Arte Povera. Prini's reclusive withdrawal led to a reductive process in his work, which became like a series of clues to memories and messages via exhumed photographs from his archives. Cattelan strives to escape remoteness and marginality. Despite not belonging to any Italian artistic tradition or history, he identifies himself with that dislocated individual, the contemporary Italian – dislocated because pressed between history and collective nostalgia for the traditional notion of Italy that no longer exists. The modern middle-class Italian is someone who somehow remains estranged from the processes of social transformation in the larger world. As an Italian, Cattelan is similarly distanced from the world's changes; however, as

an artist he participates in the hybrid, global culture of the present. He reclaims in his work a series of problems exhibited by contemporary society but avoids transforming them into mere political or aesthetic signs. Each work exists in that no-man's land where politics and art fail to understand each other. Cattelan represents a nation in the process of de-individualization, a process faced by all nations today as they adapt to the economics of globalization. His troubled works reflect the afflictions of the Western world. He thus reflects on the meaning of his past individual memories in relation to a larger and more complex past.

IV. Sly Politics

Just as Arte Povera rode the student and political movements of 1968, disguising its formalism behind a revolutionary language and attitude, Cattelan rides the weak desires of a generation unable to confront the system of conventional values, proposing himself as the unique phenomenon of an unlikely avant garde. Like Italo Calvino's character Mr Palomar in his story of that name (1983), Cattelan is inquisitive, not about the wider world but about a specific society. He is not a social activist like Piero Gilardi, a member of Arte Povera who confronted society in all its contra-dictions during the 1970s. Cattelan uses these contradictions as pure material for his work; he is not shy in exploiting his society as an open studio with all its injustices, dilemmas, violent and dramatic realities. He does not indulge in any analysis or in the attempt to find a solution; he is one of the many players of the social game. In one way or another his goal is

Piotr Uklanski
JAK
1996
Collage
Reproduced in
Goeteborgs-Posten,
Sweden, 3 January
1996

Rirkrit Tiravanija
Untitled (... Cure)
1993
Mixed media, people
305 × 305 × 305 cm
Installation,
Kunstlerhaus
Bethanien, Berlin

to survive or, even better, to win.

Campagna elettorale (*Election Campaign*, 1989), for example, was an advertisement, taken out in the major Italian daily newspaper *La Repubblica*. Here, with the sentence 'Il voto è prezioso tienitelo' ('Your vote is precious. Keep it') Cattelan underlines the idea that one's vote is an item of value, so valuable that he suggests keeping it for oneself. This is a cynical reminder that even in Italy – a country where voting is not simply a political act but a moment of public conviviality, with families strolling together to the voting booths and friends debating vehemently at home and in public – interest in the political structure of the country is receding into a more and more disturbing individualism.

Cattelan's work forecast a phenomenon which reduced the turn-out at the polling stations to less than 50 per cent, where previously in the 1970s over 80 per cent of Italians used their vote.

During 1994–95 Italy went through a period of deep transformation, a kind of moral revolution, through the efforts of the *Mani pulite* ('clean hands') campaign to rid the country of corruption. Italy itself became the subject of many of Cattelan's works at this time. The corruption which dominated public administration and political life was exposed, and a group of judges calling themselves the *Mani pulite* brought to trial and often imprisoned some of the most powerful political figures of the previous two decades. However, the collapse of the complex equilibrium between political and criminal power structures caused great resentment and violent reactions. A series of bombs exploded all over Italy, aimed, peculiarly, at art institutions. Three people were killed by a bomb near the Palazzo Uffizi museum in Florence; one bomb destroyed the Padiglione d'Arte Contemporanea, the only contemporary art institution in Milan, killing five people, among them a North African immigrant.

Cattelan acquired some of the rubble from the bombing in Milan and packed it in an industrial bag, similar to a laundry bag, for an exhibition in London, with another version shown at the Musée d'Art Moderne in Paris, where the rubble was encased in clear plastic and placed on wooden pallets, in a display vaguely reminiscent of early Minimalism. In both cases, Cattelan created an evocatively negative monument. The piece's title, *Lullaby* (1994), was a comment on an unrespon-

sive, cynical society. Here Cattelan does not produce revolutionary political art but nevertheless uses politically charged material at the heart of his subject matter.

I Found My Love in Portofino and Il Bel Paese, made in the same year, also examine the disintegration of Italian society in the 1990s. Bel Paese ('beautiful country') is the name of one of the most well-known Italian processed cheeses, and also the title of a minor book written at the beginning of the twentieth century by an obscure writer, Ernesto Stoppani, on the marvels of Italy. In I Found My Love in Portofino, some Bel Paese cheese, including its label, was devoured by a group of black rats, while in Bel Paese the design of the well-known cheese label was woven into a carpet which was constantly walked over by

visitors to an exhibition celebrating new Italian art at the Castello di Rivoli, Turin ('Soggetto, Sogetto', 1994) – transforming this symbol of Italy into a trampled smudge.

The following year, Cattelan returned to the disturbing events of 1978, when Aldo Moro was kidnapped and killed by the Brigate Rosse. The killing of Moro is a scar on the collective memory of the country; a sign of the failure of a generation who naively believed that a revolution was possible. Cattelan transforms this historic moment into a kind of collective nativity or epiphany. Originally used by the artist as a Christmas greeting card, the image was transformed eventually into an enlargement of a page from a newspaper showing a Polaroid of the kidnapped Moro, with the symbol of the Brigate

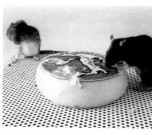
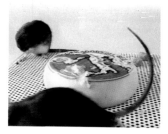

I Found My Love in
Portofino
1994
Wood, perspex, Bel
Paese cheese, live rats
150 × 50 × 50 cm

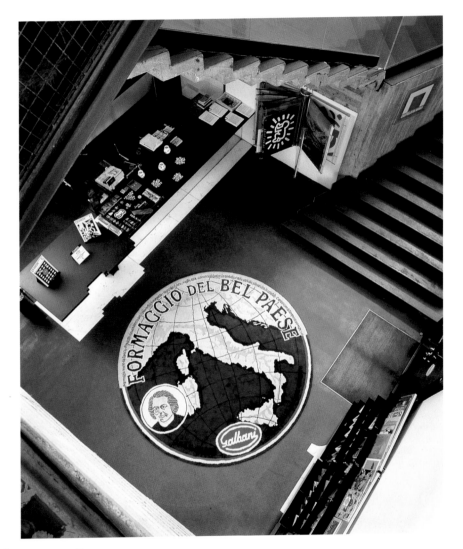

Rosse transformed into a shooting star. Considered by many as a gratuitously morbid concept, this untitled work – both as a greeting card and as 'wallpaper' - was actually an acknowledgment of a turning point for Italian society and culture – the loss of an absurd innocence in a world based on profit and exploitation. Standing before the large mural in 1993, fifteen years after Moro's tragic death, we sense both the artist's doubts and those of his entire generation. Such doubts are like a pedestal on which Cattelan's work stands.

In Italy it is a family tradition to construct a nativity scene at Christmas. Using a political image to create his own kind of nativity scene was a way for the artist to criticize the use of religion for decorative purposes, an indulgence of many Italian middle-class families. Intrigued by the idea of the nativity, Cattelan decided to create a different one every year, gradually building a composition over several instalments. The second of these works was Untitled (*Christmas 95*), a sculpture derived from three figures in Hieronymous Bosch's painting *The Garden of Earthly Delights* (1510–15), who are frozen in some kind of erotic act. Bosch is an artist whom Cattelan has observed closely, fascinated by the absurdity of his compositions and his iconoclastic attitude towards religious and conventional subjects. The third part of Cattelan's nativity, *Untitled* (*Christmas 97*), also has an (unintended) Bosch-like quality – a close-up of a hand with small Christmas fir trees growing on its finger tips.

Moving beyond the specific problems of Italy, *European Naziskin Meeting* was a rejected project for 'Sonsbeek 93' in the Netherlands. Invited to

opposite, **Il Bel Paese**
(The Beautiful Country)
1994
Wool carpet
ø 300 cm
Installation, 'Soggetto, Soggetto', Castello di Rivoli, Museo d'Arte Contemporanea, Turin

left, **Untitled**
1994
Photocopied sheets
450 × 600 cm
Installation, Galerie Daniel Buchholz, Cologne

Untitled (Natale 95)
(Untitled [Christmas 95])
1995
Neon
38 × 82 × 1 cm

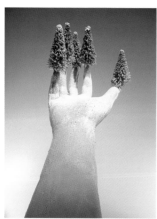

take part by the curator, Valérie Smith, Cattelan proposed the organization of a fake meeting of neo-Nazis on the day of the opening. The idea was to advertise the meeting on fly-posted notices throughout Holland a month before the show. The curator was outraged. The project was considered irresponsible and a pointless provocation. But was this really true? The work stemmed from a reflection on public and personal violence. Cattelan was thinking about several conflicts, of which he had been either a victim or a witness. His memory went back to Autonomia Operaia in Padua during the 1970s, preaching and legitimizing violence. Cattelan remembered the violent climate of those years and the inadequacy of the city to contain it. The Sonsbeek project was an exploration – not a superficial provocation – of

how we face the issue of violence, in particular violence with roots in recent European history. As a rejected project, it revealed art's reluctance to face the reality to which it belongs. By publishing her correspondence with the artist in the exhibition catalogue, Smith expressed her own inability to take genuine responsibility, through the attempt to be subversive on paper only. This was not only an issue for one specific curator; it was relevant to everyone in the art world – a world that Cattelan was constantly trying to confront.

V. Stealing Home

Cattelan uses art as a tool both to verify reality and to activate a memory of the past. All the work he has produced since 1990 is a slow march back home. But this is not the home he left when he was eighteen years old; he is seeking a home he never had.

Until 1993, his relationship with the art world was that of the classic outsider: subversive, anarchic and cynical. Not wishing to be in the spotlight, he chose to operate in dark corners, but corners accessed by the right crowd. Cattelan's method is to aim each work to a specific public, presented as a goad. He knows that our contemporary identity needs more and more powerful incentives. His own first incentive was failing the Italian test; today, he is seeking an honorary university degree, an achievement which would finally erase this moment of regret. His schooling, the subject of much of his work, was also the subject of his nightmares: his teachers and the education system were more punitive than enlightening. It may have been this

above, **Hieronymous Bosch**
The Garden of Earthly Delights (detail)
1503–4
Oil on panel
Triptych, 195 × 220 cm

left, **Untitled (Natale 96)** (Untitled [Christmas 96])
1996
Print on computer mouse pad
35 × 20 × 1 cm

below, **Il giardino delle delizie (Natale 94)** (The Garden of Delights [Christmas 94])
1994
Latex, paint
38 × 82 × 1 cm
Installation with lights, Galleria Massimo De Carlo, Milan

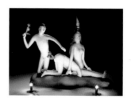

Grammatica quotidiana (Daily Grammar)
1989
Offset litho on paper
21 × 29 × 5 cm
Each sheet of the calendar reads 'Oggi' ('Today')

artist reflect the doubts presented to him as a child by society.

Cattelan's memories of his troubled education were at the core of a series of untitled works made in 1991–92. The first of these, referred to informally by the artist as 'Edizioni dell'Obbligo' ('Obligatory Editions'), consisted of a series of exercise books collected from different elementary schools and published as real paperbacks. The second untitled work, referred to as 'Punizioni – lotta di classe' ('Class Struggle Punishment') used the same principle but also included the reprimands and punishments assigned by the teachers. 'Punizioni – non devo piangere' ('Punishment – I must not cry') was a collaboration with a teacher who asked her pupils to devise their own punishments for their various wrongdoings. These works are a melancholic analysis of the sense of guilt encouraged by society in individuals from their first contact with the structured world, represented here by the school system.

When Cattelan was honoured with a solo show in 1997 at the Castello di Rivoli in Turin – a baroque castle housing the most important contemporary art museum in Italy – he again revisited the trauma of the classroom. In *Charlie Don't Surf* the viewer encountered a boy from the back, sitting at a desk at the end of a dramatic room, back-lit by a large window. Drawing nearer to this scene, one saw that his hands were pinned to the desk with two pencils. This brutal image recalls the artist's memories of a school friend he stabbed with a pen – the terrible sense of being nailed to the desk during school time, presented as an awkward crucifixion.

disappoin-tment with his educational experience that has driven his imagination to conceive an as yet unrealized project to support children with a school or centre which would define itself as a place of civil and cultural redemption. His relationship with childhood is strange, by turns nostalgic and violent. It is as if his doubts as an

Untitled (Edizione
dell'Obligo)
1991
Exercise books
29.5 × 21 cm each

Fare la lotta di classe è pericoloso.

Cattelan carefully analyses his own experience, attempting to transform the negative sign of his regrets into a positive one for the viewer. The work functions on different levels: social, cultural, conceptual and psychological. All these multiple aspects sit on a base made up of the artist's past unhappiness. This uneasy melancholy can be identified in works such as *Grammatica quotidiana* (*Daily Grammar*, 1989) a calendar on which each page bears the word 'Oggi' ('Today'). In this work, Cattelan stresses the idea that each day we need to start from scratch, facing the same problems and issues that defeat the idealistic sense of moving forward inscribed in the chronology of a real calendar. But Cattelan also uses humour to mock or bluntly quote the work of earlier Conceptual artists such as Michael Asher, Vito Acconci and Chris Burden, whose work was the result of a much longer and more complex process of research.

While the output of artists such as Sherrie Levine, Peter Nagy or Jeff Koons was defined in the mid-1980s as 'appropriation art', Cattelan's strategy is simply robbery. He steals images and ideas to create an event. Cattelan's first work to do this (and to deal directly with the mechanics of the art world) was made in 1990. He published a pirate issue of the Italian magazine *Flash Art*, substituting the cover with one of his own design. His image was of a house of cards (on the verge of collapse), built from other issues of the magazine.

Six years later, in collaboration with the artist Dominique Gonzalez-Foerster and editor Paola Manfrin, he produced the magazine *Permanent Food* – now a cult object – based exclusively on pages from other magazines, selected by guest

Charlie Don't Surf
1997
School desk, chair, mannequin, clothing, pencils
112 × 71 × 70 cm
Installation, Castello di Rivoli, Museo d'Arte Contemporanea, Turin

Charlie Don't Surf
1997
School desk, chair,
mannequin, clothing,
pencils
112 × 71 × 70 cm
Installation, Castello di
Rivoli, Museo d'Arte
Contemporanea, Turin

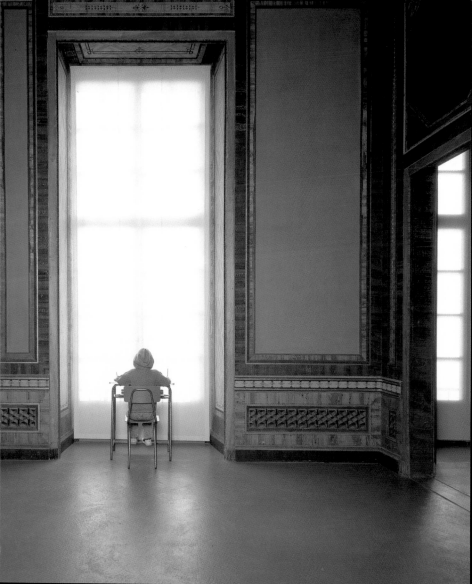

QUESTURA
DI FORLI'

OGGETTO: Verbale di denuncia di patito furto sporta da:
CATTELAN Maurizio, nato a Padova il 21.9.1960 ivi residente
in via U. Foscolo al civico 22/A, domiciliato in Forlì in
via Maroncelli al civico nr; 15 tel. 0543/23865.-

L'anno 1991, addì 22 del mese di Marzo alle ore 08.25, negli Uffici
della Squadra Mobile della Questura di Forlì.==================
Innanzi a Noi sottoscritti Ufficiali ed Agenti di P.G., appartenenti
alla suidicata Squadra Mobile, diamo atto che é"presente **CATTELAN Mau
rizio**, in oggetto meglio generalizzato, il quale per ogni effetto di
legge denuncia quanto segue:====================================
Ieri sera 21.3.91, parcheggiavo l'auo della mia ragazza **GIAMBI** Patri
zia, in questa via P. Maroncelli, alle ore 20.30, la stessa non era
chiusa a chiave.L'auto targata FO 453979 e una GOLF WV.===========
============================ All'interno dell'autovettura si trovava u
paccp nel cui interno c'era un opera "**INVISIBILE**" la stessa ha un
valore affettivo e doveva partecipare ud una mostra a Milano.=======
A.D.R.=L'auto, non é assicurata.==================================
A.D.R.=Non ho sospetti su alcuno.=================================

A richiesta dell'interessata e per i fini usi consentiti dalla
legge si rilascia copia del presente atto.=====================

COMUNE DI FORLI

artists and published with no credits or captions. The work reflects Cattelan's belief in the idea of recycling our visual anthropology, the shared wealth of our world of images.

Untitled, 1992 (a police report for a stolen invisible artwork), is another work on the idea of theft, which enters into the conceptual world of artists such as Marcel Duchamp or Piero Manzoni. Unable to produce a work for an exhibition, Cattelan decided the night before the opening to go to the nearest police station and report the theft of the non-existent work. With some persuasion, a policeman eventually diligently typed the legal report, asking for details of size and materials. Cattelan then framed the report in the gallery. Without didacticism, the artist was addressing one of the worst vices of Italian society: his surreal idea was matched by the surreal world of Italian bureaucracy. Like Italo Calvino, however, Cattelan reflects on, rather than criticizes, the dysfunction of society.

The notion of theft brought back memories of Cattelan's earlier temptation to rob a bank. - *157.000.000* (1992) is a real broken safe, from which 157 million lire was stolen. This work, while violent and crude on one level, reveals a sophisticated formalism, and is a cryptic quotation from Italian art history. The gash on the side of the safe recalls artist Lucio Fontana's gesture of stabbing his clay spheres just before they were cast in bronze, thus rendering them monuments to the power of human action.

In 1996, invited to participate in a group exhibition 'Crap Shoot' at De Appel in Amsterdam, Cattelan stole an entire show from a local gallery the night before the opening in order to display it, completely unmediated, as his own work (*Another Fucking Readymade*) the next day. The robbery was successful but a casual witness called the police; the artist was forced to return the work or face charges.

The following year in Paris, at Galerie Emmanuel Perrotin, Cattelan exactly recreated the show of his friend Carsten Höller, on display in Galerie Air de Paris next door. The viewer could arrive at the galleries from two directions. Depending on which exhibition one saw first, the other would be perceived as its reflection.

Faced with the disconcerting replica of what had been witnessed just minutes before, one felt that time had stopped, that one had not moved. Cattelan here questions the idea of the 'original', the right to copy, to repeat, not just in art but in contemporary society. The work suggested a wider investigation of the right to create, to see, to think, to absorb, to interpret and to translate. The notion of robbery had now been transformed into the notion of a mirror, reflecting both that which we see around us and that which we perceive in the minds of others.

VI. The Artist as Fundraiser

In the 1970s a group of revolutionary students had transformed the act of shoplifting in a department store by renaming it 'proletarian self-funding'. Cattelan similarly transformed the notion of the artist as social parasite into the idea of artist as 'cultural subversive', a practice that allowed him to raise enough funds to keep going ahead towards a more conventional practice.

In terms of strategy, Cattelan's work acts as a

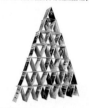

Strategies
1990
Magazine
27 × 20.5 × 1 cm

above, **Permanent Food**
(with Dominique
Gonzalez-Foerster)
1996
Magazines
23.5 × 17 × 1 cm each

opposite, **Lavorare è un
brutto mestiere**
(Working Is a Bad Job)
1993
Inkjet printed poster
270 × 580 cm
Installation, Aperto,
XLV Venice Biennale

Benetton
Advertisement
1992
Offset litho on paper
Dimensions variable

counterbalance to that of Oliviero Toscani, the notorious creative director of Benetton's advertising campaigns. Toscani takes to an extreme the hypocrisy of marketing, faking an involvement with world traumas while exploiting them as mere testimonials for the product he sells, with the cynical notion that eventually we will identify images of these tragedies with Benetton stores. Cattelan, meanwhile, reclaims images from marketing, returning them to their original creative source. For the Aperto section at the Venice Biennale in 1993 he created the piece *Lavorare è un brutto mestiere* (*Working Is a Bad Job*), in which he sold the exhibition space allocated to him to an advertising agency which used it to test the packaging for a new perfume. Revealingly, while the idea was covered by several Italian daily newspapers in their news sections, the art and culture sections of the same papers failed to notice it. This experience would prove to the artist that certain marketing strategies are not applicable to the jaded art world.

For Cattelan art is related to money because he needs to regain what was denied to his family – the cultural dignity lacking in his childhood. Rather than looking for a sponsor to finance his work, he uses the art event itself to sponsor his life. This was not a conceptual work, but simply the relinquishing of his privilege as an artist in order to gain economic advantage as a person, a basic substitution made without moral qualms. In works such as these, Cattelan brutally reveals that art can be hopeless, at times to the point where it has to disappear entirely in order to allow the author to survive. The fear of not having an income – a fear that has followed Cattelan since his childhood – is at the centre of many other works made between 1990 and 1994.

Art and work were also the subjects of *Oblomov Foundation* (1992), referring to the lazy principal character in Ivan Goncharov's novel *Oblomov* (1858). For this work, Cattelan offered a grant of 10,000 dollars to any artist who would commit to not exhibiting his or her work for a year. The grant would be provided by 100 people, each donating 100 dollars. Since Cattelan could not find an artist who was willing to comply with the rule, he decided to make himself eligible to receive his own grant. To commemorate the donors he commissioned a stone plaque listing their names to be placed, unauthorized, in the middle of a working day, on a wall of the Academy of Fine Arts of Brera, Milan. This work remained in place for more than a year before someone

realized it was not supposed to be there and ordered its removal. In an act of creative criticism this work combined the 'bread-winning' morality of the working class, the hypocrisy of artists who claim artistic freedom but then fear to lose any opportunity for the advancement of their careers, and the rhetoric of public spaces, where streets and squares are sometimes dedicated to figures about whom most people know nothing except the name on the street sign or plaque. One might wonder what they did to deserve this commemoration and speculate that they could possibly have played the same prank as Cattelan.

Esaurita (*Breakdown*, 1993) was another fundraiser, a cheap but nevertheless successful challenge to the art market. One day, while writing with a clear plastic Biro, Cattelan noticed that the ink was completely finished – unusually, because these kinds of pens are normally lost or broken long before the ink runs out. He felt that the condition of the pen was similar to that of the artist, who will one day quite unexpectedly realize that his creative 'ink' has gone for good. He decided to test whether or not the art world and its market could afford to sustain an exhausted artist by selling the pen as an artwork. Cattelan's dealer refused, but the artist indepen-dently succeeded in convincing a collector to pay a high price for it. With this work, somewhere between cynicism and research, the artist pushed the conventions and artificial values of the art world to the extreme.

VII. The Case of the Missing Artist
Such art-world subversion had been characterizing Cattelan's work since 1989, when he made the

Esaurita (Breakdown)
1993
Bic biro
14 × 1 cm

work *Untitled (Certificato medico)* (*Doctor's Certificate*). This made recourse to one of the clichés of Italian society: the common practice of obtaining a fake doctor's certificate in order to stay off work. Not feeling like working on or attending the opening of one of his exhibitions, Cattelan asked for a similar certificate from a doctor friend to be sent to the museum director. Even though on the verge of one-line jokes, these early works reveal the recurrent conflict in Cattelan's identity: how to be present and yet avoid involvement in the conventional rituals and labours of the art world, such as the private view.

The same year, at the Galleria Neon in

Bologna, Cattelan attempted to stage his first solo show. His works disappointed him so much, however, that he decided to transform the disappointment into a single work: *Untitled (Torno subito) [I'll Be Right Back]* – a simple note posted on the locked door of the gallery. This idea of escaping from the responsibilities generated by his own work is a recurrent motif. Running away and avoiding contact with the public worked as a creative stimulus, the frustrations of the viewer partly constituting the 'art'.

Cattelan's first real one-person show was presented in 1993, at Galleria Massimo De Carlo in Milan. On the opening night, it seemed that the

Certificato medico
(Doctor's Certificate)
1989
Medical certificate
21×15 cm

above, **Untitled** (Torno
subito) [I'll Be Right
Back]
1989
Engraved Perspex
8 × 10 cm

opposite, **Untitled**
1993
Teddy bear, wood, wire,
electric motor
Dimensions variable
Installation, to be
viewed only through slit
in gallery entrance,
Galleria Massimo De
Carlo, Milan

people who gathered there would again be
disappointed, for the door of the gallery was
walled off by bricks. But if they peeked inside the
window into the empty space, they could see a
small teddy bear cycling on a tightrope. This
untitled work had a poetic side, suggesting the
existential artist, isolated within his creative
realm. However, the show also commented on the
accessibility of art, not conceptually but emotion-
ally. Putting the audience outside in general, and
specifically outside the gallery, interrupted the
conventions and function of the space, transform-
ing the 'public' into window shoppers.

VIII. Animal Crackers
The teddy bear was Cattelan's first work in a series
of projects in which human feelings were grafted
onto an animal's form. The question of how
society can be addressed from an animal's point
of view pervades these works. They also address
the need to work, as well as fear, sorrow and
violence, transmuted into the shapes of animals,
or at least activated by their unlikely presence.

Among these projects were many other exper-
iments that never ended in final works, like his
attempts to teach some Indian Blue Birds to bark,
to grow birds inside bottles, and to cultivate fish
inside two-dimensional aquariums. He calls these
ideas 'shifts in domestic genetics'. It is interesting
to note that around the same time that Damien
Hirst was working with animals from an opposite
point of view, focusing on them as symbols of
death, Cattelan concentrated on the kinds of
emotion that we project onto animals. This
different use of dead animals also marks a clear
difference between the phenomenon of the
'Young British Artist' and the stagnant situation
of young Italian artists during those years. Hirst's
sharks seem to reflect the pride and arrogance of
the British individual, who even when dead
reclaims space and power, while the Italian finds
in death the ultimate moment of pathetic
familiarity, the most radical way to avoid public
responsibility.

In the summer of 1993 Cattelan left Milan for
New York. His first exhibition there, at the Daniel
Newburg Gallery, reflected his feelings of
uncertainty and impotence in the gilded cage of
the New York art system, after having had various
exhibition proposals rejected. As a child, Cattelan
had identified with a donkey, universal symbol of
foolishness. He decided to re-create this clear
image of his psychological state in the gallery
space. At the opening, a real donkey welcomed
the visitors in the fenced-in space, illuminated by
a luxurious chandelier. The work, entitled
*Warning! Enter at your own risk. Do not touch, do
not feed, no smoking, no photographs, no dogs,
thank you,* immediately brings to mind Jannis

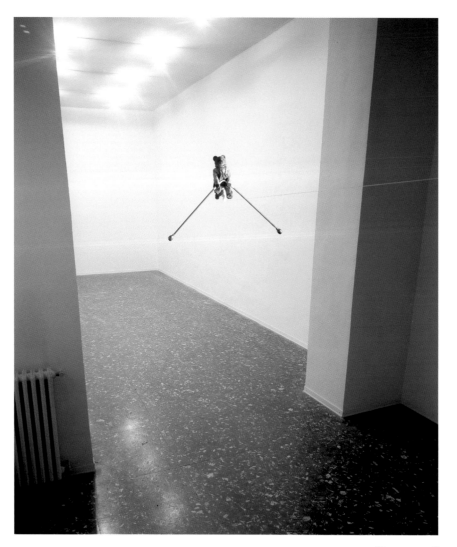

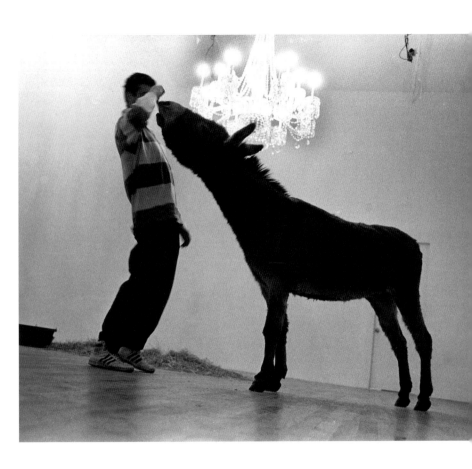

Kounellis' famous installation of live horses at L'Attico gallery in Rome in 1969. Another reference was to Richard Serra's show of 1966, also in Rome, at the Galleria La Salita, where the American artist showed live rabbits and chickens in wooden cages. Cattelan's work, however, took a different approach: the donkey is simply a visualization of a mental state, a feeling and nothing more. While Kounellis and Serra wished to disrupt the conventional space of the gallery, dissolving the borders between nature and art, Cattelan's work does almost the opposite, demonstrating how a contextual space can stifle an artist's creativity: the artist in the form of the donkey and the art world in the form of the chandelier are completely alien to one another.

Shown along with *Charlie Don't Surf* at the Castello di Rivoli, Turin, in 1997 was *Novecento* (*1900*), a taxidermized horse hung from the baroque ceiling of one of the museum's salons, its legs elongated to give the impression that the force of gravity was stretching it down to the ground. The work, whose title is borrowed from Bernardo Bertolucci's film (1976), alludes both to Italian history and to our millennial times. It is like a visual manifestation of the issues explored by Tommaso di Lampedusa in his classic novel, *The Leopard* (1958), which is centred on the idea that the moment of passage from one history to another, from one century to another, is a painful transformation. At the end of the twentieth century, like the horse, we are being pulled into the next millennium, but the gravity of the current century is pulling us backwards towards all those unresolved issues which are still with us.

Bidibidobidiboo (1996) is a sculpture depicting a squirrel which has committed suicide in its kitchen. The taxidermized animal lies lifeless on a cheap formica-topped table; a gun is on the floor beside it, dirty dishes in the kitchen sink, a water-heater on the wall. The scene is a flashback to the Cattelan family's typical Italian working-class kitchen during his childhood years. One can almost hear the blaring radio and the voices in the yard. It is a place adrift from any chance of economic redemption. This simple room is transformed by the squirrel into a surreal, symbolic image of despair: if even furry animals have no hope, what is left for us to dream about? Cattelan uses the anthropomorphic, empathetic strategies of Walt Disney. When we watch the film *Bambi*, we identify with the little deer when he loses his mother. The experience on the screen becomes our experience; the animal's trauma becomes ours. Looking at the squirrel and the dirty dishes it has left behind, we identify with a world where, all too often, dirty dishes are the only certainty.

Love Saves Life (1995) transforms one of the German folk tales of the Brothers Grimm, 'The Musicians of Bremen' (1812–15), into a magic sculpture. In the tale, four animals escape from their owners to create an ideal community which will allow them to survive into old age. Cattelan sees this idealistic message as one still relevant today, and presents the taxidermized figures of a donkey, a dog, a cat and a rooster one on top of the other, frozen in a scream for freedom. The pyramid of animals becomes for Cattelan a sort of hyper-animal, representing the individual's ability to gain strength through relationships with others who share the same spirit and goals. In

opposite, **Warning! Enter at your own risk. Do not touch, do not feed, no smoking, no photographs, no dogs, thank you**
1994
Live donkey, crystal chandelier
Dimensions variable
The artist installing the work, Daniel Newburg Gallery, New York

above, top,
Jannis Kounellis
Senza titolo (12 cavalli)
(Untitled [12 Horses])
1969
Horses
Dimensions variable
Installation, L'Attico gallery, Rome

above, below,
Richard Serra
Live Animal Habitats
1965-66
Live animals, cage
Dimensions variable
Installation, Galleria La Salita, Rome, 1966

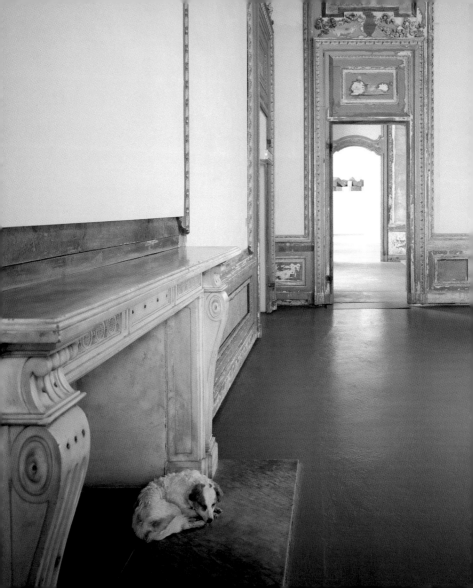

this sense, the sculpture is a message to the egocentric, uncooperative attitude of artists. For the third Skulptur Projekte in Münster (Münster, Germany, 1997), Cattelan presented this work alongside *Love Lasts Forever*, the same arrangement, but this time presented as skeletons. The skeletons contradict the 'forever', suggesting that ideas and utopias ultimately conceal the brutal reality of a skeleton.

In 'Delta', a group show at the Musée d'Art Moderne in Paris in 1997, Cattelan returned to the idea of fear and passive aggression, a concept on which he had touched several times in different ways. In the grandiose Dufy room, two Labrador dogs reclined in a corner (*3.13.81 – My Last Kiss*). This was initially confusing to visitors: dogs were an unlikely but possible presence in the museum. Cautiously approaching the dogs, the visitors made the horrifying discovery that they were dead – taxidermized animals, positioned by the taxidermist in reclining poses. The work is a tragic sculpture which again recalls the novel *The Leopard*: in the final scene a taxidermized dog, kept by the Salina family as a memento of better times, is thrown out of the window into the garbage. One could compare these animals to the small, pathetic dog and its formidable owner in Duane Hanson's sculpture *Woman with Dog* (1977). In Cattelan's work it is the Dufy room that is pathetic, with its obsolete grandiosity, while the two animals are a dormant warning of violence. Hanson's dog, like its owner, seems to accept the paralysis of daily life; they die without even realizing they are dead. This is why Hanson's figures are so frightening: they make it appear as if the process of living has been abandoned in

order to represent the meticulous stasis of life. Hanson wants his dog to look asleep. The tension of dreams and thoughts has been erased from his figures' gazes. He wants them to look real in order not to look alive. Unlike Hanson's animal figures, Cattelan's are never descriptive or hyperrealist; they represent a reality transformed by the irreversible process of the world. Everything dies, leaving its trace not through creativity but through the morbidity of a society ossified as if by a taxidermist. Icons are transformed into mummies by a society whose desire is to maintain and conserve history, not to transform it. Cattelan acknowledges this entropy through the switch in his work from actions to still images, sculptures and monuments.

Duane Hanson
Woman with Dog
1977
Cast polyvinyl,
polychrome acrylic,
cloth, hair
Lifesize

left, **Good Boy**
1998
Taxidermized dog
Lifesize
Installation, (office)
Gavin Brown's
Enterprise, New York

opposite, **Morto
stecchito** (Stone Dead)
1997
Taxidermized dog
Lifesize
Installation, Castello di
Rivoli, Museo d'Arte
Contemporanea, Turin

Untitled
1998
Skeleton of dog,
newspaper
Lifesize
Installation, 'Ironic',
Museum für
Gegenwartskunst,
Zurich

1997 was the year when Cattelan finally entered the official art world; his role as the bad-boy of Italian art was put aside. This engendered the suspicion among those who followed his work that if what he did was accepted by the establishment, it must be either devoid of content or a sell-out. Had Cattelan now become the enemy he had once mocked? It is a doubt that weakens some of his interventions while strengthening the formal aspect of his work. The strength is developed in the more sculptural works, those which have acquired their autonomy and can claim the status of contemporary icons. The weakness is revealed when the ancient spirit of the outsider is still searching for a lost freedom, the capacity to be an iconoclast. Cattelan is now an artist who is telling a story. Storytellers do not make revolu-tions but they can easily inspire them. Like the Russian artist Ilya Kabakov, whose work could be described as being grounded in his capacity to be intensely aware of the act of remembrance, while remembering the past of the Soviet Union, Cattelan has often grounded his work in his capacity to feel what he was feeling while he was still experiencing it. Each image is just the skin of a feeling, its graphic representation.

Still in 1997, at the Venice Biennale, Cattelan was selected by curator Germano Celant to exhibit in the Italian pavilion, alongside the more senior artists Ettore Spaletti and Enzo Cucchi. Celant proposed that Cattelan should make an interventional work in collaboration with the other artists. One of the resulting works, *Tourists*, involved the placement of numerous taxidermized pigeons on the structural joists and air conduits of the pavilion. Their presence made a comment on the confused state of this Venetian institution and the artist's desire to be a distanced witness of the event. The pigeons were like the collective awareness of the viewer, passing through the Italian pavilion where different generations of artists were habitually paired casually by Biennale organizers, without an understanding of their distance or an attempt to bridge this distance sensitively. At the moment when a visitor first spotted one pigeon perched overhead, all of its fellows would also come into sudden view, evoking Hitchcock's film *The Birds*. Natural inhabitants of the outdoor buildings where the Biennale is held, pigeons were transformed in Cattelan's work into a menace to the peaceful establishment of that small town called the art world.

IX. In Memoriam

At the third Skulptur Projekte in Münster, in addition to presenting *Love Lasts Forever*, with its *memento mori* connotations, Cattelan placed another morbid work in the midst of a public space which is usually idealized by the city and the organizers of the show. For Cattelan, the beautiful lake where people stroll and idle in summer, concealed, like *Love Doesn't Last Forever*, its own skeleton or rather a body on its way to becoming a skeleton. Cattelan threw into the lake a dummy of a dead woman's body (*Out of the Blue*, 1997). Public space was revealed in its duplicity, as an ideal site equally for pleasure and death. This work was intended to float just under the water but it sank out of sight, provoking the rumour that Cattelan never actually placed a 'body' in the lake, merely placing the label for the

work on its grass verge. Thus inadvertently the work also became a reflection upon the memory of monuments or public sculptures and the capacity of the landscape or urban environment to retain secrets which may never be revealed.

Such interventional strategies were developed in a different form, within institutional space, at the Consortium in Dijon in the same year, where Cattelan made two untitled works: he dug a coffin-shaped hole in the museum floor and also blocked the entrance to the gallery offices with the front of a wardrobe, which the employees were obliged to pass through to reach their working areas. While staying within the limits of

his own biography and post-existentialist attitude, his work skims the spirit of artists such as Joseph Beuys and Robert Smithson. While Beuys dug holes to plant 7,000 oaks (*7,000 Eichen*, 1982), Cattelan digs a hole just to hide himself or maybe to plant himself into another reality, yet the physicality of the action remains. Smithson's idea of a certain immanence of the art work as a transformation of nature is synthesized by Cattelan with the idea that nature can be transformed only by the amount of space that each of us is able to occupy; a notion that sees its most symbolic manifestation in the amount of earth excavated to allow our body to be buried.

Out of the Blue
1997
Stuffed cloth figure,
clothing
Lifesize
Installation, Skulptur
Projekte in Münster,
Germany

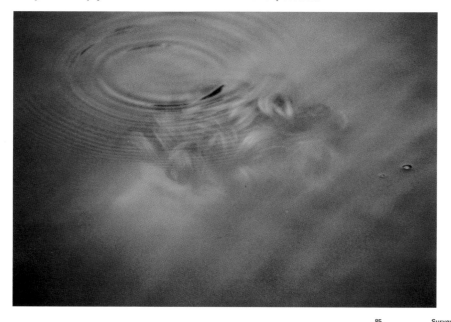

Untitled
1997
Rectangular hole, pile
of removed earth
200 × 100 × 150 cm
Installation, Le
Consortium, Dijon

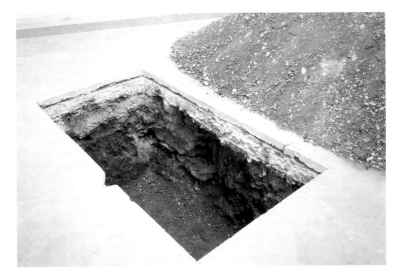

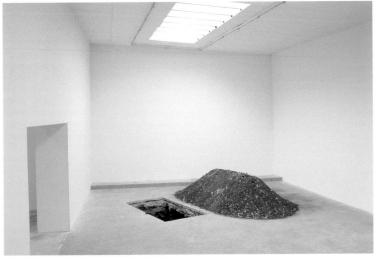

But while Beuys and Smithson kept their messianic aspirations safe from criticism, Cattelan developed a kind of self-mocking cynicism. The wardrobe in Dijon was an attempt to define the screen that divides the public from the private.

Cattelan's works from 1999 represent a deep consideration of defeat, mourning and survival. In London, at the Anthony d'Offay Gallery, he created a large-scale black granite plaque inscribed with a list of international football matches lost by the England team. At first glance reminiscent of war memorial plaques, or even of Maya Lin's Vietnam Memorial in Washington, the work faced out of the gallery into the street in a deliberate gesture of provocation. The subject matter of this 'memorial' – symbolic of popular entertainment and national identity – is addressed in an attempt to evaluate true priorities at a moment in European history which has been characterized by war. Implicitly, the British assumption that England deserves a monument, even if has not won a world championship for ages, is confronted by the Italian demand for a monument for the simple reason that 'we are the best'.

At the 1999 Venice Biennale, curated by the Swiss exhibition organizer Harald Szeemann, Cattelan arranged with a fakir, a holy man trained in actions of endurance, that he would bury himself in a mound of earth for several hours at a time in the corner of the exhibition space allocated to Cattelan. Only the fakir's hands were exposed, emerging from the ground like a flower, joined in a gesture of prayer or meditation (*Mother*, 1999). This image presents a positive aspect in relation to the London memorial. It is an image of hope,

implying that ultimately we have the capacity to escape our destiny, our roots, our obsessions and nightmares. As individuals and as artists, we have the ability to bloom from the ground like plants, which grow, no matter what the circumstances, because it is their nature and their obligation to do so. It is perhaps the awareness of his own obligations towards society which has given Cattelan the strength to defeat all the obstacles it has placed between him and his identity as an artist. Like the fakir, he explores the possibility of survival underground and of finding the energy to re-emerge under an open sky.

Untitled
1997
Wardrobe door installed
in museum doorway;
wood, paint, metal
approx. 200 × 100 × 40
cm
Installation, Le
Consortium, Dijon

Piumino
(Feather/quilt)
1978–98
Found marble
gravestone of dog
named Piumino
56 × 35 × 14 cm
Installation, 'La Ville, le
Jardin, la Mémoire',
Villa Medici, Rome

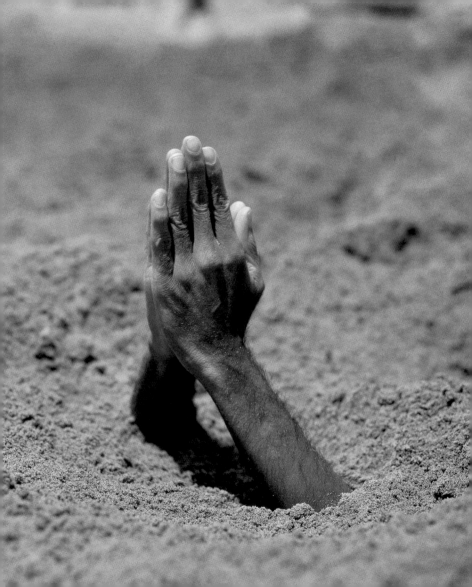

Contents

Interview Nancy Spector in conversation with Maurizio Cattelan, page 6. Survey

Francesco Bonami Sans titre: The Impossible Work of Maurizio Cattelan, page 38. Focus

Barbara Vanderlinden *Untitled*, Manifesta 2, **page 90**. Artist's Choice Philip Roth

The Breast (extract), 1972 (extract), 1994, **page 100**. Or Neroni... A Collection of Suicide Notes (extract), 1993,
page 106. Artist's Writings Maurizio Cattelan in conversation with Jens Hoffman, 2000, page 112.

Interview with Massimiliano Gioni, 1999, page 117. Bidibidobidiboo, 1996, a conversation with Barbara Casavecchia,

1998, page 116. Charlie Don't Surf, 1997, page 124. Les Penseurs de Palerme, Antonio Presti, 1998, page 105.

La Nona Ora, 1999, page 124. ... , ... , page 143.

..., 1998, page 136. Hollywood, Sicily, 2002, page 140. Félix, 2001 / Him, 2001, page 149.

..., 2002, page 144. Museum of Contemporary Art, Chicago, 2002, page 146.

Update Massimiliano Gioni 1968-2002, Maurizio Cattelan, page 152.

Chronology page 192. Bibliography List of Illustrated Works 200.

In 1998 Maurizio Cattelan created a monumental, provocative work for the second Manifesta biennial exhibition, sited that year in Luxemburg. In one of the grandiose chambers of Luxemburg's Casino he installed a living Italian olive tree which filled the room and reached to the ceiling. This installation both subverted the exhibition space and created a subtle distance between life 'outside' and art 'inside'. However, the relocation of a piece of reality was not the only challenge raised by this untitled work, also exhibited later that year at the Castello di Rivoli in Turin. A surrealistic image, it offered not one but many interpretations, presenting an intervention able to overcome the tyranny of the image through transcending depiction, representation and mediation. Like a scenographic construction, this work was intended to represent the life of an olive tree and introduce, for the duration of three months, a piece of 'reality' within the building. A living sculpture, the growing tree provided a stark contrast with the opulent décor of the room in which it was now situated.

 The realization of this work brought to mind the construction of a film set, based on simple instructions: supply a room-sized olive tree, its roots embedded in a cube of soil, and place it in the central room on the Casino's second floor. The execution of this simple task meant days of messing around with mud and soil for the exhibition team, giving the creation of this work the character of a performance. Although the initial task was clear, the process of realization of this installation gave birth to a more complex meaning. The artist's simple do-it-yourself instruction led to a larger investigation of feasibility: the olive tree's new location needed to be examined by a botanist, who came to Luxemburg to investigate the chances of survival for a Mediterranean tree so far from home. On his advice, an irrigation system was concealed within the base of soil. A week before the opening, the tree was transported to Luxemburg and hauled by a crane through the window onto the second floor, where a crew of around ten were to install the piece. For three entire days, without interruption, mud and dirt were slung around the exhibition space.

Alighiero Boetti
Monumento
all'agricoltura: Progetto
per la fiera di Verona
(Monument to
Agriculture: Project for
the Verona Fair)
1970
Ink on paper
80 × 100 cm
Plan for proposed
monument
'The stratifications
represent, in
proportion, the
geological structure of
the Earth, from centre
to surface. Tree: apple
tree.'
– Alighiero Boetti

left, **Untitled**
1998
Olive tree, earth, water,
wood, metal, plastic
800 × 500 × 500 cm
Installation in progress,
Casino de Luxemburg,
Manifesta 2, Luxemburg

Cattelan's work evoked an unrealized piece by Arte Povera artist Alighiero Boetti, *Monumento all'agricoltura* (*Monument to Agriculture*, 1970), not only through its formal resemblance to Boetti's proposed work (a living tree with its roots embedded in soil), but also because of the questions evoked by projects which are left unrealized. When investigating the feasibility of Cattelan's proposal, intensive research was focused on the solution Boetti had examined in 1969 for his similar monument – a simple but impossible idea. Boetti had made a design for an apple tree to be planted on a twenty-five-metre-high column of soil as his entry for a competition organized by the Fiat automobile company in Turin. Together with Fiat's technicians, Boetti examined the possibility of realizing his *Monumento all'agricoltura* for over a year, from 1969 to 1970, in the hope of placing it as a permanent public monument in the central square in front of the Fiat headquarters in Milan.

Boetti's ensemble was to be the living representation of an apple tree growing from a cross-sectioned transparent base which made visible the layers of earth: a living sculpture, the roots of which symbolically penetrated into the centre of the earth, while its branches reached to the sky. As a monument, it gained significance by the tension between simplicity and complexity, between the possible and impossible. Nothing remains of Boetti's planned monument but a story; it still belongs temporarily among the history of unrealized or impos-sible projects. However, because Boetti and the workers at Fiat refused to give up the idea for a long time, the monument became a legend even before its eventual non realization.

Impossible constructions, irrigation systems, apple trees, earth layers and endless utopian conversations all contributed to the formation of a legend. The unrealized *Monu-mento all'agricoltura* constituted a challenge and broadened the significance of describing or witnessing an image, however remote it may be. What remains of an unrealized project such as this is *the story of an image*. Stories about images are often stories within stories or images within images. The artist is no longer involved in the image, nor is he or she its witness. It becomes the story of how artists can cease to be the witness of their own ideas.

following page,
Untitled
1998
Olive tree, earth, water, wood, metal, plastic
800 × 500 × 500 cm
Installation, Casino de Luxemburg, Manifesta 2, Luxemburg

In his untitled work of 1998, Cattelan takes Boetti's project a step further. Cattelan has often expressed his conviction that probably there is nothing left to be invented. With this piece he seemed to build on this conviction, not by depriving the exhibition from a work 'made' by the artist but by asking those of his friends who were more informed about recent art history than he was to help him find a good idea. An artwork wasn't quite invented but, above all, a friend's story of Boetti's *Monumento all'agricoltura* was transformed. What was this a monument to? A monument to homeland, agriculture, Italian ingenuity or, perhaps, the origin of impossible images? At a time when the mechanisms behind representation are increasingly evident, obvious even, when communication is increasingly dominated by images, Cattelan seems to be focusing on the symbolic, on stories passed from person to person. The image of the tree immediately evokes the memory of something which is but a story, yet which could also symbolize, in the context of an exhibition such as this one, both the identity and origin of the artist. Viewers were confronted with a small slice of Italy, a segment of identity within a critical context which addresses the very question of identity, in an exhibition in which nationality and identity determine the selection of the artists. Cattelan laid bare the quintessential nature of national belonging through the very element of territoriality itself. Operating on the cynical fringes of communication and exhibition strategies, Cattelan thus carries further the attitude with which he has on many occasions succeeded in contaminating the exhibition and its critics, by confronting them with a dilemma: why add images

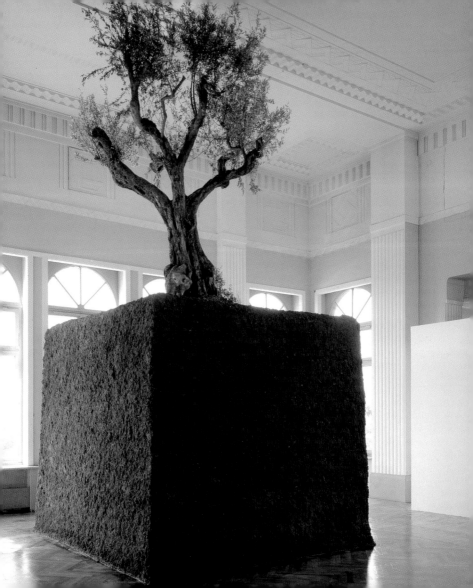

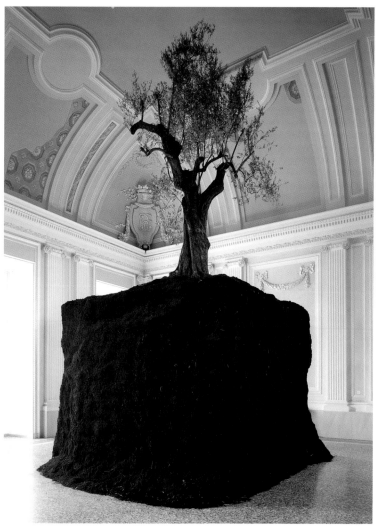

Untitled
1998
Olive tree, earth, water,
wood, metal, plastic
850 × 500 × 500 cm
Installation, Castello di
Rivoli, Museo d'Arte
Contemporanea, Turin

to the image industry? This is Cattelan's basic question, and this work has the lightness and wisdom which comes from not aspiring to add or invent anything. Thus Cattelan continues the history of works meant to be told instead of being seen; works which pose the problem of an art which is legendary. Cattelan created a telling image, a legendary tree recalling the unrealized work of a legendary artist, Alighiero Boetti. In this work, mythology, story-telling, instructions and reportage coincide.

A year before the exhibition in Luxemburg, Cattelan had realized a work which introduced the concepts of the unrealizable. For *Simplicus, Simplicissimus, Impossibile* (1997) he collected a series of conversations and descriptions of around twenty sculptures which were never realized in 1977, 1987 and 1997 for the exhibition Skulptur Projekte in Münster, held every ten years in Münster, Germany. Cattelan's contribution to this event in 1997 consisted of telling these stories, which in turn created in the listener a new version of the absent sculpture. In *Simplicus, Simplicissimus, Impossibile* Cattelan avoided positioning the artist as a witness of his own work. The piece gathered recollections or testimonies of people who were hardly involved, and others not involved at all. Here, too, the artist demonstrated his interest in inserting images and the mechanisms behind exhibition making within a more complex entity, in which image and story coincide, the realized and unrealized overlap and the work is brought a step further: it actually is executed. In addition, Cattelan did not demonstrate any interest in how the work was understood or how the material formed the work – that is, the meaning of the olive tree, or the process of its transformation into a living sculpture. What counted were the changes, alterations and transformations, through hearsay and legend.

By investigating the relationship between artists and the art system, Cattelan was able to emphasize the distance between the clandestine outsider and the compulsory exhibition; the demands of the group and the needs of the individual. He contrasted the impossibility of having constantly to produce new images and the possibility of realizing unrealized images: essential dichotomies in the redefinition of the relationship between artist and audience.

Contents

Interview Nancy Spector in conversation with Maurizio Cattelan, page 6 Survey

Francesco Bonami Stalk on the Lime: The Impossible Work of Maurizio Cattelan, page 38 Focus

Barbara Vanderlinden L'Uffizi, Manifesta 2, page 90. **Artist's Choice** Philip Roth

Portnoy's Complaint (extract), 1969, **page 100**. **... Or Not to Be: A Collection of Suicide Notes** (extracts), 1997,

page 106. Artist's Writings Maurizio Cattelan Fate la Fossa Interview with Giancarlo Di

Pietrantonio (extract), 1988, **page 112**. Incidents, Interview with Emanuela De Cecco and Roberto Pinto

(extract), 1991, **page 116**. Statements, 1995, **page 124**. Job Offer, with Roberto Nasi as interlocutor, 1992, **page 128**.

I Want to Be Famous – Strategies for Successful Living, Interview with Barbara Casavecchia, 1995, **page 132**.

Book review, 'Bruno to Pieter van Saparoea' (extracts), Interview with Jens Hoffmann and Andrea Bellini, 1999, **page 140**.

Dear ———— Letter, 2002, **page 144**. Free Fra Art – Interview with Anna Rigi, 2002, **page 148**.

Update Massimiliano Gioni Maurizio Cattelan: Less is Less, 2002, **page 156**.

Chronology **page 192**. A S Glossary 2010, List of Illustrations, **page 203**.

Portnoy's Complaint (pôrt'-noiz kem-plā nt') *n*. [after Alexander Portnoy (1933–)]. A disorder in which strongly felt ethical and altruistic impulses are perpetually warring with extreme sexual longings, often of a perverse nature. Spielvogel says: '*Acts of exhibitionism, voyeurism, fetishism, auto-eroticism and oral coitus are plentiful; as a consequence of the patient's "morality", however, neither fantasy nor act issues in genuine sexual gratification, but rather in overriding feelings of shame and the dread of retribution, particularly in the form of castration.*' (Spielvogel, O. 'The Puzzled Penis', *Internationale Zeitschrift für Psychoanalyse*, Vol. XXIV p. 909.) It is believed by Spielvogel that many of the symptoms can be traced to the bonds obtaining in the mother-child relationship.

Whacking Off

Then came adolescence – half my waking life spent locked behind the bathroom door, firing my wad down the toilet bowl, or into the soiled clothes in the laundry hamper, or *splat*, up against the medicine-chest mirror, before which I stood in my dropped drawers so I could see how it looked coming out. Or else I was doubled over my flying fist, eyes pressed closed but mouth wide open, to take that sticky sauce of buttermilk and Clorox on my own tongue and teeth – though not infrequently, in my blindness and ecstasy, I got it all in the pompadour, like a blast of Wildroot Cream Oil. Through a world of matted handkerchiefs and crumpled Kleenex and stained pyjamas, I moved my raw and swollen penis, perpetually in dread that my loathsomeness would be discovered by someone stealing upon me just as I was in the frenzy of dropping my load. Nevertheless, I was wholly incapable of keeping my paws from my dong once it started the climb up my belly. In the middle of a class I would raise a hand to be excused, rush down the corridor to the lavatory, and with ten or fifteen savage strokes, beat off standing up into a urinal. At the Saturday afternoon movie I would leave my friends to go off to the candy machine – and wind up in a distant balcony seat, squirting my seed into the empty wrapper from a Mounds bar. On an outing of our family association, I once cored an apple, saw to my astonishment (and with the aid of my obsession) what it looked like, and ran off into the woods to fall upon the orifice of the fruit, pretending that the cool and mealy hole was actually

between the legs of that mythical being who always called me Big Boy when she pleaded for what no girl in all recorded history had ever had. 'Oh shove it in me, Big Boy', cried the cored apple that I banged silly on that picnic. 'Big Boy, Big Boy, oh give me all you've got', begged the empty milk bottle that I kept hidden in our storage bin in the basement, to drive wild after school with my vaselined upright. 'Come, Big Boy, come', screamed the maddened piece of liver that, in my own insanity, I bought one afternoon at a butcher shop and, believe it or not, violated behind a billboard on the way to a bar mitzvah lesson.

It was at the end of my freshman year of high school – and freshman year of masturbating – that I discovered on the under-side of my penis, just where the shaft meets the head, a little discoloured dot that has since been diagnosed as a freckle. Cancer. I had given myself *cancer*. All that pulling and tugging at my own flesh, all that friction, had given me an incurable disease. And not yet fourteen! In bed at night the tears rolled from my eyes. 'No!' I sobbed. 'I don't want to die! Please – no!' But then, because I would very shortly be a corpse anyway, I went ahead as usual and jerked off into my sock. I had taken to carrying the dirty socks into bed with me at night so as to be able to use one as a receptacle upon retiring, and the other upon awakening.

If only I could cut down to one hand-job a day, or hold the line at two, or even three! But with the prospect of oblivion before me, I actually began to set new records for myself. Before meals. After meals. *During* meals. Jumping up from the dinner table, I tragically clutch at my belly – diarrhea! I cry, I have been stricken with diarrhea! – and once behind the locked bathroom door, slip over my head a pair of underpants that I have stolen from my sister's dresser and carry rolled in a handkerchief in my pocket. So galvanic is the effect of cotton panties against my mouth – so galvanic is the *word* 'panties' – that the trajectory of my ejaculation reaches startling new heights: leaving my joint like a rocket it makes right for the light bulb overhead, where to my wonderment and horror, it hits and it hangs. Wildly in the first moment I cover my head, expecting an explosion of glass, a burst of flames – disaster, you see, is never far from my mind. Then quietly as I can I climb the

radiator and remove the sizzling gob with a wad of toilet paper. I begin a scrupulous search of the shower curtain, the tub, the tile floor, the four toothbrushes – God forbid! – and just as I am about to unlock the door, imagining I have covered my tracks, my heart lurches at the sight of what is hanging like snot to the toe of my shoe. I am the Raskolnikov of jerking off – the sticky evidence is everywhere! Is it on my cuffs too? in my *hair*? my *ear*? All this I wonder even as I come back to the kitchen table, scowling and cranky, to grumble self-righteously at my father when he opens his mouth full of red jello and says, 'I don't understand what you have to lock the door about. That to me is beyond comprehension. What is this, a home or a Grand Central station?' '... privacy ... a human being ... around here *never*', I reply, then push aside my dessert to scream, 'I don't feel well – *will everybody leave me alone?*'

After dessert – which I finish because I happen to like jello, even if I detest them – after dessert I am back in the bathroom again. I burrow through the week's laundry until I uncover one of my sister's soiled brassieres. I string one shoulder strap over the knob of the bathroom door and the other on the knob of the linen closet: a scarecrow to bring on more dreams. 'Oh beat it, Big Boy, beat it to a red-hot pulp–' so I am being urged by the little cups of Hannah's brassiere, when a rolled-up newspaper smacks at the door. And sends me and my handful an inch off the toilet seat. '– Come on, give somebody else a crack at that bowl, will you?' my father says. 'I haven't moved my bowels in a week.'

I recover my equilibrium, as is my talent, with a burst of hurt feelings. 'I have a terrible case of diarrhea! Doesn't that mean anything to anyone in this house?' – in the meantime resuming the stroke, indeed quickening the tempo as my cancerous organ miraculously begins to quiver again from the inside out.

Then Hannah's brassiere *begins to move*. To swing to and fro. I veil my eyes, and behold! – Lenore Lapidus! who has the biggest pair in my class, running for the bus after school, her great untouchable load shifting weightily inside her blouse, oh I urge them up from their cups, and over, LENORE LAPIDUS'S ACTUAL TITS, and realize in the same split second that my mother is vigorously shaking the

doorknob. Of the door I have finally forgotten to lock! I knew it would happen one day! *Caught!* As good as *dead!*

'Open up, Alex. I want you to open up this instant.'
It's locked, I'm *not* caught! And I see from what's alive in my hand that I'm not quite dead yet either. Beat on then! beat on! 'Lick me, Big Boy – lick me a good hot lick! I'm Lenore Lapidus's big fat red-hot brassiere!'
'Alex, I want an answer from you. Did you eat French fries after school? Is that why you're sick like this?'
'Nuhhh, nuhhh.'
'Alex, are you in pain? Do you want me to call the doctor? Are you in pain, or aren't you? I want to know exactly where it hurts. *Answer me*.'
'Yuhh, yuhhh–'
'Alex, I don't want you to flush the toilet', says my mother sternly. 'I want to see what you've done in there. I don't like the sound of this at all.'
'And me', says my father, touched as he always was by my accomplishments – as much awe as envy – 'I haven't moved my bowels in a week', just as I lurch from my perch on the toilet seat, and with the whimper of a whipped animal, deliver three drops of something barely viscous into the tiny piece of cloth where my flat-chested eighteen-year-old sister has laid her nipples, such as they are. It is my fourth orgasm of the day. When will I begin to come blood?
'Get in here, please, you', says my mother. 'Why did you flush the toilet when I told you not to?'
'I forgot.'
'What was in there that you were so fast to flush it?'
'Diarrhea.'
'Was it mostly liquid or was it mostly poopie?'
'I don't look! I didn't look! Stop saying poopie to me – I'm in high school!'
'Oh, don't you shout at *me*, Alex. I'm not the one who gave you diarrhea, I assure you. If all you ate was what you were fed at home, you wouldn't be running to the bathroom fifty times a day. Hannah tells me what you're doing, so don't think I don't know.'
She's missed the underpants! *I've been caught!* Oh, *let* me be dead! I'd just as soon!
'Yeah, what do I do ...?'
'You go to Harold's Hot Dog and *Chazerai* Palace after school and you eat French fries with Melvin Weiner. Don't

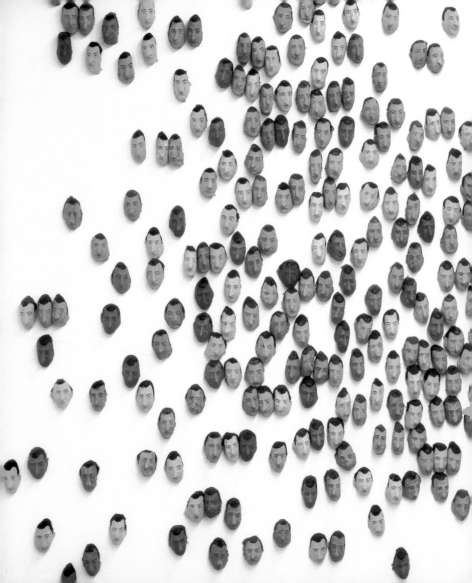

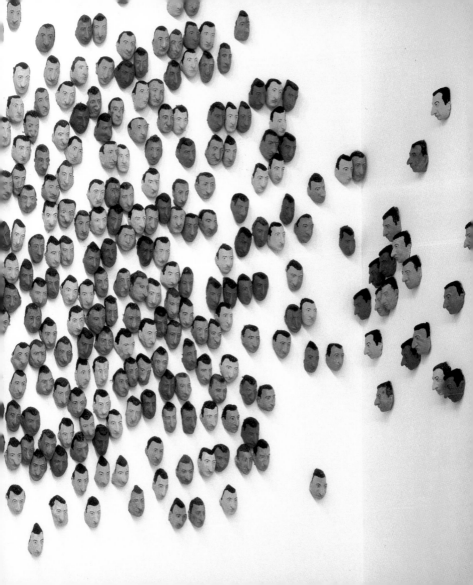

you? Don't lie to me either. Do you or do you not stuff yourself with French fries and ketchup on Hawthorne Avenue after school? Jack, come in here, I want you to hear this', she calls to my father, now occupying the bathroom.

'Look, I'm trying to move my bowels', he replies. 'Don't I have enough trouble as it is without people screaming at me when I'm trying to move my bowels?'

'You know what your son does after school, the *A* student, who his own mother can't say poopie to any more, he's such a *grown-up*? What do you think your grown-up son does when nobody is watching him?'

'Can I please be left alone, please?' cries my father. 'Can I have a little peace, please, so I can get something accomplished in here?'

'Just wait till your father hears what you do, in defiance of every health habit there could possibly be. Alex, answer me something. You're so smart, you know all the answers now, answer me this: how do you think Melvin Weiner gave himself colitis? Why has that child spent half his life in hospitals?'

'Because he eats *chazerai*.'

'Don't you dare make fun of me!'

'All right', I scream, 'how *did* he get colitis?'

'Because he eats *chazerai*! But it's not a joke! Because to him a meal is an O Henry bar washed down by a bottle of Pepsi. Because his breakfast consists of, do you know what? The most important meal of the day – not according just to your mother, Alex, but according to the highest nutritionists – and do you know what that child eats?'

'A doughnut.'

'A doughnut is right, Mr Smart Guy, Mr Adult. And *coffee*. Coffee and a doughnut, and on this a thirteen-year-old *pisher* with half a stomach is supposed to start a day. But you, thank God, have been brought up differently. You don't have a mother who gallavants all over town like some names I could name, from Bam's to Hahne's to Kresge's all day long. Alex, tell me, so it's not a mystery, or maybe I'm just stupid – only tell me, what are you trying to do, what are you trying to prove, that you should stuff yourself with such junk when you could come home to a poppyseed cookie and a nice glass of milk? I want the truth from you. I wouldn't tell your father', she says, her voice dropping

significantly, 'but I *must* have the truth from you.' Pause. Also significant. 'Is it just French fries, darling, or is it more? ... Tell me, please, what other kind of garbage you're putting into your mouth so we can get to the bottom of this diarrhea! I want a straight answer from you, Alex. Are you eating hamburgers out? Answer me, please, is that why you flushed the toilet – was there hamburger in it?'

'I told you – I don't look in the bowl when I flush it! I'm not interested like you are in other people's poopie!'

'Oh, oh, oh – thirteen years old and the mouth on him! To someone who is asking a question about *his* health, *his* welfare!' The utter incomprehensibility of the situation causes her eyes to become heavy with tears. 'Alex, why are you getting like this, give me some clue? Tell me please what horrible things we have done to you all our lives that this should be our reward?' I believe the question strikes her as original. I believe she considers the question unanswerable. And worst of all, so do I. What *have* they done for me all their lives, but sacrifice? Yet that this is precisely the horrible thing is beyond my understanding – and still, Doctor! To this day!

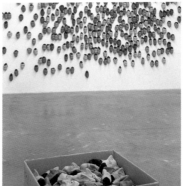

Spermini (Little Sperms)
1997
Latex, paint
500 parts, 10 × 15 × 10 cm each
Installation, Galleria Massimo Minini, Brescia, Italy

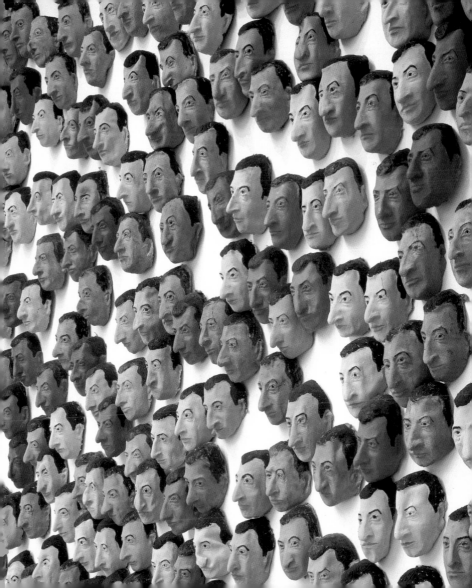

... Or Not to Be: A Collection of Suicide Notes, edited by Marc Etkind (extracts), 1997

Untitled (Replica)
1996
Knotted cotton sheets
l. 1200 cm
Installation, 'Fast
nichts/Almost
Invisible', Ehemaliges
Umspannwerk, Singen,
Germany

'I wish, Charlotte, to be buried in the dress I wear at present: it has been rendered sacred by your touch ... My spirit soars above my coffin. I do not wish my pockets to be searched. The knot of pink ribbon which you wore on your bosom the first time that I saw you, surrounded by the children – Oh, kiss them a thousand times for me, and tell them the fate of their unhappy friend! I think I see them playing around me. The dear children! How warmly have I been attached to you, Charlotte! Since the first hour I saw you, how impossible have I found it to leave you! This ribbon must be buried with me: it was a present from you on my birthday. How confused it all appears! Little did I then think that I should journey this road! But peace! I pray you, peace!

'They [the pistols] are loaded – the clock strikes twelve. I say amen. Charlotte, Charlotte! farewell, farewell!'
– From the fictional suicide note in Goethe's The Sorrows of Young Werther (1774). Goethe's story inspired a wave of suicides.

Ralph Barton was an acclaimed cartoonist for The New Yorker magazine in the 1920s. On May 20, 1931, Barton dressed in his silk pyjamas and climbed into his bed. He opened Gray's Anatomy to an illustration of a heart; and while holding a cigarette in his left hand, shot himself in the right temple. His maid found the body with a cigarette in one hand, a .25 calibre pistol in the other.

'I'm deeply sorry for you. I spent Christmas Eve alone in this apartment hearing the laughter and joy of neighbours. But it's impossible to go through it again. On a day like this everyone seeks the company of beloved ones. Here I am with nowhere to spend New Years in anyone's company. It's simply my fault. Forgive me for such a vulgar note.'
– A Brazilian cartoonist left this note to his mother on New Year's Eve. As if going to a party, he shaved and got dressed in his best white suit. He then spread a blanket and pillow on the floor, turned on the gas from his stove, and lay down to die.

'Merry Christmas.'
– This note was pinned to a teenage boy who hanged himself behind a Christmas tree.

'I would like my sister Frances to have the piano that you have in your apartment. Do this or I will haunt you. Goodbye Sweets, Be seeing you soon. Love. Joe.'
– A man to his ex-girlfriend.

'Sorry about this. There's a corpse in here. Please inform police.'
– Before hanging himself, a workman chalked this on the wall of a home he was repairing.

'Kids, if there are any errors in this letter, I did not proof it carefully.'
– A teacher to the end, the superintendent of the Cleveland public schools left this postscript to his note. His body was found in his school office with a self-inflicted bullet wound.

Untitled
1999
Found black and white
photograph
20 × 18 cm

Artist's Choice 106

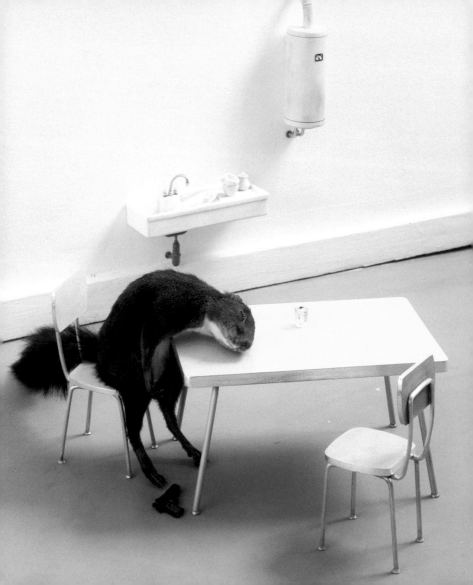

Bidibidobidiboo
1996
Taxidermized squirrel,
ceramic, formica, wood,
paint, steel
Squirrel, lifesize
Installation, Laure
Genillard Gallery,
London

'For every act there is a cause. In this instance the act is justified, at least, I believe so. The following statement will establish if my contention is right or not. I have been practicing law in this State for thirty years. Have been and still am connected with fraternal and other organizations. I have always received the esteem of my fellow men.

'For several years I have been mistaken for another party, the reason for which is a similarity of names and by being in the same profession. My full name is Ernest P., and my offices are at 519 Market Street, a lawyer by profession, aged fifty-seven, height five feet seven inches. The other person is younger and six feet in height but because of his name has been continually mistaken for me. As a fact, even people with whom I am in close contact at the Hall of Justice and the City Hall have often mistaken me for him.

'A few days ago he was charged with a statutory charge. Under the law I give him the right of presumption of innocence. However, that does not eradicate the fact that since that time I have realized from actions of many people that they seem to be under the impression that I am the one involved. A victim of circumstance, to say the least. Some people even, thoughtlessly joking, have remarked about the charge involving this man.

'It seems nothing could well be done to establish the fact that I am not involved in that statutory charge. The only way is to give it publicity and I feel the act I am about to do will solve the problem. Personally, I care not. My life has been lived. My family is of the highest moral character and I feel that a stigma would attach unless I let the public at large know, through this deed, that I am a victim of circumstance by reason of mistaken identity.

'I have been brooding over this matter, and the seriousness of the matter involving this other man makes it mandatory that I, Ernest P., should protect the reputation of my family in the only available and possible manner. Respectfully submitted.'
– *Ernest P., a San Francisco attorney, left this note to the press before poisoning himself. At the time of his suicide, an attorney with a similar name was awaiting trial on a prostitution charge.*

' ... I have no will of my own. From now on, I cannot escape from the agony. Since I began feeling other people's minds, I have come to feel even more miserable. I may look human from the outside, but my inside is empty, stupid, dull-witted and self-isolating. What on earth is in me? I may be breathing, thanks to the support of parents and other people around me, but my real self is like a lifeless doll.'
– *This note is from a depressed Japanese woman whose fiancé had recently broken off their engagement when he found out his wife-to-be was* burakumin, *a lower caste group.*

Kleider

Eldbergstrase 91

Eldbey / Lecherstrasse

Rivoli

Giori → Melbourne

enox Bienale In Istanbul

· 3 GIUGNO GURSLY = TRS̄ —

ADDRESS OF CHURNER
DOICHMAISTER
HORTENSIO

24 JUNE — 8 AUGUST ÅMAN _ NICE

Doris SKRUPPEL

STANDARD

= 5347812.4

CHRISTINE BRUCK BAUER
5875307 — 21
CATHRIN Z4

0043 1 710279036 FAX
 SOFIENSÄLE
VENIDEJEROME

PREVENTIVO BEAUBOURG

· Arissa cambio BATA BIGLIETTO]

⚇ { 551113 MONGSIO
 { 339-2883 026

338 7997 001
02 861 945 ANNA

2/3 PICTURES
 TEXT ← 2 TYPE PAGES

19 Liglio — 1 Agosto:
20
— 2002 —

Peview vittu 12 d1.00

JOACHIM OCTOVE
CHRISTA 27
317 69 800 — 22
4059 723
HOCHDÖRFER

9196 Placht
53 Cliviona

PER trove
VIVERECI
VOGLIONO 2 PALLE

Interview Nancy Spector in conversation with Maurizio Cattelan, page 6. Survey

Francesco Bonami ... It all started with The Invisible Man ... Little Joey Cattelan, page 38. Focus

Barbara Vanderlinden in ... When Morning ... page 88. Artist's Choice Philip Roth

... ... Operation Shylock, 1993, page 100. ... Oy Nat to Do ... A Collection of Sizable Notes ... page 10, ...

Artist's Writings **Maurizio Cattelan** Face to Face: Interview with Giacinto Di

Pietrantonio (extract), 1988, **page 112**. Incursions: Interview with Emanuela De Cecco and Roberto Pinto

(extract), 1994, **page 116**. Statements, 1999, **page 124**. Interview with Robert Nickas (extract), 1999, **page 128**.

I Want to Be Famous – Strategies for Succesful Living: Interview with Barbara Casavecchia, 1999, **page 132**.

Blown Away – Blown to Pieces: Conversation with Massimiliano Gioni and Jens Hoffmann, 1999, **page 140**.

The Wrong Gallery, 2002, **page 144**. Free For All – Interview with Alma Ruiz, 2002, **page 148**.

Update page ...

Chronology ... page 156. Artist 2003 ...

Face to Face
Interview with Giacinto Di Pietrantonio (extract) 1988

Untitled
1996
Exact replications of
adjacent works by John
Armleder, fabricated by
installation staff on
instructions of the
artist
Installation, 'Cabines
de bain', Piscine de la
Motta, Freiburg,
Switzerland

Maurizio Cattelan **Everything is linked but at the same time everything is
different, and this is what I'm getting at in my work when I use objects of
movement. Because art feeds off what there is around it – life, society –
there is always transformation.**

Giacinto Di Pietrantonio Is this a reflection of your somewhat varied background
outside of art school?

Cattelan **Well, yes, because the possibilities of ending up working with art
are manifold and it doesn't necessarily depend on whether or not you
attend art school. Just think of the Renaissance, when artists were
completely bound up with society – they were doctors, architects, poets.
Nowadays, that versatility still exists, but in the inspiration of the artist, the
contexts he can cull his ideas from.**

Di Pietrantonio To what extent is your reflection on objects – a line of research
opened up by Duchamp at the beginning of the twentieth century – a continuation or
a departure from its originator?

Cattelan **At the beginning of the century, Duchamp was working with
objects and was reacting to the era in which he was living and working.
While he was counterpoising them, nowadays we use objects to distance
ourselves from the craftsmanship of creation and the fact that creation can
be determined by a state of mind, an intimate emotion. This is not the case
as far as I'm concerned. In my art, I use things which surround me from the
society I live in. These are my objects. My message is that we can find a
philosophical idea through the television we watch every day.**

Di Pietrantonio You talk in terms of movement, objects from modernity, which is
the direction that criticism is taking nowadays; a Duchampian line which, in my
opinion, flies in the face of the Futurists with their exaltation of our mechanical
civilization, modernity and the symbolism they have attributed to current artistic
objects like metaphysics and Surrealism.

Cattelan Yes, you're right. In fact I am more concerned with the second tendency you mentioned rather than with readymades, although formally it might appear the other way round. I am more interested in the Futurist side of things because of the idea of movement, which links it more closely to life, while I find Duchamp very intellectual; his work is like a chess game and his relation with the object almost hysterical. He remains very far removed from the object and although his objects are very cogent, they have nothing to do with the type of object proposed by me or by other artists of my generation.

Di Pietrantonio In what way does your work deal more with internal life?

Cattelan Well, I work with things I find around me, everyday environments – which was not the case with Duchamp. The objects I use in my pieces are objects we use daily, while Duchamp never used a whole working bicycle for instance.

Di Pietrantonio Yes, but your work overturns the normal serial status of objects and makes them into one-offs.

Cattelan I always make three of every work because after reading what Warhol had to say about seriality, I don't feel the need to deal in one-offs as someone who expresses himself through painting does. I love the idea of the same piece being in New York, Australia, Europe and Japan at the same time.

Di Pietrantonio Yes, but as soon as an everyday object enters into the realm of art, even if it is produced as a multiple, it loses its original seriality and becomes a unique piece, taking on a new mystique.

Cattelan Yes, because the object no longer has its original function. That's why I always use new objects which haven't yet accrued certain connotations through their use or through history. For example, when I used two bulldozers in front of a pile of earth at Le Magasin in Grenoble, they had to be new because I wanted a contradiction between the two things. If, on the other hand, I had put two used bulldozers, everybody would have thought the bulldozers had moved the dirt. I'm more interested in maintaining that ambiguity in the use of the object […]

Flash Art, No. 143, Milan, April – May, 1988, pp. 25-27. Translated from Italian by Christopher Martin. Revised 1999.

Roberto Pinto Your most recent work, *Lullaby* (1994), which incorporates
rubble from a terrorist bombing in Italy, was shown at the Laure Genillard Gallery
in London and in a different version at the Musée d'Art Moderne in Paris. It drew
a polemical response from the media in several countries. The first to intervene
was the Italian critic Emilio Tadini, on the front page of the *Corriere della Sera*.
Let's begin with what annoyed you most about these responses.

Maurizio Cattelan **I'm pretty indifferent about what they wrote, although
I did get indignant when I read Tadini's article, not because it contained
a critique of my work but because, coming from a painter, a member of
the 'community' of artists, it expressed a poor and extremely reductive
idea of what art is. It seems that as far as he is concerned art is still
ornamental and neatly defined, like a cover for an armchair. And
secondly it led me to reflect on the nature of information: none of the
people who wrote anything picked up the phone to ask me, to find out
even one more line than what was written in the press pack. If this
front-page scoop was just based on that skeletal information, who
knows how other information is used by the media.**

Emanuela De Cecco Did you expect to get that kind of response?

Cattelan **No, I didn't expect it, but I'm very interested in the problem of
information: for example, at the 1993 Venice Biennale I hired out my
assigned space to an advertising agency. The agency used the space to
display its latest campaign for a perfume. I also hired myself out to their
press office. In order to function, this work didn't need a description; it
just required an external element which would encourage people to
reflect on the internal working of the Aperto.
 The same is true of *Lullaby*. The need to refer to the information on
which it is based is one of the boundaries of the work. But not all of my
works operate in the same way. I think others operate in a more
complete way: the meaning of the work is easier to understand. The
rubble I used in *Lullaby* is not only a precise reference but represents a
kind of snapshot of something which has happened and has involved
someone even like myself, who could be described as indifferent to
almost everything. However, like many artworks currently being
produced, if you don't know anything about their history and their
creator, if you're not introduced into the discussion, they're often
indecipherable.**

Pinto Yes, but if a work has a message, even if it communicates this through works that someone else has made, I don't think you should consider it like a masterpiece that doesn't need to be explained.

Cattelan **I keep on insisting that I make a work primarily for myself. I often can't begin to explain the internal dynamics of the thought process that brought me to that particular result. The work has a linearity of its own, but there are passages that are inexplicable, and mistakes that one hopes will come up again. I think mistakes give rise to a process that often strengthens one's thinking.**

De Cecco How did the exhibition of *Lullaby* in Paris differ from the London version?

Cattelan **In London, the rubble was held in a blue 'hold-all bag', like a laundry bag. In Paris it was sealed in clear plastic, and each pile was supported on a wooden pallet. In both cases I was attempting to arrive at a more normal, less 'artistic' object, even if ultimately when you bring rubble into a gallery it assumes a shape, so it's impossible to escape a discourse of presentation, a *mise-en-scène*. If there is something that is specifically artistic, it's whatever allows you to get the most out of your idea. If your idea is to do have something done to somebody you have to find the best possible way of getting it done. I think this is an element even in non-artistic situations. Once I read an interview with the film director Steven Spielberg, who said he would always know how many people would watch one of his films, depending on what he was shooting. That's something that fascinates me. On one hand you have the author, on the other the film industry and what the film is going to give you in economic terms: a kind of calculated prostitution.**

Pinto Among all the disasters that happen every day, what led you specifically to choose rubble from the remains of the PAC [the Padiglione d'Arte Contemporanea in Milan, blown up by a terrorist bomb in 1993]? Was this because it was an art museum?

Cattelan **I only considered later on the implications of taking the remains of a museum into another museum or art gallery. I'd like to structure an installation so that you come into a gallery and find that it contains another smaller one. I imagine this really crazy collector**

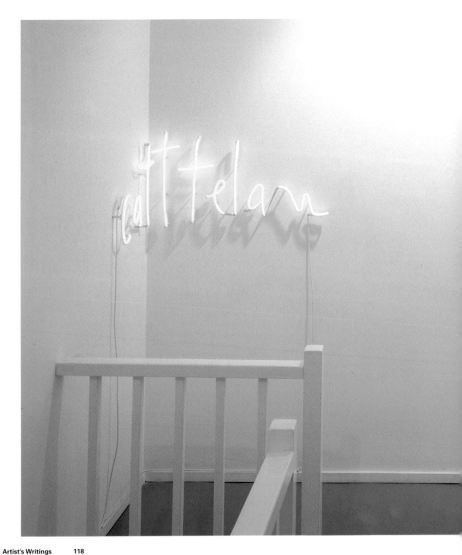

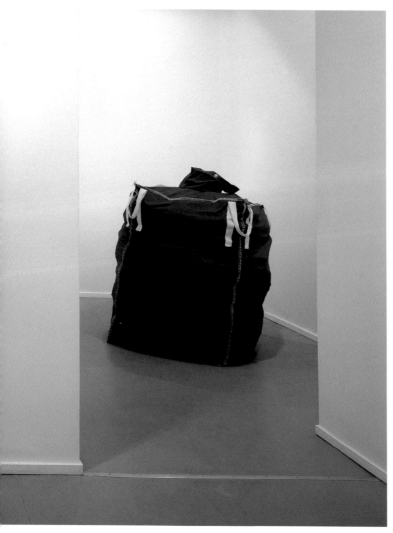

Installation, Laure
Genillard Gallery,
London
right, **Lullaby**
1994
Industrial bag, rubble
85 × 85 × 135 cm
left, **Catttelan**
1994
Neon sign
35 × 140 × 3 cm

saying, 'Oh, this work's lovely, so's this one, but where am I going to hang it?' and then you would offer the collector the whole gallery. The image of PAC stayed with me. I must confess that I didn't shiver when I thought of the people who lost their lives, but nevertheless I really did feel that something was in danger. It was a moment when two great forces confronted one another, one wanting innovation and the other being opposed to it. I thought it was the beginning of a big plan, a strategy, trying to put everyone into a condition where they would lose their points of reference [...]

De Cecco Your work makes a kind of exemplary incursion into current events.

Cattelan The true history of the work is the history of a difficulty repeating itself. I've also started to think about the difficulty of being Italian, having a heritage, relationships with other artists, being a member of a community with a history. You arrive in the art world, you're nobody (hence the absence of an author figure), and immediately you have to get someone excited in your stuff when they see it for the first time. For a while I saw myself as being almost like an immigrant. I thought that the best thing in that case would be to act like a complete foreigner, so that one could lay claim to one's autonomy and origins. The situation assumes a dignity of its own, even if one then goes on to touch something within oneself, something that might disturb the spectator, not only because, in the case of *Lullaby*, people died in the bombing it refers to. Yet this is not the best image of ourselves to export abroad.

Pinto I didn't understand many of the journalists' polemics. It was as if Picasso were being hauled over the coals for making *Guernica* – or Gerhard Richter, for his painting series based on the 'suicides' of the Red Army Faction's Baader Meinhof group in a German prison (*18. Oktober 1977*, 1988). I can't see anything scandalous in making a point about a social problem, especially one which has claimed victims.

Cattelan It wasn't my intention to make a point about a social problem.

Pinto Richter isn't a supporter of the Red Army Faction, yet his work was a testimony that he had to make.

Cattelan That he felt like making.

Gerhard Richter
Plattenspieler (Record
Player) from the cycle
18. Oktober 1977
1988
Oil on canvas
62 × 83 cm

De Cecco I think that making a point about contemporary events has a meaning in reference to an artist's previous career, to a form of authority already acquired. Many artists have felt the need to assume, via their work, a position about the war in Bosnia, but it's very difficult not to succumb to the most banal rhetoric.

Cattelan I really wouldn't want to touch the war in Bosnia because I don't know much about it. I can be sensitized to it, I can make gestures of solidarity, but my problems are here, they are where I am, not where the Bosnians are. The bomb in PAC really exploded here, and one became aware of a profound sense of menace. I felt that it was an extremely symbolic image of so many things, not just of that gesture, but of all the opposites: death and life, hate and love. It's a symbol.

De Cecco I remember being impressed when I read in the papers, at the end of that August after the PAC bombing, that the architects involved in the rebuilding of the art pavilion had already begun the process of rubble removal, to calm people down, to make them think that nothing had changed. The Milanese, returning from their holidays, would find the building almost as it had been, as though nothing had happened. I thought it was interesting that you confronted the event by using as your starting point the rubble that had been removed, the material trace of what had occurred.

Cattelan I hadn't thought of that, the fact that rebuilding is a form of psychological calm.

De Cecco The reconstruction was done by the same architect who had designed the original building. Maybe the decision to do this was a denial of the injury and pain, which threw everyone into confusion, so that in a rather dangerous way rebuilding is confused with removal.

Cattelan There's also a denial of growth, because it was and, after reconstruction, still is an 'old' structure which is ineffective in the face of contemporary art, which has its own precise needs today, different from those of the period in which the building was designed […]

De Cecco Why did you decide to put the rubble in a bag?

Cattelan Because it had to be transported; then in the gallery there would be the problem of arranging the rubble in a particular way to constitute it as some form of history. The bag was like a kind of funeral,

but you can see the rubble: you just have to open the fastening. You can even take some of it home as a souvenir if you want. I also liked using the normal demolition crew's system for transporting rubble. In the London installation there was a particular atmosphere, vaguely religious; there was something respectful in the way the bag was approached.

De Cecco I saw this work as implicitly distancing itself from a story of pain, in contrast to Hans Haacke's installation *Germania*, in the German Pavilion at the Venice Biennale in 1993. There, as one walked through the rubble of the pavilion's smashed floor tiles, the artist's allusion to Germany's turbulent past was brought closer to you. In *Lullaby*, the contained rubble becomes more like dust, an indirect story of death.

Cattelan **Yes, but in a sense it represents it more [...]**

De Cecco In the film *Henry: Portrait of a Serial Killer* (1990), the protagonist's serial killings turn death into a daily event. The more death is represented in detail, the more it is explained, the more cold it becomes. When it is hidden its emotional value grows; the image draws its strength from the lack of definition.

Cattelan **Maybe it becomes clear to you every now and again; then pathos gets in the way and there's always a let down. There is even pathos in *Lullaby*. Before deciding to make it I thought about it for two or three months and had to decide which was worth more: my selfishness or my feelings – if I could only choose one. The only feeling I had was that I had been a participant in an event which had affected everyone, and which had just surrounded us all of a sudden. And then there's the fact that I almost always feel absent and uninformed about the life around me. Each time I visit another environment I have to ask substantial questions in order to express myself [...]**
I believe that things are fine the way they are, in the sense that it's going to take centuries to change them, but you adjust them, bring them into your own dimension a bit, make them less distant.
Flash Art, No. 182, Milan, March, 1994, pp. 116-118, Translated from Italian by Shaun Whiteside, 1999.

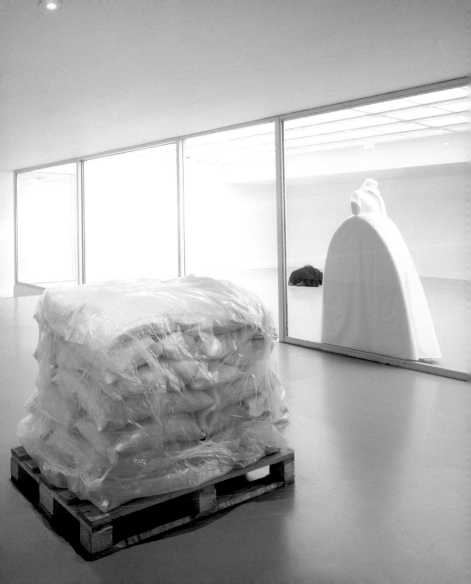

Untitled
1995
Black and white
photograph mounted
on aluminium
Lifesize

Things I'll Never Do Again: The Truth Is Not Out There
I will not do that thing with my tongue.
I will not fake seizures.
I will not eat things for money.
I will not reincarnate as Sammy Davis, Jr.
I will not instigate revolution.
I will not draw naked ladies.
I will not see Elvis.
I will not encourage others to fly.
I will not be a thirty-two year-old woman.
I will not cut corners.
I will not sell land in Florida.
I will not do anything bad ever again.
I will not show off.
I will not be a dentist.
I will not torment the emotionally frail.
I will not carve gods.
I will not aim for the head.
I will not send lard though the mail.
I will not dissect things unless instructed.
I will not get very far with this attitude.
I will finish what I sta

Influences

Once a friend of mine asked me what had influenced me and my work as an artist.
I was influenced by:

My father, who used to say I would go blind if I didn't stop that thing

Moby Dick

Listening to my uncle Franco

Sniffing gun powder in Salerno and Anzio

My former wife

Reading *Popeye, Toots and Casper* and *Chris Crustie*

Some rumours about albino alligators in New York

Some story about a pill that you can put in the tank of a car with just a drop of water and drive around with no fuel

The story that George Gershwin actually never wrote a single song – it was his twin who could play and George would keep him tied to a rock down in the cellar

That other story about James Dean – he never actually died and he's now living with Elvis; and Hitler is waiting for them in Argentina and they are gonna write a movie all together.

You know, it's just a stupid question:

I was influenced by every single second I spent riding my bicycle.

I never understood if birth helps life anyway.

Untitled
1995
Postcards mailed by the
artist to himself with
images of his work used
as 'stamps'
10 × 15 cm each

MAURIZIO CATTELAN
VIALE BLIGNY 42
20136 MILANO

MAURIZIO CATTELAN
VIALE BLIGNY 42
20136 MILANO

MAURIZIO CATTELAN
VIALE BLIGNY 42
20136 MILANO

MAURIZIO CATTELAN
V.LE BLIGNY. 42
20136 MILANO

MAURIZIO CATTELAN
VIALE BLIGNY 42
20436 MILANO

MAURIZIO CATTELAN
V.LE BLIGNY. 42
20136 MILANO

MAURIZIO CATTELAN
V.LE BLIGNY. 42
20136 MILANO

MAURIZIO CATTELAN
VIALE BLIGNY 42
20436 MILANO

MAURIZIO CATTELAN
V.LE BLIGNY 42
20136 MILANO

MAURIZIO CATTELAN
V.LE BLIGNY. 42
20136 MILANO

MAURIZIO CATTELAN
VIALE BLIGNY 42
20436 MILANO

MAURIZIO CATTELAN
VIALE BLIGNY 42
20436 MILANO

Interview with Robert Nickas (extract) 1999

Robert Nickas You're a professional ...

Maurizio Cattelan **Art worker.**

Nickas But with you, there's not always an actual work.

Cattelan **There was the time I had to go to the police to tell them that someone stole an invisible sculpture from my car.**

Nickas An invisible piece?

Cattelan **I was supposed to have a show at a gallery, and I didn't really have anything for them** ...

Nickas ... and you didn't know how to tell them?

Cattelan **Yes, so I decided to report that a sculpture had been stolen from my car.**

Nickas So you'd have a good excuse for the gallery?

Cattelan **Exactly. I went to the police station in the early morning, and I was frantic, 'Oh my God ... '**

Nickas And they believed you?

Cattelan **Sure. [*laughs*]**

Nickas Didn't you once steal someone else's work and then bring it to the place where you were having your show?

Cattelan **Yes. This was more about displacement. I thought it was interesting to move one place completely into another.**

Nickas So you broke into the gallery?

Cattelan **Yes, we broke inside at night.**

Nickas Whose work did you take?

Cattelan **Actually we took everything from the gallery …**

Nickas Like the fax machine and all the stuff in the office?

Cattelan **Everything. We just rented a van and filled it up.**

Nickas This was in Amsterdam?

Cattelan **Yes, at De Appel. They wanted me to do a piece in a week, but I'm not used to working so quickly, so I thought the best way to get something that fast was to take the work of someone else.**

Nickas That's a new take on the readymade.

Cattelan **Well, when you don't know what to do …**

Nickas Were you arrested?

Cattelan **No. This is why I did the piece in Holland … It took a while for everyone to calm down, but then we became very good friends and [the other gallery] even asked me to do a show with them.**

Nickas But that's your ultimate punishment – you had to figure something out for another show.

Cattelan **Yeah, it's true.**

Nickas Crime doesn't pay.
index, New York, September/October, 1999, pp. 59-60.

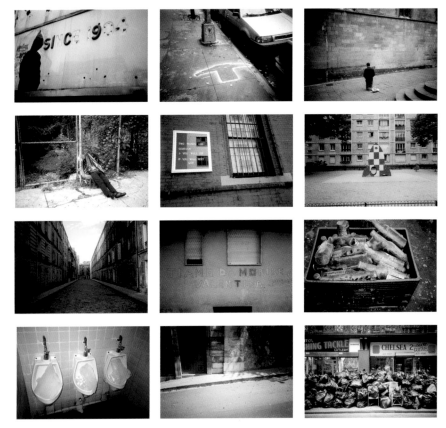

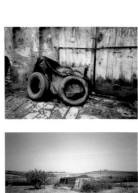 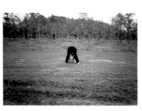

 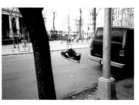

 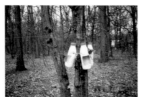

Barbara Casavecchia Is it really necessary to leave the '*Bel Paese*' (the 'beautiful country', as Italy is patriotically known) in order to find America, as you did?

Maurizio Cattelan **The international curator Hou Hanru has recently coined the term 'typical global man'. I'm not comfortable with this idea, or its gender. I don't recognize myself in his generic traveller. I have no desire – in Hanru's words – 'to be global', whatever that might mean. His notion that things start to get interesting at the point where the global and the local meet, to me only mirrors the empty rhetoric of MTV-style sloganeering: 'Think global; act local.'**

Casavecchia When abroad, is it any easier to feel like an outsider, a clandestine figure, to keep a distance?

Cattelan **This is why I think nomadism is so important today: not only does it provide a constant reminder of what being an outsider feels like, but it helps you return home and see the place you live with re-opened eyes. I travel for my research, not because I can afford to or for any of those reasons. I travel because I need to, because I think it's that important. In fact my personal values are probably just as small-town working-class as they were when I first arrived in New York on a Greyhound bus several years ago. This is probably at the root of my increasing belief that art's universality is what makes it more essential to civilization than even before.**

Casavecchia You use the word outsider; but what are you outside of? *Flash Art* just published a list of top 100 artists and you are number one. The biennial survey of new international artists, *cream* (Phaidon Press, 1998), includes you among its selected 100 artists leading into the next millennium. How does it feel to be part of the *crème de la crème* of contemporary art?

Cattelan **_cream_ is more like a yearbook of trends and issues. Ironically, I think that its eventual presence as a book is what might make it hugely effective at getting new art across to a larger public. What I'd really like to see is a handbook or supplement instructing ordinary people all over the world on how to discover interesting artists in their own back yard.**

Casavecchia When you presented your last project at The Museum of Modern Art, New York (1998), you stated that Picasso was 'the greatest magician and

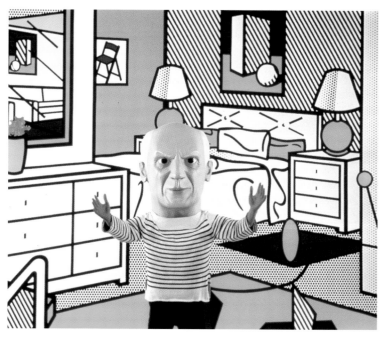

left and overleaf,
Untitled
1998
Papier mâché, paint,
costume
Mask, 32 × 21 × 24 cm
Greeting visitors in
front of Lichtenstein
painting and in
entrance areas at The
Museum of Modern Art,
New York

opposite, **Untitled**
1998
Ink on paper
33 × 24 cm
Pre-production
drawing, with Umberto
Manfrin

entertainer in twentieth-century artistic practice'. Funnily enough, a couple of
years ago the critic Jeff Rian used exactly the same words to describe you. Who,
then, were you really parodying in the work (*Untitled*) , with that big mask of the
venerable old Pablo's face?

Cattelan **Well, I think Warhol really had the last word about that. It's
difficult, as an artist, to admit you want to be famous. Being an artist
has nothing to do with fame, it has to do with art, that intangible thing
needing integrity. Nevertheless, I think one has to confess a desire to be
famous, otherwise one is not an artist. Art and fame are the expression
of a desire to live forever, two things which are strictly interlinked.**

Casavecchia In the past, you made dealers dress up in costume; now there's a
profes-sional actor playing a character. The theatrical dimension seems even
stronger in this work. Was the staging, the *coup de theatre*, always so important?

Cattelan **Contemporary art will never achieve the audience of football,
pop music or television, so I think we should stop comparing its
possible area of influence to that of big mass-media events. New**

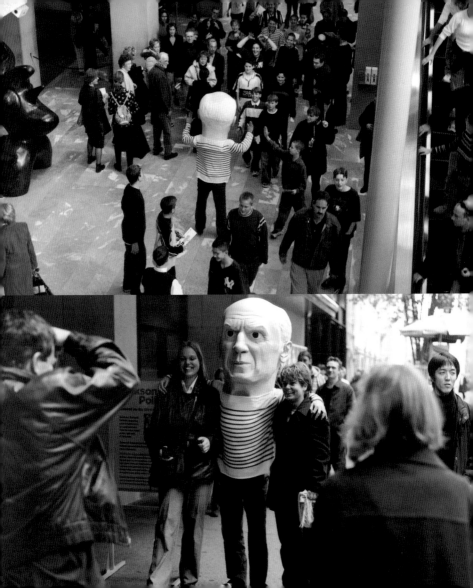

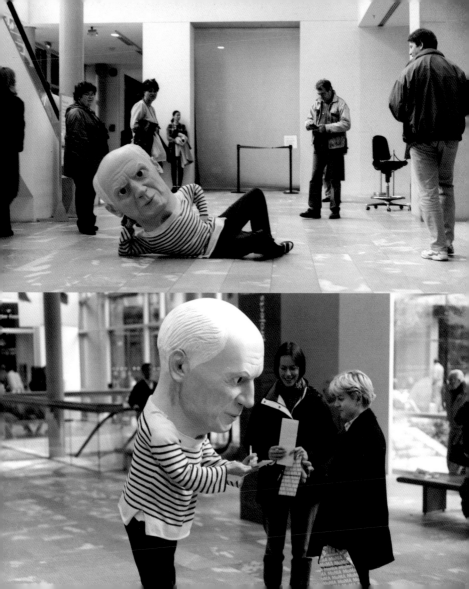

buildings such as the Museo Guggenheim in Bilbao, as well as many recent international exhibitions, play inside the logic of the spectacle; they attract a large number of people as 'artistic' Disneylands. Today sensationalism has replaced the critic's knowledge of reality; the laws of the market are stronger than the efforts to fight against singular thought. We live in the empire of marketing, spectacle and seduction, so one of the roles of artists and curators is to deconstruct those strategies, to resist their logic, to use them, and/or find new means of activism against them.

Casavecchia *Strategies* was the title of one of your early pieces in 1990, constructed from issues of *Flash Art* magazine. Which strategies do you think we should deconstruct?

Cattelan **Unlike many artists of my generation I'm not really interested in revealing media strategies. In this respect, I'm definitely an heir of 1980s mass culture.**
 During that period, Japanese producer Yasushi Akimoto invented a TV programme, 'Onyannko Club', which included a feature showing how to transform any teenager into a star. This was the best part of the show. The audience was given the illusion that real producers were attending the audition; even if everybody knew the whole thing was set up, they enjoyed the experience a lot. Personally I never understand anything before having experienced the whole process.

Casavecchia At the Castello di Rivoli in 1997 you installed enormous trolleys for art shopping (*Less than Ten Items*); for the Aperto section of the Venice Biennale in 1993 you rented your space to an advertising agency (*Lavorare è un brutto mestiere* [*Working Is a Bad Job*]). Yet now the Vodka producers Absolut have used your name to endorse their advertising campaign; have the factors been reversed?

Cattelan **That's hard to answer. Yes, humour is something few people think about in terms of the extreme effort to create a structure of power, which is usually humourless. No one has ever explained to me why people like David Bowie or Kirk Douglas and even the Queen of Holland want desperately to be contemporary artists when they could avoid it altogether and enjoy the little success they probably already have. All the world wants to be an artist, in the old-fashioned sense of the word, and we keep discussing what an emerging artist is.**

A Perfect Day
1999
The artist's gallerist,
Massimo De Carlo,
adhesive tape
Installation, Galleria
Massimo De Carlo, Milan

Casavecchia Any reference to news and current events seems to have disappeared from your recent work, except for the occasional reference to the art world. Is this a sign of a new direction you are taking?

Cattelan Everyone knows that artists don't change society, but this means downsizing the problem anyway. Artists take part in the process of information. If artists only do cubes, then everything the world will know about art is cubes. But if artists tackle different subjects, these start to get into differential dialogues regarding the nature and circumstances of art. Maybe this doesn't change the world, but at least it changes the context, where one has a chance to experience it in unexpected ways. If Jacques-Louis David hadn't existed, our notion of what was actually possible at that time would be very different. Visual history is important for grounding a record of what's happening – levels of intention, levels of confidence, levels of aggression or control. The choice of new subjects starts to break some barriers in that protected enclave, the world of art.

Casavecchia In your most famous self portrait you're on the ground, your tongue sticking out, your 'paws' bent on your chest. Your work is full of bears, horses, dogs, squirrels, pigeons, any kind of more or less domestic, taxidermized animal. Why do you insist so much on the animal, often macabre, dimension?

Cattelan The idea is to talk about the highest form of human art, and in my opinion the highest form of human art is tragedy. Because we are, maybe, the only creatures who are intimately aware of the fact that we're going to die, even when death is not imminent. We know death is a fearful thing. But other creatures fear it when it's there: a big gaping jaw is about to eat them. We humans will just be sitting, and all of a sudden we might go, 'Oh shit, I'm going to die.' In every century you find it in opera and theatre and sometimes it's in music. Certainly in the twentieth century, the blues is the apex of the appreciation of tragedy, of loss. I'm going to get up this morning, and I'm going to put on my shoes. The idea that I put on my shoes in the morning is the hardest thing in the world.

Casavecchia We are back to the old idea of the tragic as the other face of comedy?

Cattelan I think that, most of all, I'm interested in the tragi-comical

Mini-me
1999
Resin, rubber, fabric,
hair, paint
h. 35 cm

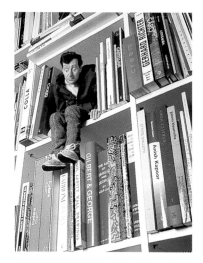

element: there's humour and there is humility. I'm specifically interested in any kind of emotion that could enter my work. Some of my pieces are very depressing. When people accept to do them, they know it's a ridiculous scenario, but they seem to enjoy it anyway. However, I also humiliate myself: at the end of the day, the only person who really turns out to be ridiculous is me.

Casavecchia Then the ferocious irony of some works of yours is not aimed only at the other, at his or her frailty and weakness. You are a victim of failure yourself.

Cattelan **I carry inside me the idea that it's better to be more things than one, that many gods are better than one, that many truths are better than one.**

Casavecchia 'All interviews are pre-packed,' you said. What sort of game are we playing then?

Cattelan **Just playing. You'd be in the shower or you'd pull down your pants and play choo choo train.**

Casavecchia Any other question?

Cattelan **Are you a Joan Crawford fan?**
Flash Art, No. 215, Milan, April – May, 1999, pp. 80-81. Cattelan's responses borrowed from various previously published sources, including internet discussion by the curators of *cream: contemporary art in culture* (Phaidon Press, 1998).

Blown Away – Blown to Pieces
Conversation with Massimiliano Gioni and Jens Hoffmann 1999

Massimiliano Gioni Why do we need a new biennial? We already have a few: Johannesburg, Venice, Sao Paulo, Santa Fe, Taipei, Istanbul, Berlin ...

Jens Hoffmann That's the whole point. If there had been just a couple of them, we would have never dared to organize a new one [the Caribbean Biennial, a project in progress]. Now, just one more biennial doesn't really make a difference.

Maurizio Cattelan **Jens is right: it kind of disappears among the others, and disappearing is a good way to start working. It's a way of dealing with problems from the inside, which is what I always try to do. Never set yourself aside: always try to camouflage.**

Gioni This is what Maurizio has been trying to do as an artist, at least in the past: subverting the system from within, as many critics have pointed out about his work. Aren't you supposed to change your strategies when you pick up the role of the curator?

Cattelan **For me a curator's job is not so much about finding answers; it's more like asking questions, which is what artists are trying to do anyway. It's not that I believe in the idea of the curator or the critic as an artist, but there is definitely an amount of creativity in putting together a show. Besides, the role of the artist is much more corrupted than we like to think: he is never an innocent creator, detached from practical issues. In a way he is already a curator, of his own image at least. And he deals daily with problems that curators are familiar with: finding money, developing a concept for a show, getting someone to write a good piece for a catalogue.**

Hoffmann My intentions behind curating are probably different from Maurizio's. In a certain way exhibition making is an artform on its own. I do not see myself as the servant of artists, only realizing their projects as an administrator. I see curating much more as an artistic and intellectual discipline/practice.

Gioni Would you describe this biennial as an art project or as a space for artists to show their work?

Hoffmann There will definitely be no biennial-like exhibition but nevertheless I would not see it as an art project. It is very much in-between. I would like this biennial to come out as complex as life itself.

Cattelan **I personally think it is a way to discover how far institutions can**

work on an experimental level. This biennial is not exactly a show, a shop window for artists' projects or objects: it's less and more than that – more or less.

What I'm really interested in is the notion of complexity, the idea that there are no fixed roles and definitions. Everyone is forced to change roles every single moment of his life. One minute you act like a star, and then you have to be all smiley and cheesy and flattery to get the attention of someone who is a better star than you. Or maybe you try to be polite with a waiter and your voice sounds funny and so it comes out in the wrong way and you have to apologize, otherwise you are not going to get served. Complexity is not an invention of what we used to call postmodern discourse: it's a matter of everyday life. I would like this biennial to come out like that, something really everyday-ish. No one should be able to tell if it's an artwork or a critical and curatorial statement. No one should be able to figure out where the artworks are, if there are any, or what the artists are doing there.

Gioni Actually I haven't figured out yet what all the artists are supposed to do during this biennial. The press release mentions panel discussions, quick talks with the locals. And it also has a slight postcolonialist touch to it, plus a critical edge against the art system. Nevertheless you two are inviting all the usual suspects of the artworld. Are you trying to kidnap these famous artists, to blow them away, as the title says? Or are you inviting them just for the publicity?

Hoffmann At the beginning we had really different ideas about which artists to invite; but dealing with other people's opinions is a fundamental aspect of curating. I honestly don't know what will happen there but I think ambiguity is crucial in this project. I always try to find a certain intellectual frame for what I do, but the impulse to do something might come from a totally different source than my own mind. When I work I try to follow a certain vague feeling. Ultimately, individual artistic statements define one's idea for an exhibition. It is good to keep following the flux of things, closing the frame you are in as late as possible. You will never capture the whole picture anyway, but at least you are left with something new and unexpected.

Cattelan **Jens is right: just let art be; do not control or place the work of art in a preset frame of mind. All concepts have to be transformed at the end of a thought process. It takes some courage to let a show become different from what was originally planned. However, change and chance shouldn't be predetermined. Artists and curators are sparring partners: they keep hitting each other. It doesn't matter who wins: what really makes a**

La dolce utopia (Sweet Utopia), with Felipe Palerno
1996
Helium-filled balloon
h. 10 m, ø 4 m
Installation, 'Traffic', capc Musée d'art Contemporain, Bordeaux

difference is the amount of energy that goes between them. So, to answer your question, we are kidnapping these artists; at the same time we are trying to get some publicity from their names. Doing just one thing at a time is often counter-productive: we are trying to exploit as much energy as possible.

Gioni South America and the Caribbean are usually identified with the idea of energy, at least according to Western stereotypes.

Hoffmann The location was clear very early on. We wanted to find the biggest stereotype of an exotic holiday place, a site North Americans and Europeans would dream of after a hard year's work. Sometimes you wonder why some of these new biennials emerge where they do and I guess our choice of the Caribbean had a lot to do with that.

Gioni And art is always a matter of context, isn't it?

Cattelan **You see, you keep going back to the problem of art, which to me is not really relevant, especially when organizing a biennial. The problems we are dealing with are much more down to earth: who is going to pay for the plane tickets; who is going to send all the press releases; who will make phone calls to reserve the ads in the magazines. Art is what's left between a fax to a gallery, a phone call to a collector and a reservation at some hip restaurant in Tribeca. This doesn't mean I subscribe to the cynical idea that art is just a matter of visibility, promotion and public relations.**
 What I'm trying to say is that art is a collision of different systems and levels of reality. And I wish our biennial could reflect all this. On the other hand, complexity is hard to grasp, so our project might turn out as a total flop. Which is okay, because failure is closer to reality than art itself.

Hoffmann If there is any critical edge to this project it is the idea that art is part of more complex environments: it's a stratified reality, where practical issues clash against idealistic visions.
Material, No. 2, Migros Museum, Zurich, November 1999. Jens Hoffmann, born in Costa Rica, is a curator based in Brussels and New York; Massimiliano Gioni is an editor at *Flash Art* magazine, Milan.

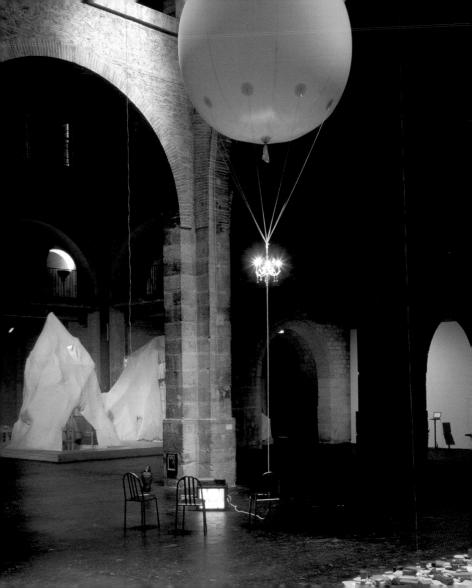

The Wrong Gallery 2002

The Wrong Gallery is the smallest exhibition space in New York. Located on 20th Street, in Chelsea, New York, The Wrong Gallery is nothing but a glass door with one square meter of exhibition space behind it.

Directed by Maurizio Cattelan, Massimiliano Gioni and Ali Subotnick, The Wrong Gallery is a small niche for the survival of radical experiments, but it's also a shop window, just like the ones that have started popping up all over Chelsea and the Meat Market in New York.

Yet another exercise in simulation, The Wrong Gallery perfectly replicates the structure of the art system, while radically transforming its scale and meaning. Just like Cattelan's magazines *Permanent Food* and *Charley*, The Wrong Gallery is both a collective project and a parasite, that grows gathering energies from its surroundings, as it equally flirts with the real estate paranoia of NY art dealers and the guerrilla tactics of clandestine underdogs.

A no profit, no budget enterprise, The Wrong Gallery is a Do It Yourself venture, which has to reinvent itself for every project, finding new sponsors, partners and friends. The Wrong Gallery in fact does not play any role in the market: it does not buy or sell; it does not represent any artist. It operates as a mini-kunsthalle or like a tiny museum. Or, as Maurizio Cattelan says, 'The Wrong Gallery is just the back door to contemporary art.'

In less than a season, and with very limited resources, The Wrong Gallery has already presented works and special projects by Turner Prize winner Martin Creed, by international stars Paul McCarthy and Jason Rhoades, who were invited to realize a new piece for the Christmas holidays. Irish artist Phil Collins has transformed the whole gallery into a light box, depicting scenes from his stays in Beograd, while Elizabeth Peyton has painted a special Valentine's Day piece. The line up for the 2003 season also included Sam Durant, Lawrence Weiner, Daniel Buren and many others.

'The Wrong Gallery', *Flash Art*, No. 228, Milan, January–February 2003

left, **Martin Creed**
Work No. 122: All the sounds on a drum machine
1995–2000
Drum machine, amplifier, plinth
Courtesy Gavin Brown's enterprise
The Wrong Gallery
12 October – 16 November 2002

right, **Phil Collins**
Sinisa and Sanja
2002
Two colour photographs printed on reverse print backlit film
80 × 80 cm each
Courtesy the artist and Maccarone Inc.
The Wrong Gallery
21 November – 10 December 2002

opposite, **Daniel
Squires**
A dancer with the Merce
Cunningham company
The Wrong Gallery
15 November 2002

below, **Paul McCarthy
and Jason Rhoades**
Humpback (The Fifth
Day of Christmas),
from the '13 Days of
Christmas Shit Plugs'
series
2002
Santa Claus, angel,
ribbon, shit
Courtesy the artists and
Galerie Hauser & Wirth,
Zurich
The Wrong Gallery
12 December 2002 – 17
January, 2003

Alma Ruiz For your 2003 exhibition at The Museum of Contemporary Art, Los Angeles, you have chosen to create *Charlie* (2003) a piece that features a child riding a tricycle. Many of your pieces, like *Lullaby* (1994) and *Charlie Don't Surf* (1997), also refer to childhood. Is such work a form of autobiography?

Maurizio Cattelan **Not really. It's not necessarily about me; it's more about everyone. I think you should always try to touch upon themes that are meaningful to everyone; for this reason the themes in my work are things like death, childhood, sadness, suicide, and so on.**

Ruiz You are interested in addressing universal themes?

Cattelan **'Universal' is a bit too serious a term. I think my work is more about common feelings and experiences. I think childhood, for example, is a confusing time; feelings seem clearly divided between good and evil and yet behind this clear-cut distinction lies a universe of doubt. A child, for example, can love his mother very intensely one minute, and then hate her terribly the next over something insignificant and silly. Maybe this kind of confusion is reflected in the way my work functions: I like my images to be very clear and straightforward, but the more you look at them the more ambiguous they become.**

Ruiz How does *Charlie* relate to your previous work?

Cattelan **Certain references recur over and over in my work. They pop up all the time, even when I wish they wouldn't. But that's OK: I find it quite useful to repeat things over and over ad infinitum. Sooner or later I might get it right.**

Ruiz Yet you always try to come up with a new project for each exhibition.

Cattelan **That's just to keep the interest up. It's an antidote to boredom and a way to keep my work from becoming routine. I'm really not that interested in finding my own 'signature style', and I'm not interested in imposing myself and that style on other people. I'd rather be something different every time.**

Ruiz That might also be a way to discover what is common to all of us.

Cattelan **Yes, the more you change, the more you are likely eventually to say**

Charlie
2003
Resin, rubber, human hair, electric engine, battery, remote control unit
Lifesize

something meaningful to everybody. I've always tried to work that way, jumping from one problem to another with a certain lightness. You must find a balance between novelty and repetition. The challenge is to do something that looks 'classic' and yet is still strange. All the ideas and themes in the world already exist and belong to everyone; there isn't really much that we as artists can invent.

Ruiz If your work is not autobiographical, why does your own face appear in it so often?

Cattelan My face is a mask, a prop. I use my own face as a way to generate sympathy from the viewer, who sees my face and imagines that it is literally me who must be suffering. That connection creates a sense of empathy.

Ruiz The face of *Charlie* looks like something between a real child and a caricature of a grown-up Maurizio Cattelan. Why did you not choose the image of yourself as a child?

Cattelan My work is not really about providing explanations for the viewer or telling my life story. That's the job of curators and critics, not mine. To me childhood is a fiction, one of many possible narratives. There may be an element of autobiography, if you wish, but my work is more about the way you reconstruct memory and relive moments of your life in a new way. When you remember the past, you project an image of yourself as you are now. The past is an invention that always takes place in the present.

Ruiz Besides having yourself or a surrogate perform an action, your work often demands movement or response from the audience.

Cattelan An artist must establish some kind of dialogue; otherwise, what's the point? If you don't have an audience, you're just talking to yourself.

Ruiz At MOCA, the museum will be turned into a playground, as the child in *Charlie* rides his tricycle through the galleries. Isn't this a violation of sacred space, since traditionally museums have been places where visitors are quiet and respectful?

Cattelan Actually, assumptions like this one, which we all have about museums, don't reflect their reality at all. The more you go to museums the more you realize that they are packed with students, tourists and people just out to have a good time. Sure, institutions are supposed to be quiet and

solemn, but actually museums are noisy and crowded and very market-oriented. So this piece, or *Untitled* (2001) (the piece at the Boijmans-van Beuningen Museum in Rotterdam), or *Untitled* (1998) (the Picasso look-alike greeting visitors at New York's Museum of Modern Art), might come across as being very critical of museums, but they simply reflect the existing situation. I'm not doing anything particularly brave or radical; I'm only adding a new element which exposes what has been underway at museums for a long time now. In that sense I'm just a parasite. I don't invent anything; I just use what's already there.

Ruiz *Charlie* appears within the context of the museum's permanent collection. Is there a parasitical relationship between your work and the museum collection?

Cattelan Maybe I'm being held hostage in the museum ... or maybe I'm just very small, propped up on the shoulders of giants. As an artist, there is always something terrifying about being part of a museum collection or being invited to show work in an institutional context. It can be quite stressful. Even though it's a celebration of your work, it also frames you. You are trapped. Gaining recognition and being collected by museums is nice but it can also spell the end of you. Being accepted can be more dangerous than being refused, so I sometimes use such occasions to show off my own weaknesses, or sneak away.

Ruiz Do you feel that your work connects to other artists, movements, or traditions?

Cattelan Just like all other names in history, mine is tentatively written in pencil and sooner or later is destined to fade. That's why I always like to keep to my corner. I really don't deserve much attention.

Ruiz The fact that this little boy is going to be riding his tricycle around the museum every day raises deeper issues. Are we actually letting him play, or is he working for free? Is he having fun, or is he being forced into child labour?

Cattelan Maybe he is only taking a bit of exercise! Or maybe we're doing him a favour, training him early for the hardships of life! (laughter) Jokes aside, I like my work to take both sides. I don't like to stand up for any particular point of view; that's the viewer's job. Depending on how you look at it, what I do can appear either generous or exploitative. So, is the kid playing or is he working? Either way, it's OK by me. I like the ambiguity.

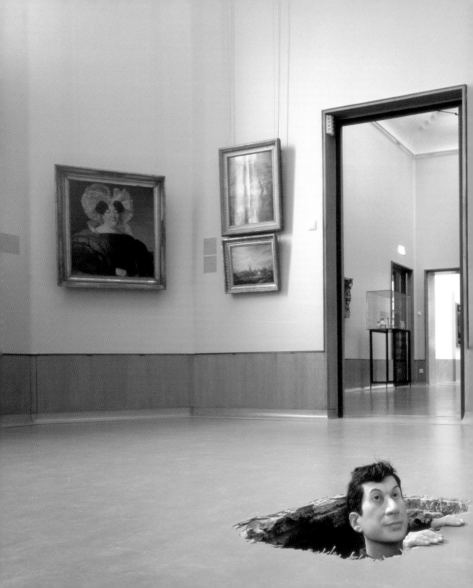

Untitled
2001
Wax figure, fabric
Figure, 150 cm; hole,
60 × 40 cm
Installation, Boijmans
Museum, Holland

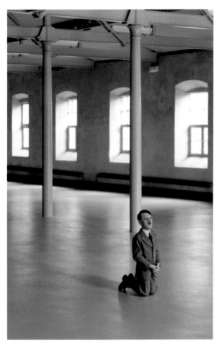

Besides, even if he's playing, he's being forced to play; his freedom's been taken away in either case, so it doesn't make much difference.

Ruiz You have often been described as the court jester of the contemporary art world.

Cattelan **Even when you are playing, you have to follow some rules, otherwise it's chaos, not fun. In a way, work and play are two symptoms of the same disease. No matter what, we always seem to come up with laws to govern our actions; we long for order. I have tried many ways to escape this situation. I've even tried to stop working altogether and delegate everything to other people, but it's just impossible. You always have to be there anyway, or create some new rule to ensure that things go right. There really is no end to work.**

Ruiz I understand that you delegate your work to others and in some cases you even supervise a piece from far away. Even lectures and interviews like this one may actually be carried out by surrogate Maurizio Cattelans (which leads me to wonder:

Him
2001
Wax, human hair, suit,
polyester resin
101 × 41 × 53 cm
Installation,
Fargfabriken, Stockholm

who is really answering these questions, anyway?).

Cattelan **For me delegation is not some kind of a statement or stand. It's a necessity, a way of problem-solving. Something needs to be done so you find someone who can do the job best. So, for interviews for example, I look for someone who is interesting and entertaining. Or if there is a particular piece that needs to be built, I try to find someone who can build it better than I can. There is nothing radical in this: we all do it everyday. Besides, if you are think you can control everything, you'll be instantly screwed.**

Ruiz So for you what's important is the end result.

Cattelan **Yes, but the end result is the process. My working process is to delegate; it has to be that way because I just can't control everything myself. You have to relinquish control more and more, but that doesn't mean you lose interest in the process. It's just a different way of handling things, I guess. As long as things get done, then I'm happy.**

Ruiz Which brings me to another aspect of your work, specifically the concept of authority and how you represent it. Isn't delegating a way of questioning the artist's authority? Many of your works like *La Nona Ora* (1999), *Him* (2001) and *Frank and Jamie* (2002) critique different manifestations of power. Do you also think *Untitled* (2003) defies authority?

Cattelan **This probably goes back to the idea of childhood as a period of confusion. When you are a child, authority seems very warm and protective, even appealing. Authority can make you feel safe and protected. On the other hand, as a kid you are too undisciplined even just to sit still and be quiet, like the kid running wild at MOCA.**

Ruiz Is the child a subversive component that disrupts the order of the museum?

Cattelan **I wouldn't put it that way. I'm not trying to overthrow an institution or to question a structure of power. I'm neither that ambitious nor that naive. I'm only trying to find a degree of freedom. After all, the museum is a welcoming place for the kid on the bike. He is protected there; he can have fun and nobody will hurt him. I'm not against order or authority as such; I just think that you can create new margins for freedom in every context.**

Ruiz The MOCA piece is the first mechanized work that you have ever done. What

prompted you to do an animated piece?

Cattelan **Actually many of my works move:** *Errotin, le vrai lapin* **(1995) moved, and** *AC Fornitore Sud* **(1991) did too. The Picasso look-alike was alive, as was** *Mother* **(1999) at the 48th Venice Biennale. These all involved living, moving people. I like to think that many of my pieces are dynamic. Even those in which you only see the end result of an action, for me the action that came beforehand is what's really important.**

Ruiz But in *Charlie* the child is not a living human being, impersonating a character, but a machine.

Cattelan **Again, I am more interested in the result. The kid is mechanical simply because I thought it would occupy the space in a more interesting way. But it's not a comment on mechanization or anything like that. I was interested in creating a character and letting him run wild.**

Ruiz Is there a link between the child on a bike and the city of Los Angeles?

Cattelan **Well, now that you mention it, we could say the mechanized boy is a cinematic creature, which is perfect for LA. To me what really mattered was trying to find a way to give the kid a certain personality, to turn him into a character whom you could feel attached to, despite the fact that he looks kind of empty, or dead.**

Ruiz Morbidity often appears in your work. Your sculptures are very lifelike and creepy. When you look at them they seem very real, as if they're about to move. This time it does.

Cattelan **There is this really great coincidence between Italian and English that I have always liked. In Italian, the word 'morbido', which sounds like the English word 'morbid', means soft and tender. Of course in English, 'morbid' means something creepy and deathly. If I could situate my work anywhere, I would place it somewhere in that area, between softness and perversity. It should be tender, comforting and seductive, and yet corrupted, twisted and consumed. This is pretty much what we were saying about childhood and our attitudes towards authority. You can't really untangle your feelings about childhood, or authority – or death, for that matter. They repel you, yet at the same time you are strangely attracted too.**
Previously unpublished

Contents

Interview Nancy Spector in conversation with Maurizio Cattelan, page 6. Survey

Francesco Bonami Static on the Line: The Impossible Work of Maurizio Cattelan, page 38. Focus

Barbara Vanderlinden Untitled, Manifesta 2, page 90. Artist's Choice Philip Roth

Portnoy's Complaint (extract), 1969, page 100. ... Or Not to Be: A Collection of Suicide Notes (extracts), 1997,

page 106. Artist's Writings Maurizio Cattelan Face to Face: Interview with Giacinto Di

Pietrantonio (extract), 1988, page 112. Incursions: Interview with Emanuela De Cecco and Roberto Pinto

(extract), 1994, page 116. Statements, 1999, page 124. Interview with Robert Nickas (extract), 1999, page

128. I Want to Be Famous – Strategies for Successful Living, Interview with Barbara Casavecchia, 1999, page

132. Blown Away – Blown to Pieces: Conversation with Massimiliano Gioni and Jens Hoffmann, 1999, page

140. The Wrong Gallery, 2002, page 144. Free For All – Interview with Alma Ruiz, 2002, page 148.

Update Massimiliano Gioni Maurizio Cattelan – Rebel with a Pose, page 158.

Chronology page 192 & Bibliography, List of Illustrations, page 210.

'Fair is Foul, and Foul is Fair'
– William Shakespeare, Macbeth

Repent and Sin No More

Maurizio Cattelan is an inveterate sinner. He has
no scruples about coveting his neighbour's house,
or stealing his possessions. In fact, he has built
his career on questioning the dogmas of ownership
and property, eventually turning himself into a
thief of style and even actual artworks. With
Cattelan at large, the contents of a gallery might
disappear overnight, only to turn up the next day
in another exhibition, bearing his signature and
the title *Another Fucking Ready Made* (1996) –
both a public admission of plagiarism and a quirky
slogan for a slacker's guerrilla war against the
traditions of contemporary art.

In museums and galleries, Cattelan often digs
holes, corridors and secret passages, sneaking in
through the back door, or – vice versa – escaping
the scene of the crime. In 1999, he even buried a
man alive (*Mother*, 1999).

Cattelan is also a liar, who has elevated falsity
to a fine art. In 1992, he set up the Oblomov
Foundation, which promised to award a grant of
$10,000 to young artists on the condition that
they would produce no work for a year; he
awarded himself the prize and kept the money. In
2000 he convinced sponsors, dealers and
museums to pay for his 'Caribbean Biennial',
which turned out to be a holiday in the sun for a
handful of artists.

Showing no respect for his elders, Cattelan
has humiliated many figures of authority who
have crossed his path. He symbolically crucified
one of his dealers by fixing him to the wall with

duct tape (*A Perfect Day*, 1999), and dressed
another up as a giant penis (*Errotin, le vrai lapin*,
1995). Pablo Picasso – another victim of
Cattelan's many parricides – was transfigured via
an actor in a mask into a ridiculous caricature:
demoted to a walk-on role as a doorman, in
striped shirt and sandals, welcoming visitors into
the lobby of the Museum of Modern Art in New
York (*Untitled*, 1998). Most recently, two wax
policemen (*Frank & Jamie*, 2002), in complete
military attire, found themselves head over heels,
in a staggering image of surrender.

Mea Culpa

Like any hardened sinner, Cattelan always
proclaims his innocence. He has probably never
actually read the Bible, but has lived and breathed
Catholicism since his childhood, spent in the
streets of Padua, a small town in Northeast Italy.[1]
'He who is without sin, let him cast the first
stone', the gospels exhort. And off goes Cattelan,
lobbing a huge meteorite at a perfect replica of
Pope John Paul II. The Holy Father falls onto his
side, sinking into a red carpet sea, his image
frozen somewhere between the Titanic and a
3-D version of a Francis Bacon painting. Glass
splinters lie all around, the skylight shattered
into pieces.

A baroque vision corroded by pop immediacy,
this floored pope – titled *La Nona Ora* (*The Ninth
Hour*, 1999), the time of day when Christ died on
the cross – clearly represents a point of no return
in Cattelan's work. It incorporates many of his
obsessions – namely his restless intolerance of
power, his need for confrontation, and his
macabre taste for cartoon-like absurdities –

which transforms his exhibitions into sudden epiphanies and legendary exploits, often on the edge of illegality and aggression. But *La Nona Ora* also opens a hiatus between Cattelan's earlier pieces and his more recent works. To use the same marketing terminology with which Cattelan often describes his work, one could say that *La Nona Ora* is a benchmark – a turning point, a synthesis of the past and the prophecy of what is yet to come.

Angry Young Man

More spectacular than any of his previous interventions, *La Nona Ora* is the result of a carefully staged production that completely erases the apparently rough spontaneity of the artist's earlier works. These include the knotted sheets he suspended from a gallery window in order to escape an exhibition (*Una domenica a Rivara* [*A Sunday in Rivara*], 1992); his fake doctor's certificate (*Certificato medico* [*Doctor's Certificate*], 1989); a police report on the so-called theft of a non-existent artwork (*Untitled*, 1992); and his multiple self portraits on acetate, in fact made by the police based on descriptions from family and friends (*Super Noi* [*Super Us*], 1992). With *La Nona Ora*, Cattelan seems to leave behind his envy and anger against the mechanisms regulating the art world that have dominated his work from the early 1990s. During that decade he adopted the role of an idiot savant, a pantomime of the artist inflected by an acute form of performance anxiety. Against all the odds, he managed to sit down at the same table as the rich and the famous while publicly confessing his own inadequacies and pointing out the dysfunctions of the system within which he

was (un)willingly trapped. In this sense, his appropriation of the mythology of Conceptual art – with his continuous references to Marcel Duchamp, Piero Manzoni and Alighiero Boetti amongst others –seemed naïve, and yet strangely suspect. It was as though Cattelan had casually appropriated the most radical ideas of the avant garde simply because they were cheap, easy and practical enough to guarantee immediate results and, eventually, fame.[2]

Flirting with Disaster

Suspending his reflection on the artist's position within the tradition of contemporary art, with *La Nona Ora* Cattelan finally jumps into reality. Significantly, this work also represents a drastic shift in the sheer physical dimensions of his interventions. Unlike most of his previous projects – and only partially anticipated by such pieces as *Novecento* (*1900*, a taxidermized horse suspended from a pulley made in 1997) and the untitled living olive tree installed in a casino in Luxemburg in 1998 – *La Nona Ora* functions as a complex installation that takes over the entire exhibition space. It is a life-size environment, literally stretching from floor to ceiling. Viewers find themselves enveloped in a set that has a cinematic quality, recalling a Disneyland diorama or a scene reconstructed in some Hollywood studio.

This increase in complexity and scale reflects Cattelan's new ambitions: he is no longer simply acting out against the ghosts of power that haunt the art world. He is now fighting a more powerful adversary – pushing his irreverence far beyond the privileged circles of contemporary art. His vehemence is intact, and he continues to adopt

following pages, **La Nona Ora (The Ninth Hour)**
1999
Mixed media
Lifesize
Installation,
'Apocalypse', Royal
Academy, London

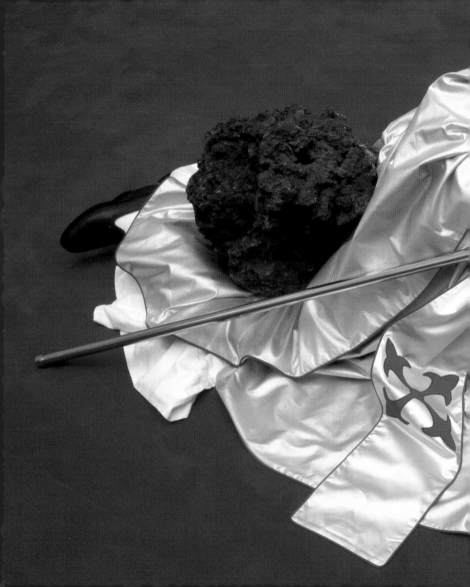

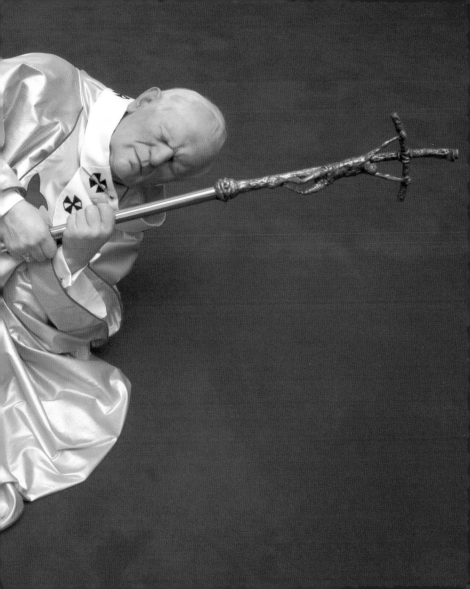

the same weapons used by his enemies; yet Cattelan's productions have become slicker and more dramatic in order to deal with the mighty forces of religion.

Or, like Don Quixote, is Cattelan really only tilting at windmills? His gesture of dethroning the Holy Father is surely suffused with the demon of irony, for *La Nona Ora* preserves all the grotesque characteristics that animated Cattelan's earlier works. And despite its blasphemous content and violent imagery, this work could simply be the visual equivalent of a bad joke, tinted with Cattelan's typical black humour. Like any joke, perhaps La Nona Ora shouldn't be taken too seriously. After all, the pose of the Pope mannequin is clearly inspired by a secular, cartoon tradition, recalling the undaunted efforts of Coyote to demolish Roadrunner with ACME dynamite. And in *La Nona Ora* there is never any illusion that this representation of the Pope is any more than a dummy; there is no risk of mistaking him for the real thing. It is in the end a caricature, like a *papier-mâché* puppet in a carnival parade, or some gruesome Halloween mask.

Straight Fiction

The influence of these popular traditions on Cattelan's world has been extensively discussed by other authors.[3] Like François Rabelais' *Pantagruel* (1532) or Victor Hugo's *Notre Dame de Paris* (1831), Cattelan's universe swarms with deformed characters in a series of distorted roles: dealers performing in the place of the artist; institutions forced to come to terms with their own weaknesses; curators turned storytellers; artists behaving like burglars ...

The Hieronymus Bosch-like personas trapped in Cattelan's world live in a slippery territory, where definitions and borders must be continuously negotiated and redefined, while roles are subverted and exchanged under the pressure of never-ending abuses of power, intricate rites of humiliation, and unjustified excursions into celebrity. As the ringmaster of this circus, Cattelan holds the privilege of commanding order and confusion: his carnival of fools flips the world upside down, and throws it into a forest of paradox and lies.

Looked at in these terms, *La Nona Ora* – as with all Cattelan's best works – is an ambiguous image, an emblem of complexity, refusing to take a clear position on its own subject. One might even argue, for example, that this work is a metaphor for sanctity, a postmodern crucifix that captures the Pope at a moment of fragility and martyrdom that wins back his holiness. Placed at the intersection between opposing tensions, *La Nona Ora* resonates like a loony tune played to the tempo of a requiem. And yet there is no passion in Cattelan's work, no expressionistic emphasis, and no blood – just the occasional dash of lipstick, or a pint of tomato juice. Cattelan's Pope is merely an empty simulacrum made out of wax, reminding us that his iconoclasm always belongs to the realm of representation, to the kingdom of pure simulation.

A theatrical element pervades all of Cattelan's work. In the past, this attitude was best expressed through the subversive gestures of a juvenile delinquent or the tricks of a court jester. Even his most inert objects and artworks seemed to preserve the trace of an action, like the

evidence of some criminal act carried out in the dark. These latent performances may have taken place on the stage of contemporary art, but they also made continuous reference to the theatre of cruelty of our everyday life, with its small victories and sudden tragedies. With *La Nona Ora*, however, Cattelan seems to be pointing his finger at a more intricate apparatus of media strategy and consensus manipulation – the attack is now against the spectacle of propaganda and ideology. His has become a theatre of misinformation.

White Noise

And it is to the realm of information that *La Nona Ora* has returned. During its relatively short life, it has become a ubiquitous image, reproduced in hundreds of magazines and newspapers. In less than a couple of years, it was seen speeding from the Kunsthalle in Basel to the Royal Academy in London and the National Gallery in Warsaw. In 2001, after a quick stop at Christie's in New York – where it was sold for $900,000, scoring a personal record for the artist and one of the highest prices of the season – *La Nona Ora* flew all the way to the Venice Biennial. Travelling faster and further afield than the Pope himself, this work has become an involuntary metaphor for contemporary art's recent infatuation with a blockbuster mentality and corporate velocity: iconoclasm turned iconophilia, one could say.

As biennials and large-scale exhibitions multiply across the globe, scandals and spectacles are becoming the norm, turning art into a cultural industry. Like it or not, capturing visitors and generating media attention have become the internationally accepted currency, even in the ivory tower of contemporary art; shocks are not only accepted, they are expected and welcomed. As is the case with many other artworks of the late 1990s, *La Nona Ora* participates in this new MTV-style ritual of vision, in which idols are simultaneously adored and destroyed.

First presented in 1999, *La Nona Ora* was born at the climax of a decade in which both art and artists entertained more than a few dangerous liaisons with the media system by inventing user-friendly personalities and photogenic installations, or – vice versa – by manipulating our data-sphere as viruses of infotainment with carefully planned taboo-violations and sponsored sensations. Jeff Koons and Damien Hirst – artists whom Cattelan admires with the devotion of a fan – are the most recognizable brand names associated with this paradigm shift, which has infested the contemporary art world both in terms of economics and the artworks themselves.[⁴]

In the case of Cattelan, this attraction to spectacle and entertainment was superimposed on a ten-year-long career, during which the artist often addressed the function of gossip, rumour and communication, while also playing with the machinery of consensus. From his surreal *Campagna elettorale* (*Election Campaign*) of 1989, when he placed the slogan 'Your Vote is Precious. Keep It' in major Italian newspapers, to his plans for a fake neo-Nazi rally (*European Naziskin Meeting*, 1993); from the pages of his many magazines (such as *Permanent Food*, a pre-digested combine composed of pages stolen from other publications) to the politically charged, and yet playful images of illegal immigrants in soccer uniforms (*AC Forniture Sud* [*Southern Suppliers*

PERMANENTFOOD

Permanent Food
(Edited with Paola
Manfrin)
1996–
Magazine
192 pages
Issue No. 8
left, artist's cover
showing the drawing 4
Bananas by Erwin Wurm

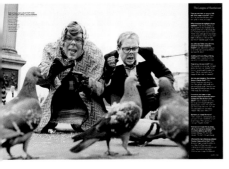

Permanent Food
(Edited with Paola
Manfrin)
1996–
Magazines
192 pages
this page, issue No. 9
opposite, issue No. 10

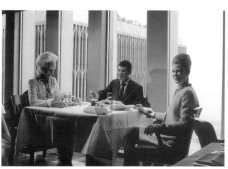

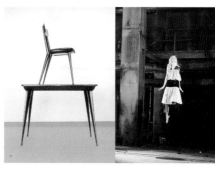

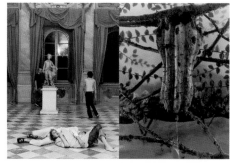

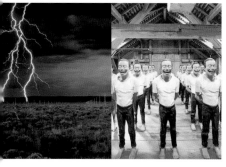

FC], 1991), Cattelan has tried to place his art at the crossroads between different systems of information and beliefs. His pieces function as Trojan horses, perfectly replicating the appearance of order, only to insinuate new doubts. In other words, his artworks are pretexts with which to infiltrate scepticism into an organized structure, attempting to subvert it from within, and always in the artist's favour.

In this sense, Cattelan's work is a catalyst for opposed forces and creeds; it is open to a variety of points of view. Whether collecting rubble from a terrorist bomb site (*Lullaby*, 1994) or creating a miniaturized version of Adolf Hitler (*Him*, 2001), Cattelan aims at magnifying contradictions. As the artist himself explains, his artworks must act as 'fields of encounters'; they are 'projections of desire' and frustration – icons of friction, which need to be completed by the direct, often indignant reaction of their viewers.[5]

Cattelan's shock tactics differ, therefore, from the sensationalized art of the 1990s. It is not the surprise effect or the spectacle *per se* that interests him; it is rather the possibility of using objects and artworks to create new relationships and connections. Ideally Cattelan would like each of his pieces to operate like *Stadium* (1991), an elongated table-football game played by teams from Italy and North Africa, bringing together different individualities and perspectives, contributing to create a complex set of contrasting energies and feelings, equally balanced between irony and despair, pacifism and violence, generosity and parasitism. In *Stadium*, just as in any other work by Cattelan, the borders between participation and abuse are extremely thin. Throughout his work, Cattelan deals with the issue of complicity. Many of his escapades and exploits would not have been possible without the voluntary help of his partners and accomplices, who are often willing to bend the rules of the game and get a fair share of the fame, shame and fun.

In the face of Cattelan's most recent pieces, neutrality is not permitted. It is impossible to be innocent: whether you decide to condemn his acts as blasphemous or support them as radical, you are always bound to take a position. The result is an explosion of viewpoints and explanations. Even when the object itself disappears – as it did in the case of the fakir whom Cattelan buried in Venice (*Mother*), or the dummy of a woman's corpse that he threw into the Aasse lake in Münster (*Out of the Blue*, 1997) – Cattelan's personas tend to live on in the confusion of multiple versions of the same story. Despite their aggressive, in-your-face attitude, his frontal attacks are not created to impose a single vision or break a specific taboo; they aim to disperse themselves in an infinite variety of interpretations. This is what Cattelan means when he claims that he's simply trying to represent the complexity of the real.[6]

Less is More

In many of his interviews – which are often conducted by stand-ins and surrogates pretending to be the artist, or constructed using fragments of other conversations, stolen from the most disparate sources – Cattelan repeats that there are no facts, only interpretations. He goes on to say that there is no such a thing as one

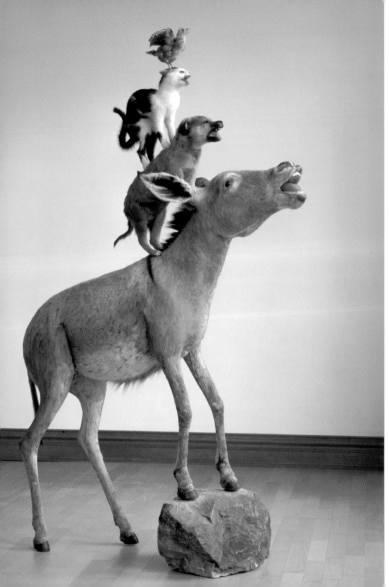

Untitled
1998
Taxidermized donkey,
dog, cat and bird
165 × 120 × 40 cm

single truth: 'The truth is not out there. It's just the moment you claim something as your own.'[7] As the curator and writer Alison Gingeras has noted: 'Cattelan disavows the role of the artist as guardian of the Enlightenment ideals of moral rationality, historical consciousness, and truth. Instead, his sociology-sans-truth sets into motion a much more disruptive scenario.'[8] In such a world even identity becomes uncertain: it is impossible to say where the universe ends and where the self begins; impossible to distinguish between what's mine and what's yours.

Despite this unstable identity, Cattelan seems to enjoy the challenge of capturing his own image in the dozens of self-portraits that have continuously punctuated his career. Even though he has often taken on the role of a clandestine character fated to invisibility, Cattelan has also created an endless army of puppets, dummies, Mini-mes and alter egos with his own features. Set in every possible situation, these creatures can be found spreading across gallery walls, sitting on bookshelves, peaking into museums, riding tricycles. Seen in this context, even his parade of taxidermized animals can be interpreted as a variation on the theme of self-representation – a multiple portrait of the artist as a dead dog.

Paradoxically this overexposure of the self never becomes narcissism: in his self-portraits Cattelan always tries to transform himself, often adopting a burlesque mask. His portraits are consistently exaggerated, and therefore imprecise, as if at the very moment he gave in to the idea of being frozen by an image he were already trying to escape by becoming someone else.

This excess of visibility, then, might be said to function as an antidote, a desperate attempt to fill a vacuum in order to confirm one's own presence, which would otherwise be condemned to anonymity, and eventually to invisibility. 'Without others, I'm nothing', Cattelan explains,[9] as if to suggest that his identity is just a form of approximation, a pale reflection caught in the eyes of the observer. With these exercises in vanishing and transformation, Cattelan acts out – and sometimes even seems to enjoy – the symptoms of a never-ending schizophrenia.

This attitude results in a voracious curiosity and an uncontrollable appetite for any form of communication. Cattelan mostly spends his days talking on the phone, e-mailing, or compulsively flipping through magazines, catalogues, books, often looking for an idea – what in the past was called 'inspiration' – or for an image that might end up in the next issue of *Permanent Food*, a second-generation magazine made of pages ripped-off from other periodicals.

As a consequence, Cattelan doesn't seem to believe in style as a signature imposed on a particular material or form. To him, and to many artists of the same generation – Pierre Huyghe, Olafur Eliasson, Tobias Rehberger, Rirkrit Tiravanija, Piotr Uklanski and numerous others – style is just an attitude that can easily be translated into a variety of media, languages and visual solutions. For these artists stylistic consistency and formal coherence are no longer an issue. Style is just a means to flexibility, never an end in itself.

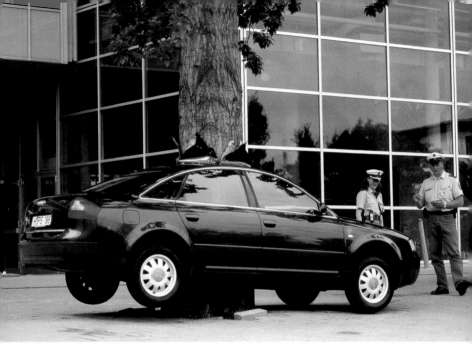

Close Encounters

Ambiguity, then, might be the key with which to enter Cattelan's world. His recent works reflect a state of uncertainty even in their own physical presence. From *La Nona Ora* to *Him*, *Frank & Jamie* or *Untitled* (2000) – for which he wrapped a car around a tree in Hannover – Cattelan's objects seem to dwell in an intermediate zone, a no-man's land. They clearly occupy the same space as their viewers and yet they step back from it, enclosed in a suspended, unreal atmosphere that is obviously fictional and constructed. Most

often, Cattelan's work forces viewers to modify not only their beliefs, but also their physical collocation in space: spectators are either faced with gigantic, out-of-scale monsters like *Felix* (2001), a seven-metre-tall cat's skeleton, or they have to kneel down to discover little houses for rats and mice, or miniaturized elevators.

True to the deceptive nature of his practice, Cattelan rarely places his works in a central position. They are often hidden, sequestered in a corner, or camouflaged under a sheet – as with the life-size elephant of *Not Afraid of Love* (2000).

Untitled
2000
Audi car, tree
Lifesize
Installation, 'In
Between: Expo 2000',
Hannover

Untitled
2000
Polyester resin, brass
fixtures, mixed media
with sound track,
electric lights
Door, 13 × 4 cm,
garbage can h. 6 cm,
Ø 2.5 cm
Installation, West Flat
Residence Apartment at
ArtPace, San Antonio

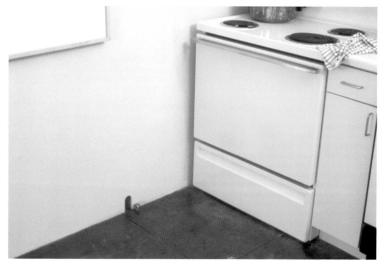

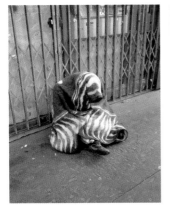

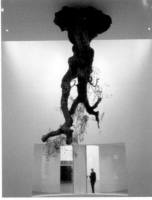

At other times they are suspended from the ceiling or half-hidden in the ground. They can be lost in the streets like *Gerard* (1999) – a homeless man made out of rags – or flipped upside down like the tree (*Untitled*, 2000) installed in the Kunstmuseum, Bonn. Or they can function like a stage set or backdrop, as in the Hollywood sign transferred to the hills of Sicily (*Hollywood*, 2001) or the menacing billboard installed in a street in Spain (*Untitled*, 2001), which solemnly proclaimed that fourteen people had died and two injured in a total of eighty-one accidents at this location. No matter how aggressive and violent, Cattelan's works always tend to undermine their own authority by choosing a marginal position. They never stand upright: they are literally and metaphorically de-based, deprived of a pedestal, always in a precarious position. They are sculptures, but they systematically refuse the moral and formal weight of monuments.

It is this feature that makes Cattelan's art so accessible, twisted evidence of which can be found in the numerous attacks that have damaged or destroyed his work in the recent past. Cattelan is a vandal whose work often gets vandalized in return. He seems to place his figures in an ambiguous territory that immediately instigates extreme reactions on the part of his viewers. Usually the spectators' response remains in the realm of protest or angry recrimination, but at times it can trespass into extreme physical and

Untitled
2001
Stainless steel,
composition wood,
electric motor, electric
light, electric bell,
computer
2 parts, $30 \times 12 \times 12$ cm
Installation,
International Triennale
of Contemporary Art,
Yokohama

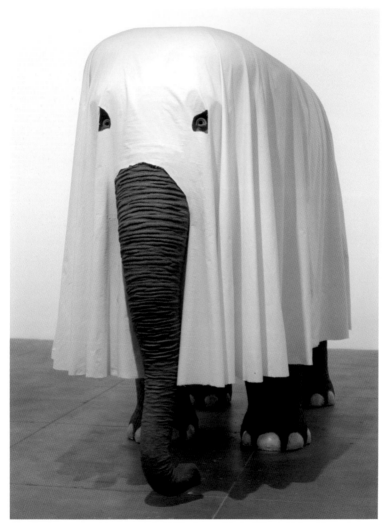

Not Afraid of Love
2000
Polyester styrene, resin,
paint, fabric
205.5 × 312.5 × 137 cm

aggressive behaviour. In 2000, while on view at the National Gallery of Warsaw, *La Nona Ora* was attacked by two members of a Catholic political party. During an official visit, they lifted the meteorite and tried to put the Pope back on his feet in an attempt to restore his dignity. In 2001, *La Rivoluzione Siamo Noi* (*We Are the Revolution*, 2000), a dummy with Cattelan's features was damaged by a visitor as she tried to liberate the puppet from the coat hanger on which it dangled, because it apparently reminded her of a relative who had died by hanging. And, most recently, the miniature Hitler was nearly shot at the Castello di Rivoli, in Italy, where a security guard on nightshift mistook it for an intruder.

These stories – which the artist proudly passes down as his own personal urban legends – not only testify to the confrontational nature of Cattelan's feats; they also reveal the vernacular quality of his work. In a sense, Cattelan gives form to a peculiar variation of figurative sculpture that is immediately comprehensible to a wide audience. Despite his acquired familiarity with the language of Conceptual art and post-Minimalist practice, when he sits down to produce an image, Cattelan always deploys a popular earnestness that verges on tabloid aesthetics.

Sliding Down the Surface of Things

More importantly, true to the persona of lazy underachiever – a role he has been interpreting since the beginning of his career – Cattelan completely delegates the manufacture of his pieces to craftsmen, professionals, art directors and other accomplices. This extended family is

the contemporary incarnation of Andy Warhol's factory; unlike Warhol though – and in tune with the progressive dematerialization of the service industry – Cattelan doesn't even need a physical space to carry out his plans. He has no studio and his structure is flexible and interchangeable, mostly invisible, somewhere between a think-tank and a criminal association. Everything can be communicated via fax, e-mail, or phone, without leaving any trace; Cattelan orders the hit, but never gets his hands dirty, his role being that of employer, editor and fugitive.

This refusal of any form of physical labour – with all its romantic subtexts – is profoundly connected to Cattelan's proletarian upbringing: in the personal mythology that he has created around himself, work stands as a synonym for abuse, alienation, blood, sweat and tears. No matter what he learnt in church, Cattelan soon discovered that there is no redemption through labour. A bastard son of Duchamp and Boetti, he stands halfway between laziness and asceticism.

For this reason Cattelan's production always seems tuned to an icy, passionless detachment. Even when imbued with irony or despair, his art possesses the sterile precision of a coldly contemplated plan. The artist's vision – his trademark – is clearly there, and yet the execution barely carries the signs of his direct involvement. This predilection for an impersonal, expressionless quality is another trait typical of many artists of his generation – one could again mention Koons and Hirst, but also artists as distant as Carsten Höller and Vanessa Beecroft. Under the influence of commercial photography, fashion, television,

Clipping from a Polish newspaper showing *La Nona Ora* (*The Ninth Hour*, 1999) being attacked by two members of a Catholic political party at the National Gallery in Warsaw

Felix
2001
Oil on polyvinyl resin
and fibreglass
1,829 × 3,566 × 549 cm
Installation, Museum of
Contemporary Art,
Chicago

digital technology and cinematic effects, throughout the 1990s we witnessed the diffusion of sharp images, cold, scientific sensibilities, and distant beauties. Immediately recognizable as artworks, these images nevertheless maintained a coefficient of anonymity.

This frozen quality (which can also be found in the pages of the latest issues of *Permanent Food*) is amplified by Cattelan's paradoxical practice – established from the beginning – of creating works that are predominantly three dimensional, yet planned with the intention of later translation into photographs and reproductions. Cattelan is a fastidious self-editor who has deeply assimilated the strategies of commercial photography and advertising. An omnivorous consumer of images, he firmly believes that the presence of his work in magazines, books and newspapers is as crucial as its appearance in galleries or museums: reproductions are yet another means to survival – a matter of visibility.

All of Cattelan's sculptures and installations, then, are both peremptory and ephemeral. Sometimes they survive only through photographs, as in the case of the Hollywood sign installed on the hills of Palermo, and the performances of his dealers Emanuelle Perrotin and Massimo De Carlo during exhibition openings; or Picasso singing for his supper at MoMA. On the one hand, Cattelan seems to believe in the creation of highly physical objects, often resulting from a complicated tour de force. On the other, his creations are bound from birth to dematerialization, and will be immortalized only by photography.

The Queen is Dead

Perhaps because they are always intended to manifest themselves later through photographs, the characters invented by Cattelan often appear soulless, empty and absent, like corpses. And throughout his career, he has often tinkered with the idea of death. His taxidermized animals are the most obvious example of this fascination – macabre attempts at asphyxiating the breath of life. When they are not paralyzed and stiff, Cattelan's animals are simply stripped bare, left with nothing but their bones: skeletons pop up everywhere in his work, even enlarged to mammoth dimensions, as in the threatening and yet strangely cute *Felix*.

In Cattelan's universe, death can be a liberating experience, an escape from the burden of life. With an untitled work for his one-man show at Le Consortium in Dijon in 1997, Cattelan even went so far as to dig his own grave, finding the easy way out from the claustrophobic rooms of the museum. Just like Cattelan, the squirrel who has shot himself in *Bidibidobidiboo* (1996) is probably glad to leave his boredom and troubles behind; and he can finally forget about the dirty dishes in the sink. Even a humorous comment such as 'Don't Forget to Call Your Mother' – a neon sign appearing in one of Cattelan's photographs (*Don't Forget to Call Your Mother*, 2000) – sounds like a terrible *memento mori* when placed in this context.

In Cattelan's recent works – and specifically in *La Nona Ora*, *Him*, and *Frank & Jamie* – the obsession with death is transformed into a weapon against the rhetoric of power. Grouped together in what the artist describes as a trilogy

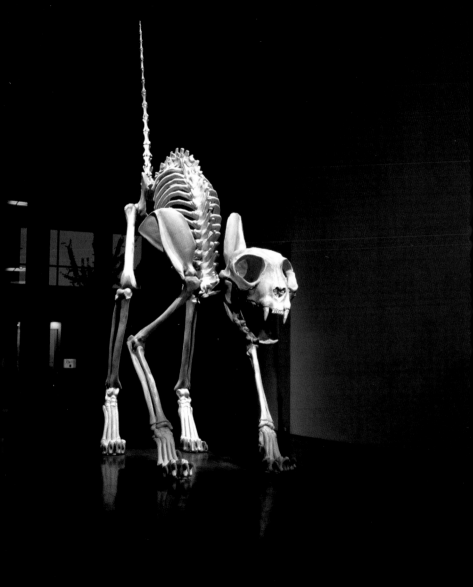

Don't Forget to Call Your Mother
2000
Cibachrome, Plexiglas,
aluminium back
66 × 101.5 × 2.5 cm

against any form of ideology, these three works not only share the same punk, fuck-it-all attitude; they also participate in the same ritual of exorcism against the spectres of history and authority. But, first and foremost, their similarities are formal: perfect wax reproductions, they boast real clothes and real hair.

Since the time of ancient Rome, wax has been engaged in a morbid relationship with death: employed as a casting material for death masks, wax eternally preserved the features of the dead, bestowing on corpses the consolation of celebrity, the mirage of immortality. With Madame Tussaud's famous museum, founded in 1835, wax

sculptures finally entered the dominion of popular culture, delivering a severe blow to the hierarchies of power. In wax museums everything is immediately accessible, everything is on the same plane, upheld through a deliriously democratic principle: the powerful are portrayed next to the stars, Elvis a few metres away from Marie-Antoinette, Hitler next to Dante. History is subjected to a levelling process, a temporal implosion, which annuls all difference.[10]

By adopting the formulaic vocabulary of Tussaud's waxworks – perhaps also filtered through Hiroshi Sugimoto's powerful photographic portraits of wax mannequins

representing historical figures – Cattelan makes clear reference to the subversive nature of wax museums, where the trajectory of history is transfigured by popular imagination. With this trilogy, Cattelan envisions an imaginary world in which icons of power are finally overthrown, defeated and deposed. Viewers are granted the privilege of strolling next to sovereigns and representatives of the established order. Their lives can be approached, infiltrated; their defects exposed and scrutinized – the fantasy of direct democracy finally realized.

Property is Theft

Despite their traditional, almost illustrative quality, these works prove that Cattelan's anarchic insolence has not yet worn thin. In fact, his strategies of subversion might even have become more radical. In the past he used to steal only from his fellow artists, testing the limits and privileges of the art world. Now, his insubordinate scepticism is directed against reality. For this reason he has abandoned the formal vocabulary of post-Conceptual art, embracing instead a more direct, even populist, syntax of representation. The accent is no longer on appropriation as a means to criticize the modernist values of intellectual property and innovation; in his most recent works, reality itself is re-appropriated and transformed, or – better – questioned.

In this sense, Cattelan's work states its distance from artists who have adopted apparently similar formal solutions in the past. While it clearly draws from the tradition of hyperrealistic sculpture, Cattelan's recent production differs from such work in that it seems to lack any faith in its own means of representation. When compared to the work of an artist such as Duane Hanson, for example, it is clear that Cattelan's sculptures show little interest in the perfect simulation of reality. With Hanson there seems to be a form of pride in capturing visual reality precisely as it is: simulation is an accomplishment that even has something miraculous about it. With Cattelan, on the other hand, things start to get interesting when they go wrong, when the reproduction of reality is slightly off, twisted or corroded from within. He manages to insinuate into his wax dummies a germ of perversity. Indeed, there is something profoundly degraded and profane in his theatre of puppets: like creatures born out of some miscarried genetic manipulation, they might seem perfect at first glance, but on closer inspection they reveal their flaws. Their scale is often wrong, their position awkward, their gazes miserably empty. Still and frozen as pillars of salt, they are always corrupted: they stink of death and other catastrophes.

A similar stench infested the hill of Bellolampo, overlooking the city of Palermo in Sicily, where Cattelan erected his life-size replica of the Hollywood sign that crowns the streets of LA. Certainly his most grandiose operation to date – with its 500 tons of steel, iron and concrete – Cattelan's *Hollywood* laid its foundations on a garbage dump, while hovering above the city of Palermo like a collective hallucination. Yet another exercise in simulation, *Hollywood* underlined a further recurring theme in Cattelan's recent work. Like many artists of his generation, Cattelan always seems to start off

Hollywood
2001
Scaffolding, aluminium,
lights
23 x 170 m
Installation, XLIX
Biennale di Venezia,
Palermo, Sicily

Hollywood
2001
Scaffolding, aluminium,
lights
23 x 170 m
Installation, XLIX
Biennale di Venezia,
Palermo, Sicily

consideration does not necessarily translate into a passive attitude, since recognizing the power of images is the first step towards learning how to fight them. Once again, the strategy chosen by Cattelan is that of a slow erosion. The external appearance of things is left untouched, but their perception is drastically transformed. Cattelan's Hollywood sign is inserted in a totally different landscape; the dream of instant celebrity insecurely rests on a pile of trash.

Less Than Zero

From the imaginary geography traced by his Hollywood sign, all the way back to *Lullaby*, one can sense an unequivocal utopian tension in Cattelan's work, which nevertheless seems bound to fail. Many of his images capture moments of loss and surrender: the artist as a schoolboy nailed to his desk (*Charlie Don't Surf*, 1997); his face sunk in a dish of spaghetti (*Untitled*, 2000); a donkey paralyzed in the air (*Untitled*, 2002); a friend's mouth stuffed with a cork, as though there were nothing left to say (*Untitled*, 2000). The message of loss and final delusion is never clearer than in *Untitled* (2002), a tombstone engraved with the epitaph: 'Why Me?'

But it is with *La Rivoluzione Siamo Noi* (2000) that Cattelan casts perhaps his most tragi-comic representation of his chronic pessimism and troubled self-esteem. Named after a seminal photograph by Joseph Beuys,[12] *La Rivoluzione Siamo Noi* portrays Cattelan as a young boy with strangely mature features, dressed in a felt suit, modelled after the costume that Beuys had designed and worn in his performance *Isolation Unit* (1970) and later hung as an iconic work of

with a declaration of impotence: in a world that is clogged with images and other background noises, the margins of action are drastically limited; originality is a myth, or even a lie. Art is bound to play with what is already there in an endless series of permutations, as if reality and its spectacle could only be rearranged, never reinvented.

Indeed, today's art largely relies on a systematic practice of recycling, thriving on the ruins of the present. Bits and pieces of reality – 'crumbs' as Cattelan calls them – are constantly re-assembled and torn apart.[11] Films are cut and pasted; details enlarged; contexts overlapped; ideas stolen; images replicated. Whether one thinks of Douglas Gordon's *24 Hour Psycho* (1993), his slowed-down version of Hictchcock's celebrated film, or of Cattelan's *Hollywood*, in the face of certain icons, contemporary artists feel both excited and helpless: knowing they cannot compete with such highly sophisticated forms of spectacle, their strategy is simply to bask in the light reflected by their aura. This practical

Untitled
2000
Black and white
photograph, digital
print on paper
41.5 x 33 cm

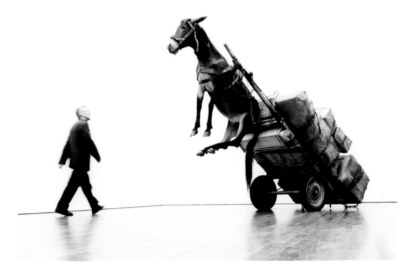

Untitled
2002
Taxidermised donkey,
cart
Life size
Installation, 'Public
Affairs. Von Beuys bis
Zittel: Das
Offentliche in der
Kunst', Kunsthaus
Zurich

the 1970s. Cattelan's dummy is left to dangle from a coat-hanger like an old umbrella, forgotten in a corner after a stormy day.

A gloomy allegory of inaction, Cattelan's *La Rivoluzione Siamo Noi* is the symmetrical inversion of Beuys' original vision. In 1972, in his own *La Rivoluzione Siamo Noi*, Beuys had portrayed himself in his typical guerrilla outfit – felt hat, fishing jacket, jeans, combat boots, and a sack slung over his shoulder. Both partisan and prophet, Beuys proudly marches towards the camera; the words 'We Are The Revolution' are scribbled in Italian at the bottom of the picture. A striking image of dynamism, Beuys' *La Rivoluzione Siamo Noi* possesses the crudeness of a revolutionary poster, the clarity of a Communist manifesto, and the aura of a religious

icon, all contributing to make this photograph one of the best commentaries on the expectations and dreams projected onto avant-garde art in the late 1960s and early 1970s.

Thirty years later, under the same rebellious title, yet now charged with self-deprecating irony, Cattelan portrays himself trapped in a corner, disarmed and paralyzed: a totem of inevitable defeat. There is little room for radical poses, the work seems to suggest, when words such as 'utopia' and 'revolt' are used by artists, car dealers and copywriters alike. Today the avant garde travels first class, and its products are promoted via press releases, commercials and other marketing tools. Revolutionary acts have been neutralized, becoming simply a pleasant intermission in the prime time of our lives. As

far left, **Untitled (pourquoi moi)**
2000
Limestone
200 × 120 cm

left, **Untitled**
2000
121 × 55 × 6 cm
Felt suit, wooden hanger

the legend of the artist as saviour wears thin, Cattelan chooses to abdicate the role of the militant, building himself a nice little pillory to carry out his ritual of self-mortification. All around him, the museum is left completely empty, the white cube stripped bare, in a bad replica of a typical gesture of the 1960s, which has now become the classic decor adopted in boutiques all over the world.

Beuys walked down a paved road, his eyes focused on the future, his mind probably set on his next military campaign; his revolutions were ideological wars that had to be fought by any means necessary. Cattelan meanwhile appears ashamed of his own mediocrity, trying to escape his responsibilities, which seem to have spiralled way out of control. And yet, by calling himself out

and questioning his own role, Cattelan manages to suggest that Beuys himself might have not been entirely sincere. His radicalism begins to look like the result of a carefully arranged cult of personality, accompanied by a few promotional coups; his rebellion seems perfectly functional to the demands of the art world and the real world of his day. Not that Cattelan's case is really any different, but at least from the start he has admitted that he isn't really ready for heroism. Cattelan responds to such a challenge with glacial inanity, turning paralysis into a new kind of activism.

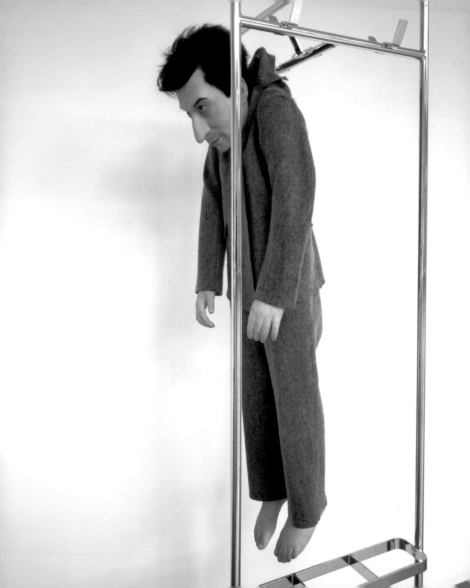

1 For a complete analysis of Maurizio Cattelan's work in the
 context of Italian culture, see Francesco Bonami's text in
 this volume: 'Static on the Line: The Impossible Work of
 Maurizio Cattelan'.

2 See ibid. for an in-depth reading of Cattelan's references to
 conceptual art and particularly Arte Povera. Briefly one
 could say that to the Arte Povera artists, 'poverty' was a
 matter of ideology, while to Cattelan, making a virtue out of
 necessity, it was a matter of survival.

3 See Laura Hoptman, 'Trickster', in *Maurizio Cattelan*,
 Kunsthalle Basel, 1999, n.p.; Giorgio Verzotti, *Maurizio
 Cattelan*, Charta, Milan, 2000. In her interview with the
 artist in this volume, Nancy Spector also touches upon the
 legacy of the *Commedia dell'arte* tradition in Cattelan's
 work.

4 For a reading of the many intricate relationships linking art
 to entertainment in the 1990s, see Philippe Vergne, in *Let's
 Entertain. Life's Guilty Pleasures* (exhibition catalogue),
 Walker Art Center, New York, 2000.

5 Cattelan in an interview with the author: 'Maurizio Cattelan,
 Face Off', *Flash Art*, No. 218, Milan, May–June 2001, p. 117.

6 'I work with images, trying to reflect the schizophrenia of
 reality', ibid.

7 See the interview with Nancy Spector in this volume, p. ?

8 Alison Gingeras, 'A Sociology without Truth', in *Parkett*, No.
 59, Zurich, 2000, p. 53.

9 Quoted in 'Maurizio Cattelan, Face Off', *Flash Art*, No. 218,
 Milan, May–June 2001, p. 117.

10 As the philosopher and literary critic Umberto Eco writes:
 'Another characteristic of the wax museum is that the notion
 of historical reality is absolutely democratized ... Historical
 information is sensationalistic, truth is mixed with legend
 ... The end result is absolutely oneiric.' See Umberto Eco,
 Travels in Hyper-reality (1975), Harcourt Brace, New York,
 1986, pp. 14–16. On these subject see also Tracey Bashkoff,
 Nancy Spector, Norman Bryson, and Thomas Kellein,
 Sugimoto Portraits, Abrams, New York, 2000.

11 As Cattelan explains in his interview with Nancy Spector in
 this volume: 'I'm always borrowing pieces – crumbs really –
 of everyday reality. If you think my work is very provocative,
 it means that reality is extremely provocative.'

12 For a close reading of Beuys's *La Rivoluzione Siamo Noi*, see
 Francesco Bonami, 'Every Artist Can Be a Man. The Silence of
 Beuys is Understandable', in *Parkett*, No. 59, Zurich, 2000,
 pp. 60–65.

La Rivoluzione Siamo Noi
2000
Polyester resin figure,
felt suit, metal coat
rack
Puppet: 124.9 × 32 × 23
cm, wardrobe rack:
188.5 × 47 × 52 cm
Intallation, Migros
Museum für
Gegenwartskunst, Zurich

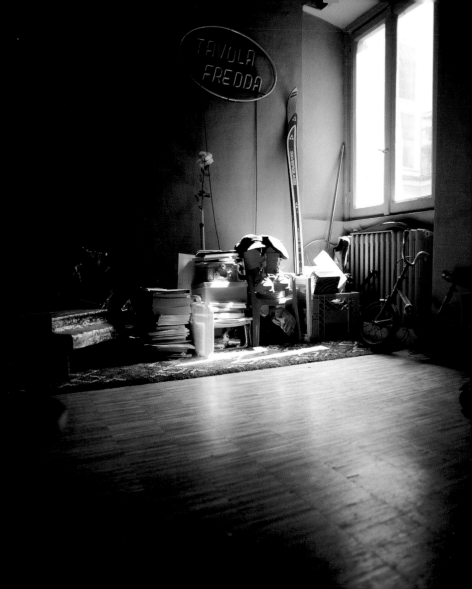

Contents

Interview Nancy Spector in conversation with Maurizio Cattelan, page 6. Survey

Francesco Bonami Static on the Line: The Impossible Work of Maurizio Cattelan, page 38. Focus

Barbara Vanderlinden, Untitled, Manifesta 2, page 90. Artist's Choice Philip Roth

Portnoy's Complaint (extract), 1969, page 100 ... Or Not to Be: A Collection of Suicide Notes (extracts), 1997,

page 106 Artist's Writings Maurizio Cattelan, Face to Face: Interview with Giacinto Di

Pietrantonio (extract), 1988, page 112. Incursions: Interview with Emanuela De Cecco and Roberto Pinto

(extract), 1994, page 116. Statements, 1999, page 124. Interview with Robert Nickas (extract), 1999, page 128.

I Want to Be Famous – Strategies for Successful Living: Interview with Barbara Casavecchia, 1999, page 132.

Blown Away – Blown to Pieces: Conversation with Massimiliano Gioni and Jens Hoffmann, 1999, page 140.

The Wrong Gallery, 2002, page 144. Free For All – Interview with Alma Ruiz, 2002, page 148.

Update Massimiliano Gioni Maurizio Cattelan – Rebel with a Pose, page 158.

Chronology page 192 & Bibliography, List of Illustrations, page 209.

Selected exhibitions and projects 1987–89

1987
'Peep Show',
Palazzo Albertini, Forlì (solo)

'Biennale giovani',
Palazzo delle Esposizioni, Faenza (group)
Cat. *Biennale giovani*, Palazzo delle Esposizioni, Faenza, text C. Cerritelli

'Emergenze',
Galleria Neon, Bologna (group)

'Ambientarte',
Rocca Caterina Sforza, Forlì (group)

'Indagine 87',
Palazzo Re Enzo, Bologna (group)

Artist's book, *Personale*, Palazzo del diavolo edizioni, Forlì

1988
'Natura Codarda',
Galleria Neon, Bologna (solo)
Cat. *Natura Codarda*, Galleria Neon, Bologna, texts A. Ventrone, S. Verdicchio

'Wheeling Project',
Zeuss, Milan (group)

'Aumento di Temperatura',
Galleria Neon, Bologna (group)

1989
'Biologia della Passioni',
Galleria Fuxia, Verona; **Galleria Neon**, Bologna, **Loggetta della Pinacoteca**, Bologna (solo)
Cat. *Biologia della Passioni*, Edizioni Essegi, Ravenna, texts Franco Bolelli, B. Bandini, Stefano Casciani, C. Mantica, Alessandro Mendini

Article, 'Pensieri molesti', *Gran Bazaar*, No. 68, Milan

'Il pianeta sognato',
Varese (group)

'Individual-Media',
Dilmos, Milan (group)

'La mostra non mostra',
Galleria Primo Piano, Milan (group)
Cat. *La mostra non mostra*, Galleria Primo Piano, Milan, text Giulio Ciavolliello
'Oratori di San Sebastiano',
Forlì (group)

Selected articles and interviews 1987–89

1987
Papi, G., 'Peep Show ultimo tango al computer', *L'Unità*, Bologna, 4 April

Marogna, G., 'Trash Design', *Casa Vogue*, Milan, September
Vincenzo, G., 'Sperimentazione d'autore', *Per Lui*, Milan, September

1988
Auregli, Dede, 'Una Natura Codarda', *L'Unità*, Bologna, 30 January
Cavallari, L., 'Nuovo "styling" richiami dadaisti', *Il resto del Carlino*, Bologna, 6 February
Daolio, Roberto, 'Stagione Neon', *Flash Art*, No. 146, Milan
Di Pietrantonio, Giacinto: Cattelan, Maurizio, 'Face to Face: Interview with Giacinto Di Pietrantonio', *Flash Art Italia*, No. 143, Milan, April–May

Goldsmith, M. C., 'Oggetti meccanici', *Modo*, No. 101, Milan

1989
Auregli, Dede, 'Maurizio Cattelan', *L'Unità*, Bologna, 26 May
Coen, Vittoria, 'Maurizio Cattelan', *Flash Art*, No. 151, Milan
Trevisan, G., 'Si affida alle radici', *L'Arena*, Verona, 14 May

Untitled, 1989. T-shirt with logo of the Romagnola Scienziati Co-operative, a fictional name used by the artist to propose projects.

Selected exhibitions and projects 1989–91

Cat. *Oratori di San Sebastiano*, Forlì, text Roberto Daolio

'Metessi',
Galleria Carrieri, Rome (group)
Cat. *Metessi*, Galleria Carrieri, Rome, text Gabriele Perretta

'Paesaggi Interni',
Palazzo del diavolo, Forlì (group)

1990
'Strategie',
Galleria Neon, Bologna; **Studio Oggetto**, Milan; **Leonardi V-Idea**, Geneva (solo)
Cat. *Strategie*, Edizioni Essegi, Ravenna, text Roberto Daolio

'Existenz Maximum',
Instituto degli innocenti, Florence (group)
Cat. *Existenz Maximum*, Instituto degli innocenti, Florence, text Alessandro Mendini

'Design Balneare',
Centro Polivalente, Cattolica (group)
Cat. *Design Balnéare*, Centro Polivalente, Cattolica, text U. La Pietra

'Borderline '90',
Convento di Monteciccardo (group)

'Improvvisazione libera',
Centro per l'Arte Contemporanea Luigi Pecci, Prato (group)

'Take Over',
Galleria Igna Pin, Milan, toured to **Landau Gallery**, Los Angeles; **Gallery**, New York (group)
Cat. *Take Over*, Galerie Inga Pin, Milan, texts Manuela Gandini, Loredana Parmesani

'Ipotesi d'arte giovane',
Fabbrica del Vapore, Milan (group)

1991
Artist's action, *Stand abusivo*,
'Arte Fiera', Bologna

Artist's action, *Rasegna piccoli editori*,
Castello di Belgioioso, Italy

'La mostra si mostra',
Galleria Neon, Bologna (group)

'Loro',
Castello Visconteo, Trezzo (group)
Cat. *Loro*, Castello Visconteo, Trezzo, texts C. C. Canovi, S. Simoni, et al.

'Briefing',
Galleria Luciano Inga Pin, Milan (group)

Untitled (Edizioni dell'Obbligo), 1991, Castello di Belgioioso, Italy

Selected articles and interviews 1989–91

Maggi, L., 'Oggetti transfigurati', *Casa Vogue*, No. 210, Milan

1990
Ciavoliello, Giulio, 'Maurizio Cattelan', *Flash Art Italia*, No. 158, Milan

Daolio, Roberto; Coen, Vittoria, 'I ragazzi della Via Emilia', *Flash Art Italia*, No. 158, Milan
Simoni, S., 'Maurizio Cattelan', *Juliet*, No. 47, Trieste

1991

Romano, Gianni, 'Loro', *Lapiz*, No. 78, Madrid

Stand abusivo, 'Arte Fiera', Bologna, 1991

Selected exhibitions and projects 1991–92

'Anni 90',
Galleria d'Arte Moderna, Bologna
(group)
Cat. *Anni 90*, Galerie d'Arte Moderna,
Bologna, texts Renato Barilli, Roberto
Daolio

'Operazione San Giustino',
Milan (group)

'Via Crucis',
San Marino (group)

'Siamo qui e stiamo facendo',
Comune di Castellafiume, Italy (group)
Cat. *Siamo qui e stiamo facendo*, Comune
di Castellafiume, Italy, texts Gabriele
Perretta, Giacinto Di Pietrantonio

'Medialismo',
Galleria Vitolo, Rome (group)
Cat. *Medialismo*, Galleria Vitolo, Rome,
texts Gabriele Perretta, Paolo Vitolo

1992
Artist's action, *Doppiogioco*,
Serre di Rapolano

Artist's action, *Oblomov Foundation*,
Accademia di Brera, Milan

'Edizioni dell'Obbligo',
Juliet, Trieste (solo)

'Twenty Fragile Pieces',
Galerie Analix – B & L Polla, Geneva
(group)
Cat. *Twenty Fragile Pieces*, Galerie Analix –
B & L Polla, Geneva, text Gianni Romano

'Ottovolante',
**Galleria d'Arte Moderna e
Contemporanea Accademia Carrara**,
Bergamo (group)
Cat. *Ottovolante*, Galleria d'Arte Moderna
e Contemporanea Accademia Carrara,
Bergamo, texts Gregorio Magnani, et.al.

'Una domenica a Rivara',
Castello di Rivara, Rivara, Italy (group)

Selected articles and interviews 1991–92

Fanelli, Franco, 'Neo-Post-Iper', *Il
Giornale dell'Arte*, No. 91, Turin
Grasso, Sebastiano, 'L'arte in cerca di
popolarità sposa il calcio', *Corriere della
sera*, Milan, 18 May
Reschia, C., 'Il calcio balilla fa
spettacolo', *La Stampa*, Turin, 11 May
Romano, Gianni, 'Anni Novaenta', *Lapiz*,
No. 91, Madrid
Soft, C., 'Bologna, un calcio al razzismo',
Italia Oggi, Milan, 26 May
Spadoni, C., 'L'arte fa 2000', *Il resto del
Carlino*, Bologna, 26 May

Cherubini, Laura, 'Medialismo', *Flash Art*,
No. 166, Milan

Casciani, Stefano, *Design in Italia
1950–1990*, Giancarlo Politi Editore,
Milan
Carmagnola, F.; Senaldi, M., 'Arte
organizzazione e complessità', *Flash Art
Italia*, No. 163, Milan
Corgnati, Martina, 'Concettuali in città',
Arte, No. 158, Milan
Pinto, Roberto, 'Maurizio Cattelan:
Everyday Outlaw', *Flash Art*, No. 164,
Milan

1992

Luca, E., 'Tanti messaggi colorati di
simbolica ironia, *Il Piccolo*, Trieste, 11
February, 1993

Stefano Tutolo
Scrivere non è il mio mestiere

Edizioni dell'Obbligo

Ciavolello, Giulio, 'Se avessi cento
bocche', *Juliet*, No. 61, Trieste
Pinto, Roberto, 'Ouvertures', *Flash Art*,

1993
Galleria Massimo De Carlo, Milan (solo)

Galleria Raucci/Santamaria, Naples (solo)

Galleria Massimo De Carlo, Milan (group)

'Cattelan, Hyvrard, Parreno, Wallinger',
Galerie Emmanuel Perrotin, Paris (group)

'Maurizi',
Depot, Bologna (group)

'L'Arca di Noe',
Flash Art Museum, Trevi (group)
Cat. *L'Arca di Noe*, Flash Art Museum,
Trevi, texts G. Graves, P. Nardon, F.
Pietracci

'Hôtel Carlton Palace, Chambre 763',
Hôtel Carlton Palace, Paris (group)
Edition of artists' postcards, *Hôtel Carlton
Palace, Chambre 763*, Oktagon, Cologne,
text Hans Ulrich Obrist

'Documentario',
Spazio Opos, Milan (group)
Cat. *Documentario*, Spazio Opos, Milan,
texts Elio Grazioli, et al.

'Nachtschattengewächse',
Museum Fridericianum, Kassel (group)
Cat. *Nachtschattengewächse*, Museum
Fridericianum, Kassel, text Viet Loers

'Aperto 93',
XLV Venice Biennale (group)
Cat. *XLV Venice Biennale*, Edizioni La
Biennale di Venezia, texts Francesco
Bonami, Roberto Pinto, et al.
Cat. *Aperto 93*, Giancarlo Politi Editore,
Milan, texts Achille Bonito Oliva, Léonie
von Oppenheim, et al.

'Sonsbeek 93', (Project refused)
Arnhem (group)
Cat. *Sonsbeek 93*, Snoeck-Ducaju & Zoon,
Arnhem, texts Maurizio Cattelan, Valérie
Smith, et al.

Tarzan & Jane, 1993, Galleria
Raucci/Santamaria, Naples

No. 166, Milan
Romano, Gianni, 'El juego del Arte',
Lapiz, No. 86, Madrid

1993
Vettese, Angela, 'Ernst', *Il Sole 24 Ore*,
Milan, 28 February

Videtta, G., 'Il posto delle favole? Nella
realtà', *Il Mattino*, Naples, 19 May

De Cecco, Emanuela, 'Maurizio Cattelan',
Flash Art, No. 163, Milan
Giacomotti, F., 'L'Armando Testa va in
Biennale', *Italia Oggi*, Milan, 9 June
Mazzitelli, 'L'arte cerca pubblicità', *La
Repubblica*, Rome, 9 June
Peretta, Gabriele: Pinto, Roberto,
'Medialismi', *Politi*, Milan
Salvioni, Daniela, 'Venezia', *Flash Art*, No.
172, Milan

Buchholz, Daniel; Magnani, Gregorio,
*International Index of Multiples from
Duchamp to the Present*, Spiral-Wacoal Art
Centre, Tokyo; Walter König; Cologne
Corvi Mora, Tommaso, 'In Italy There Is
No Sport as Popular as Football', *Purple
Prose*, No. 3, Paris
Daolio, Roberto, 'Presenze', *Flash Art*, No.
180, Milan
De Cecco, Emanuela, 'Maurizio Cattelan',
Flash Art Quotidiano, Milan, 10–11 July
Gazzola, E., 'Maurizio Cattelan', *Segno*,
Pescara, March
Notte, R., 'Maurizio Cattelan', *Roma*,
Rome, 6 May

Selected exhibitions and projects 1993–94

1994
Laure Genillard Gallery, London (solo)

Galerie Analix – B & L Polla, Geneva (solo)

Galerie Daniel Buchholz, Cologne (solo)

Daniel Newburg Gallery, New York (solo)

'Incertaine Identité',
Galerie Analix – B & L Polla, Geneva (group)
Cat. *Incertaine Identité*, Galerie Analix – B & L Polla, Geneva; Georg Editeur, Geneva, texts Maurizio Cattelan, Barbara Polla, Gianni Romano, et al.

'Rien à signaler',
Galerie Analix – B & L Polla, Geneva (group)
Cat. *Rien à signaler*, Galerie Analix – B & L Polla, Geneva, texts Gianni Romano, et al.

'Soggetto, Soggetto: Una nuova relazione nell'arte oggi',
Castello di Rivoli, Museo d'Arte Contemporanea, Turin (group)
Cat. *Soggetto, Soggetto: Una nuova relazione nell'arte oggi*, Castello di Rivoli, Museo d'Arte Contemporanea, Turin, texts Francesca Pasini, Antonella Russo, Giorgio Verzotti

'Prima Linea',
Flash Art Museum, Trevi (group)
Cat. *Prima Linea*, Flash Art Museum, Trevi, texts Francesco Bonami, Giacinto Di Pietrantonio, Gianni Romano

'L'Hiver de l'Amour',
ARC, Musée d'Art Moderne de la Ville de Paris, toured to **P.S.1**, Long Island City,

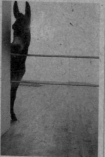

Warning! Enter at your own risk. Do not touch, do not feed, no smoking, no photographs, no dogs, thank you, 1994, Daniel Newburg Gallery, New York

Selected articles and interviews 1993–94

Perretta, Gabriele, 'Maurizio Cattelan', *Flash Art*, No. 163, Milan
Romano, Gianni, 'Cattelan', *Zoom*, No. 124, Italy

1994
Arachi, A., 'L'opera d'arte? Una tonnellata di macerie', *Corriere della sera*, Milan, 3 February
De-Cecco, Emanuela; Pinto, Roberto, 'Incursioni', *Flash Art Italia*, No. 182, Milan
Di Pietrantonio, Giacinto, 'Uno spostamento reale', *Flash Art*, No. 182, Milan
Gandini, Manuela, 'Ma dov'è l'artista? Sta rovistando nella discarica', *Il Giorno*, Milan, 5 February
Grant, Simon, 'Maurizio Cattelan', *Art Monthly*, No. 174, London, March
Jeffett, William, 'Maurizio Cattelan', *Artefactum*, No. 52, Antwerp
Pasini, Francesca, 'Ecco gli italiani che incantano Parigi', *Il Secolo XIX*, Genova, 12 March
Lillington, David, 'Maurizio Cattelan', *Time Out*, London, March
Tadini, Emilio, 'Poveri anarchici', *Corriere della sera*, Milan, 3 February
Vettese, Angela, 'Le macerie del PAC, metafora interiore', *Il Sole 24 Ore*, Milan, 13 February

Bonami, Francesco, 'Maurizio Cattelan', *Flash Art*, No. 178, Milan

Selected exhibitions and projects 1994–95

New York (group)
Cat. *L'Hiver de l'Amour*, ARC, Musée d'Art Moderne de la Ville de Paris, texts Francesco Bonami, et al.

'Sound',
Galerie Emmanuel Perrotin, Paris (group)

'Domestic Violence',
Giò Marconi, Milan (group)

1995
Artist's action, *Choose Your Destination: How to Get a Museum-paid Vacation*,
USF Contemporary Art Museum, Tampa

'Errotin, le vrai lapin',
Galerie Emmanuel Perrotin, Paris (solo)

'Photomontage',
Le Consortium, Dijon (group)

'Das Spiel in der Kunst',
Neue Galerie, Graz; **Ar/ge Kunst**, Bozen (group)
Cat. *Das Spiel in der Kunst*, Neue Galerie, Graz; Ar/ge Kunst, Bozen, texts C. Bertola, P. A. Rovatti, Angela Vettese

'Kwangju Biennale',
Kwangju, South Korea (group)
Cat. *Kwangju Biennale*, Kwangju Biennale Press, texts Francesco Bonami, et al.

'Caravanserraglio',
Ex-Aurum, Pescara (group)
Cat. *Caravanserraglio*, Ex-Aurum, Pescara, texts Giacinto Di Pietrantonio

'Le labyrinthe moral',
Le Consortium, Dijon (group)

'La Collezione',
Castello di Rivoli, Museo d'Arte Contemporanea, Turin (group)
Cat. *La Collezione*, Castello di Rivoli, Museo d'Arte Contemporanea, Turin, text Giorgio Verzotti

Comic Strip (with Umberto Manfrin), 1995

Selected articles and interviews 1994–95

Myerson, Clifford, 'Cattelan', *Untitled*, No. 5, London
Verzotti, Giorgio, 'Once More with Intellect: Italy's New Idea Art', *Artforum*, No. 9, New York

1995

Hahn, Clarisse, 'Maurizio Cattelan', *Art Press*, No. 201, Paris, April
Rian, Jeff, 'Maurizio Cattelan', *frieze*, No. 23, London
Santacatterina, Stella, 'Strategies towards the Remaking of the Artistic Self', *Third Text*, No. 37, London, Winter, 1996

Titz, Walter, 'Im Kunst und Spielsalon', *Kleine Zeitung*, No. 9, Graz

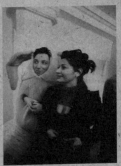

Errotin, le vrai lapin, 1995, Galerie Emmanuel Perrotin, Paris, *l. to r.*, Emmanuel Perrotin, Sylvie Fleury

Bonami, Francesco, 'El desierto de los Italianos', *Atlantica*, No. 10, Gran Canaria
Bourriaud, Nicolas, 'Pour une esthétique relationnelle', *Documents*, No. 7, Paris
Holler, V. C., 'Kanone auf Seide', *Die Furche*, No. 39, Vienna
Troncy, Eric, 'The Wonder-Bra(in)? Are We Really Destined For Stupidity?', *Flash Art*, No. 183, Milan
Zahm, Olivier, 'Openings: Maurizio Cattelan', *Artforum*, No. 10, New York, Summer

Selected exhibitions and projects 1996

1996
First publishes and edits *Permanent Food*. Issues 1–3 co-edited with Dominique Gonzalez-Foerster, thereafter co-edited by Paola Manfrin

Galleria Massimo De Carlo, Milan (solo)

Ars Futura, Zurich (solo)

Laure Genillard Gallery, London (solo)

'Triple Axel',
Le Gymnase, Roubaix, France (group)

'Fool's Rain',
Institute of Contemporary Arts, London (group)

'Joep Van Lieshout, Jouke Kleerebezem and Paul Perry, Maurizio Cattelan',
Le Magasin, Centre National d'Art Contemporain, Grenoble (group)

'Beige',
Saga Basement, Copenhagen (group)
Cat. *Beige*, Saga Basement, Copenhagen, texts Elein Fleiss, Olivier Zham

'Alfabetizzazione',
Castel S. Pietro, Italy (group)
Cat. *Alfabetizzazione*, Castel S. Pietro, Italy, text Roberto Daolio

'A/drift; Scenes from the Penetrable Culture',
Center for Curatorial Studies, Bard College, Annandale-on-Hudson, New York (group)
Cat. *A/drift; Scenes from the Penetrable Culture*, Center for Curatorial Studies, Bard College, Annandale-on-Hudson, New York, texts Joshua Decter, et al.

'Campo 6: il villaggio a spirale',
Galleria Civica d'Arte Moderna e Contemporanea, Turin, toured to
Bonnefanten Museum, Maastricht (group)
Cat. *Campo 6: il villaggio a spirale*, Galleria Civica d'Arte Moderna e Contemporanea, Turin, texts Francesco Bonami, E. Dissanayake, Vittorio Gregotti

'Ultime Generazioni',
Palazzo delle Esposizioni - Ala Mazzoniana della Stazione Termini, Rome (group)
Cat. *Ultime Generazioni*, Quadriennale d'Arte di Roma, Rome, texts Angela Vettese, et al.

'Interpol',
Fargfabriken, Stockholm (group)
Cat. *Interpol*, Fargfabriken, Stockholm, text J. Aman

'Fast nichts/Almost invisible',
Ehemaliges Umspannwerk, Singen, Germany (group)

background, **Working is a Bad Job**, 1996, Le Magasin, Centre National d'Art Contemporain, Grenoble

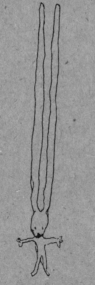

Drawing for **Untitled**, 1996, installed, 'Beige', Saga Basement, Copenhagen

Selected articles and interviews 1996

1996

Budney, Jen, 'Maurizio Cattelan', *Flash Art*, No. 189, Milan
Verzotti, Giorgio, 'Cattelan', *art+text*, No. 54, Sydney

Guha, Tania, 'Maurizio Cattelan', *Time Out*, No. 1334, London

laure genillard
gallery

38a foley st
london W1P 7LB
tel 0171 436 2300
fax 01442 832530

7.2 – 16.3.96
tues – fri 11–6 pm
sat 11–5 pm

maurizio cattelan

private view tues 6 feb 6–8 pm

Pesch, Martin, 'Fast nichts/Almost invisible', *frieze*, No. 32, London, 1997

Selected exhibitions and projects 1996–97

'L'art au corps',
Musée d'Art Contemporain, Marseille
(group)
Cat. *L'art au corps*, Musées de Marseille,
texts Catherine Millet, François Pluchard

'Crap Shoot',
De Appel, Amsterdam (group)
Cat. *Crap Shoot*, De Appel, Amsterdam,
text Nina Folkersma

'Collections du Castello di Rivoli, FRAC
Rhône Alpes et Le Nouveau',
Musée de Villerbannes, Villerbannes,
France (group)

'Carte Italiano',
Centro d'Arte, Athens (group)
Cat. *Carte Italiano*, Centro d'Arte, Athens,
texts Gianni Romano

'Cabines de bain',
Piscine de la Motta, Freiburg,
Switzerland (group)

'Traffic',
capc Musée d'art Contemporain,
Bordeaux (group)
Cat. *Traffic*, capc Musée d'art
Contemporain, Bordeaux, texts Nicolas
Bourriaud, Jean-Louis Froment

'Once Removed',
Laure Genillard Gallery, London (group)

'Departure Lounge',
Clocktower Gallery, New York (group)

'Immagini Italiane',
Italienische Kunstinstitut, Dusseldorf
(group)

ABSOLUT CATTELAN.

Advertisement for Absolut Vodka, 1997

1997
Espace Jules Verne, Brétigny-sur-Orge,
France (solo)

Castello di Rivoli, Museo d'Arte
Contemporanea, Turin (solo)
Cat. *Maurizio Cattelan*, Castello di Rivoli,
Museo d'Arte Contemporanea, Turin;
Charta, Milan, text Giorgio Verzotti

Le Consortium, Dijon (solo)

Maurizio Cattelan
13 DICEMBRE 1997 - 21 FEBBRAIO 1998

Selected articles and interviews 1996–97

Winkelmann, Jan, 'Crap Shoot',
Metropolis M, No. 3; Utrecht, June

Flash Art

Budney, Jen, 'Quasi per gioco', *Flash Art*,
No. 159, Milan
Martaix, Ingrid, 'Dossier', *Documents sur
l'art*, Dijon, Winter
Di Costa, G., 'Maurizio Cattelan', *Flash
Art*, No. 198, Milan
Rian, Jeff, 'Maurizio Cattelan ... Went
Home', *Flash Art*, No. 190, Milan, October
Van Houts, Catherine, 'Inbreken en
schaduwen bij wijze van kunst', *Het
Parool*, Amsterdam, 11 April
Vettese, Angela, 'Art in Milan', *Parkett*,
No. 46, Zurich
Vettese, Angela, 'I tragici giochi del triste
cattelan', *Il Sole 24 Ore*, Milan, 25
February
Zahm, Olivier, 'World Tour', *Purple Prose*,
No. 11, Paris

1997

Meneguzzo, Marco, 'Maurizio Cattelan',
Artforum, New York, February, 1998

Gauville, Hervé, 'Cattelan fait son trou à
Dijon', *Libération*, Paris, 13 February
Janus, Elizabeth, 'Maurizio Cattelan',
frieze, No.34, London, May

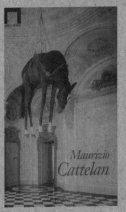

Maurizio
Cattelan

Selected exhibitions and projects 1997

'Dynamo Secession',
Wiener Secession, Vienna (solo)
Cat. *Maurizio Cattelan*, Wiener Secession, Vienna, text Francesco Bonami

'Moi-même, soi-même',
Galerie Emmanuel Perrotin, Paris (solo)

'Kartographi',
Muzej Suvremene Umjetosti Umjetnicki Paviljon, Zagreb (group)

'Future Present Past',
XLVII Venice Biennale (group)
Cat. *Future Present Past: XLVII Venice Biennale*, Electa, Milan, texts Germano Celant, et al.
Cat. *Dall'Italia*, Electa, Milan, text Germano Celant

Galleria Massimo Minini, Brescia (solo)

'Delta',
ARC Musée d'Art Moderne de la Ville de Paris (group)
Cat. *Delta*, ARC Musée d'Art Moderne de la Ville de Paris, text Francesco Bonami

'Transit',
École nationale supérieure des beaux-arts, Paris (group)
Cat. *Transit*, École nationale supérieure des beaux-arts, Paris, text Jean-François de Canchy

'On Life, Beauty, Translations and Other Difficulties',
5th Istanbul International Biennial (group)
Cat. *5th Istanbul International Biennial: On Life, Beauty, Translations and Other Difficulties*, Istanbul Foundation for Culture and Arts, texts Rosa Martinez, et al.

'Connecion implicite',
École nationale supérieure des beaux-arts, Paris (group)
Cat. *Connecion implicite*, École nationale supérieure des beaux-arts, Paris, text Jean Delaise

'Skulptur Projeckts in Münster',
Münster (group)
Cat. *Sculpture Projects in Münster*, Verlag Gerd Hatje, Ostfildern-Ruit, Germany, texts Francesco Bonami, Daniel Buren, Klaus Bussman, Walter Grasskamp, Kasper König, Florian Matzner

'Odisseo',
Studio della Vittoria, Bari, Italy (group)
Cat. *Odisseo*, Bari, Italy, text Giacinto Di Pietrantonio

'A Summer Show',
Marian Goodman Gallery, New York (group)

'Fatto in Italia',
Centre d'Art Contemporain de Genève, Geneva; **Institute of Contemporary Arts**, London (group)
Cat. *Fatto in Italia*, Centre d'Art

SCULPTURE. PROJECTS IN MÜNSTER 1997

Selected articles and interviews 1997

Huck, B., 'Plötzlich diese Übersicht', *Der Standard*, Vienna, 31 January
Hofleitner, Johanna, 'Der Körper – nackt, bekleidet, verkleidet', *Die Presse*, Vienna, 3 February

Gale, David, 'Maurizio Cattelan', *Daily Telegraph*, London, 22 November
Verzotti, Giorgio, 'Made in Italy', *Artforum*, New York, February, 1998

Untitled, 1997, 'Fatto in Italia', exterior of the Institute of Contemporary Arts, London

Selected exhibitions and projects 1997–98

Contemporain de Genève, Geneva;
Institute of Contemporary Arts, London;
Electa, Milan, texts Paolo Colombo,
Francesco Bonami, Elizabeth Janus, Pappi
Corsicato, Nadia Fusini, Carolyn Christov-
Bakargiev

'Moment Ginza',
**Le Magasin, Centre d'Art Contemporain
de Grenoble**, France; **Fargfabriken**,
Stockholm (group)

'Truce: Echoes of Art in an Age of Endless
Conclusions',
SITE Santa Fe, New Mexico (group)
Cat. *Truce: Echoes of Art in an Age of
Endless Conclusions*, SITE Santa Fe, New
Mexico, texts Francesco Bonami, Collier
Schorr, et al.

'Trash',
Palazzo delle Albere, Trento (group)

'504',
Zentrum für Kunst und Design,
Braumschweig (group)

'Art Calls',
Copenhagen (group)
'Light Show',
Galleria Massimo De Carlo, Milan (group)

'Treffpunkt niemandsland',
Brennero, Italy (group)

1998
Book, *Maurizio Cattelan*, Centre d'art de
Brétigny-sur-Orge; Le Consortium, Dijon;
Galerie Emmanuel Perrotin, Paris

Institute of Visual Arts, University of
Wisconsin, Milwaukee (solo)

'C',
Elizabeth Cherry Contemporary Art,
Tucson, Arizona (group)

'Projects 65: Maurizio Cattelan',
The Museum of Modern Art, New York
(solo)
Cat. *Projects 65: Maurizio Cattelan*, The
Museum of Modern Art, New York, text
Laura Hoptman

Ten Part Story, 1998, artist's project
for 'C', Elizabeth Cherry Contemporary
Art, Tucson, Arizona

Selected articles and interviews 1997–98

MacNeil, W. A., 'Even SITE Visited with
O'Keeffe Mania', *Albuquerque Journal*,
Albuquerque, 17 July
Walker, H., 'Truce Doesn't Hold Its Fire',
Albuquerque Journal, Albuquerque, 17
July

Budney, Jen; Schwarzér, Uwe, 'Cityscape
Milan', *Flash Art*, No. 194, Milan,
May–June
Daolio, Roberto, 'Maurizio Cattelan',
Artel, Bologna, June
Obrist, Hans Ulrich; Tortosa, Guy; et al.,
Unbuilt Roads: 107 Unrealized Projects,
Cantz Verlag, Ostfildern
Perreau, David, 'Maurizio Cattelan: Travail
de sape', *Ommibus*, No. 22, Paris
Pinto, Roberto, 'Maurizio Cattelan,
l'architettura del pensiero', *Linea
d'Ombra*, No. 126, Milan, June
Posca, C.; König, Kasper, 'Was Sie Schon
Immer Wissen Wollten', *Kunst und der
öffentliche Raum*, No. 2, Münster
Stafford, A., 'Maurizio Cattelan: Tricks are
for Kids', *Surface*, Los Angeles, Spring
Vidali, Roberto, 'Maurizio Cattelan',
Juliet, No. 83, Trieste

1998

Leguillon, Pierre, 'Maurizio Cattelan:
Museum of Modern Art', *Art Press*, No.
243, Paris

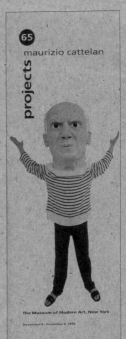

65
maurizio cattelan

projects

The Museum of Modern Art, New York

November 5 – December 8, 1998

Selected exhibitions and projects **1998–99**

'Artificial',
Museu d'Art Contemporani, Barcelona
(group)

'Unfinished History',
Walker Art Center, Minneapolis (group)
Cat. *Unfinished History*, Walker Art Center,
Minneapolis, text Francesco Bonami

'Wounds: Between Democracy and
Redemption in Contemporary Art',
Moderna Museet, Stockholm (group)
Cat. *Wounds: Between Democracy and
Redemption in Contemporary Art*, Moderna
Museet, Stockholm, texts David Elliot,
Pier Luigi Tazzi, et al.

'100 Jahre Secession – Das Jahrhundert
der künstlerischen Freiheit',
Wiener Secession, Vienna (group)
Cat. *100 Jahre Secession – Das
Jahrhundert der künstlerischen Freiheit*,
Prestel, New York; Munich, texts Robert
Fleck, et al.

'Ironic',
Museum für Gegenwartskunst, Zurich
(group)
Cat. *Ironic*, Museum für Gegenwartskunst,
Zurich, texts Jeff Rian

'Cet été là ... ',
**Centre Régional d'Art contemporain
Languedoc-Roussillon**, Sète, France
(group)
Cat. *Cet été là ...*, Centre Régional d'Art
contemporain Languedoc-Roussillon,
Sète, France, texts Noëlle Tissier, Bernard
Marcadé

'Manifesta 2: European Biennial of
Contemporary Art',
Casino de Luxemburg, Luxemburg
(group)
Cat. *Manifesta 2: European Biennial of
Contemporary Art*, Agence
Luxembourgeoise d'Action Culturelle
Luxemburg; Idea Books, Amsterdam,
texts Emanuela De Cecco, Robert Fleck,
Barbara Vanderlinden, et al.

'Weather Everything',
Leipzig (group)
Cat. *Weather Everything*, Cantz Verlag,
Ostfildern, 1999, texts Eric Troncy, Klaus
Werner, Jan Winkelmann

1999
Anthony d'Offay Gallery, London (solo)

'Let's Get Lost', (Project refused)
St. Martin's College of Art, London
(group)

'La Ville, le Jardin, la Mémoire',
Académie de France à Rome, Villa

MAURIZIO CATTELAN

30 APRIL TO 19 JUNE
PRIVATE VIEW 29 APRIL 6.30PM

ANTHONY D'OFFAY GALLERY · 9 DERING STREET · LONDON W1

Selected articles and interviews **1998–99**

Bonami, Francesco, 'Maurizio Cattelan',
cream: contemporary art in culture,
Phaidon Press, London
Perreau, David, 'Maurizio Cattelan: The
Village Idiot', *Art Press*, No. 233, Paris,
March

1999
Martin Coomer, 'Maurizio Cattelan', *Time
Out*, London, 9–16 June

Storr, Robert, 'Art Carnies', *Artforum*, New
York, September

Selected exhibitions and projects **1999**

Médici, Rome (group)

'dAPERTOtutto',
XLVII Venice Biennale (group)
Cat. *XLVII Venice Biennale*, Edizioni La
Biennale di Venezia, texts Agnes
Kohlmeyer, Harald Szeemann, et al.

Kunsthalle, Basel (solo)
Cat. *Maurizio Cattelan*, Kunsthalle, Basel,
texts Laura Hoptman, Madeleine Schuppli

'La casa, il corpo, il cuore',
**Museum Moderner Kunst Stiftung
Ludwig**, Vienna (group)

'Signs of Life',
Melbourne International Biennial,
Australia (group)
Cat. *Melbourne International Biennial*,
Melbourne International Biennial, texts
Juliana Engberg, et al.

'Abracadabra: International
Contemporary Art',
Tate Gallery, London (group)
Cat. *Abracadabra: International
Contemporary Art*, Tate Gallery, London,
texts Catherine Grenier, et al.

'Blown Away',
6th Carribean Biennal,
organized by Maurizio Cattelan and Jens
Hoffmann
Golden Lemon, British West Indies, St.
Kitt (group)
Cat. *Blown Away*, Le Consortium, Dijon

'Let's Get Together',
Kunsthalle, Vienna (group)

'Zeitwenden',
Kunstmuseum, Bonn (group)

Selected articles and interviews **1999**

Withers, Rachel, 'Body Count', *Artforum*,
New York, September

Imhof, Dora, 'Stein fiel vom Himmel –
direkt auf den Papst',
Basellandschaftliche Zeitung, Liestal, 21
October
Imhof, Dora, 'Der Stein der Anstosses',
Der Bund, Bern, 26 October
Lichtenhahn, Stephan, 'Italiener bringt
den Papst zu Fall', *Blick*-Zurich, 16
October
Mack, Gerhard, 'Ein Künstler legt den
Papst flach', *Cash*, Zurich, 29 October
Maurer, Simone, 'Der Papst bestaunt
seinen Sturzflug', *Tages ~ Anzeiger*,
Zurich, 27 October
Suter, Raphael, 'Wie der Papst in die
Kunsthalle kam', *Basel-Stadt*, Basel, 15
October
Th.Degen-Müller, Severino, 'Unhaltbar',
Basellandschaftliche Zeitung, Liestal, 27
October
Vogel, Maria, 'Von einem Himmelsstein
getroffen', *Neue Luzerner Zeitung*, Luzern,
5 November

Gioni, Massimiliano, 'The Beach: Utopia
2000', *Flash Art*, Milan, Summer, 2000

Casavecchia, Barbara, 'I Want to Be
Famous – Strategies for Successful
Living', *Flash Art*, Milan, April–May
Cattelan, Maurizio, 'Admit you have a
desire to be famous: An exclusive
interview with Maurizio Cattelan', *Art-
Land*, Vol. 5, No. 1, April
Cattelan, Maurizio; Hoffman, Jens;
Massimiliano, Gioni, 'Blown Away – Blown

Selected exhibitions and projects **1999–2000**

THE HUGO BOSS PRIZE 2000

2000
Nominated for Hugo Boss Prize 2000, New York

'Forum',
Musée National d'Art Moderne, Centre Georges Pompidou, Paris (solo)

Marian Goodman Gallery, New York (solo)

Museum für Gegenwartkunst, Zurich (solo)

'Maurizio Cattelan 00.2'
ArtPace, San Antonio (solo)

Migros Museum für Gegenwartskunst, Zurich (solo)

'Over the Edge',
Ghent, Belgium (group)

'Sharing Exoticisms',
Lyon Biennial (group)

Centre for Contemporary Art,
Kitakyushu, Japan (solo)

'Let's Entertain',
Walker Art Center, Minneapolis, toured as 'Son et Lumière: l'âge des divertissements' to **Musée National d'Art Moderne**, Centre Georges Pompidou, Paris (group)
Cat. *Let's Entertain*, Walker Art Center, Minneapolis, texts Philippe Vergne

'Apocalypse: Beauty and Horror in Contemporary Art',
Royal Academy, London (group)
Cat. *Apocalypse: Beauty and Horror in Contemporary Art*, Royal Academy, London, texts Norman Rosenthal, Michael Archer, et al.

'Presumed Innocent',
CAPC Musée d'Art Contemporain,
Bordeaux (group)
Cat. *Presumed Innocent*, CAPC Musée d'Art

MAURIZIO CATTELAN

FEBRUARY 24 – MARCH 25, 2000

MARIAN GOODMAN GALLERY

MAURIZIO CATTELAN

17 JUNI BIS 13 AUGUST 2000
ERÖFFNUNG FREITAG, 16 JUNI, 19.00 UHR

MUSEUM FÜR GEGENWARTSKUNST
UNIVERSITÄTSSTR 270, ZURICH, HANSADSTRICH MUSIK
DI–FR 17.00 – 19.00 UHR, SA–SO 11.00 – 17.00 UHR

info@museum.ch

Selected articles and interviews **1999–2000**

to Pieces', *Material*, No. 2, Migros Museum, Zurich, November
Leguillon, Pierre, 'Maurizio Cattelan', *Art Press*, No. 243, Paris, January
Nickas, Bob, 'Maurizio Cattelan with Bob Nickas', *index*, New York, September–October
Pinchbeck, Daniel, 'Interview with Maurizio Cattelan', *Art Newspaper*, Vol. 10, No. 88, London, January
Verzotti, Giorgio, 'Maurizio Cattelan', *Flash Art Italia*, Milan, April–May

2000

Smith, Roberta, *New York Times*, 17 March

Vogel, Matthias, 'Maurizio Cattelan im Migros-Museum', *Neue Burder Zeitung*, Zurich, 16 July

Joo, Eungie, 'Let's Entertain: Walker Art Center', *Art Press*, Paris, May

Alberge, Dalya, 'Academy to Stage a Modern Apocalypse', *The Times*, London, 3 May
Buck, Louisa, 'Apocalypse Now: A Global Sensation?', *Art Newspaper*, London, September
Buck, Louisa, 'Two Draughtsmen of the Apocalypse', *The Independent*, London, 13 September
Downer, Leslie 'Artists see Visions of "Apocalypse" Now', *Wall Street Journal*, New York, 3 October
Gibbons, Flachra, 'Sensation's over, now it's Apocalypse', *The Guardian*, London, 3 May
Wilson, Michael, 'Apocalypse', *Art Monthly*, London, November

[Maurizio Cattelan 00.2]

[ArtPace]

Selected exhibitions and projects 2000–01

Contemporain, Bordeaux, texts Stéphanie Moisdon, et al.

'Herausforderung Tier – von Beuys bis Kabakov',
Städtische Galerie, Karlsruhe, Germany (group)

'Age of Influence: Reflections in the Mirror of American Culture',
Museum of Contemporary Art, Chicago (group)

'The arsFutura Show',
arsFutura Galerie, Zurich (group)

'home is where the heArt is',
Museum van Loon, Amsterdam (group)

2001
'Hollywood',
Special Project for the 49th Venice Biennale (solo)
with the patronage of the City of Palermo, Sicily and the support of AMIA

'Felix',
Museum of Contemporary Art, Chicago (solo)

Fargfabriken, Stockholm (solo)

Museum Boijmans Van Beuningen, Rotterdam, The Netherlands (solo)

Selected articles and interviews 2000–01

Bonami, Francesco, 'Every Artist can be a Man, The silence of Beuys is understandable', *Parkett*, No. 59, Zurich
Bourriaud, Nicolas, 'A Grammar of visual delinquency', *Parkett*, No. 59, Zurich
Gingeras, Alison M., 'A Sociology without truth', *Parkett*, No. 59, Zurich
Gioni, Massimiliano, 'Maurizio Cattelan', *Flash Art*, Milan, January–February
Jackson, Tina, 'Snap Shot, Get Stuffed', *The Big Issue*, London, 17 April
Liu, Jenny, 'Trouble in Paradise', *frieze*, London, March–April
Lyttleton, Celia, 'Maurizio Cattelan: Art Terrorist or Merry Prankster', *Very* 6 March
Shave, Stuart 'The Artful Dodger', *I-D*, London, March

2001
Bellet, Harry, 'Maurizio Cattelan ecrit "Hollywood" dans une decharge de Sicile', *Le Monde*, Paris, 12 June
Bruschi, Valentina, 'Oggi l'arte sembra nata a Hollywood', *Il Messaggero*, 5 June
'Maurizio Cattelan: Hollywood, 2001', *Artforum*, New York, September
Russi Kirshner, Judith, 'Palermo Hollywood', *New Art Examiner*, Chicago, September–October

Casadio, Mariuccia, 'The Making of Cattelan's Tyrannosaurus "Felix"', *Vogue Italia*, October

Fanelli, Franco, 'Un bambino di nome Adolf', *Vernissage*, October
Gioni, Massimiliano, 'Maurizio Cattelan, "Him"', *Flash Art*, Milan, May–June
Lindwall, Johan T., 'Kompisarna säger att jag kan få "klipparm"', *Expressen*, 25 October
Orengo, Nico, 'Cattelan: Ho messo Hitler in ginocchio', *La Stampa*, 7 October
Vastano, Stefano, 'Quel nulla chiamato Hitler', *L'Espresso*, 25 October

Selected exhibitions and projects **2001–03**

'Dévoiler, Vivent les Frac (suite)',
Institut d'art contemporain,
Villeurbanne, France (group)

'Places in the Mind: Modern Photographs from the Collection',
Metropolitan Museum of Art, New York (group)

'Abbild: Recent Portraiture and Depiction',
Steirischerbst, Graz (group)

2002
Marian Goodman Gallery, New York
(solo)

'Charley',
P.S. 1 Contemporary Art Center, Long Island City, New York (solo)

'Public Affairs',
Kunsthaus, Zurich (group)
Cat. *Public Affairs*, Kunsthaus, Zurich

'TeleVisions: Kunst Sieht Fern',
Kunsthalle, Vienna (group)

'From the Observatory',
Paula Cooper Gallery, New York (group)

'L'art d'aujourd'hui',
Musée de Grenoble (group)

'Wallflowers',
Kunsthaus, Zurich (group)

'Hello, My Name Is … ',
Carnegie Museum of Art, Pittsburgh, Pennsylvania (group)

2003
Museum Ludwig, Cologne (solo)

Museum of Contemporary Art, Los Angeles (solo)

50th Venice Biennale (group)

Deste Foundation for Contemporary Art, Athens, Greece (solo)

Lyon Biennial (group)

Selected articles and interviews **2001–03**

Gioni, Massimiliano, 'Maurizio Cattelan, Giu la mashera', *Flash Art*, Milan, April
Scherr, Apollinaire, 'The Fallen Pope Provokes a Sensation in Poland', *New York Times*, 13 May

2002
Levin, Kim, 'Maurizio Cattelan at Marian Goodman Gallery', *Village Voice*, June
Vogel, Carol, 'Don't Get Angry. He's Kidding. Seriously,', *New York Times*, 13 May

Smith, Roberta, 'From the Observatory', *New York Times*, April

Obrist, Hans Ulrich, 'Interview with Maurizio Cattelan', *Features*, May
Schwerfel, Heinz-Peter, 'Maurizio Cattelan: Kunst unter Schock', *Art*, Hamburg, March

2003

Lageira Jacinto, 'Absurdity For All, Belonging to Nobody, Maurizio Cattelan', *Parachute*, No. 109, January

Alberge, Dalya, 'Academy to Stage a Modern Apocalypse', *The Times,* London, 3 May, 2000

Arachi, A., 'L'opera d'arte? Una tonnellata di macerie', *Corriere della sera,* Milan, 3 February, 1994

Auregli, Dede, 'Una Natura Codarda', *L'Unità,* Bologna, 30 January, 1988

Auregli, Dede, 'Maurizio Cattelan', *L'Unità,* Bologna, 26 May, 1989

Bandini, B., *Biologia della Passioni,* Edizioni Essegi, Ravenna, 1989

Barilli, Renato, *Anni 90,* Galerie d'Arte Moderna, Bologna, 1991

Bellet, Harry, 'Maurizio Cattelan ecrit "Hollywood" dans une decharge de Sicile', *Le Monde,* Paris, 12 June, 2001

Bertola, C., *Das Spiel in der Kunst, Neue Galerie,* Graz; Ar/ge Kunst, Bozen, 1995

Bolelli, Franco, *Biologia della Passioni,* Edizioni Essegi, Ravenna, 1989

Bonami, Francesco, *XLV Venice Biennale,* Edizioni La Biennale di Venezia, 1993

Bonami, Francesco, *L'Hiver de l'Amour,* ARC, Musée d'Art Moderne de la Ville de Paris, 1994

Bonami, Francesco, *Prima Linea,* Flash Art Museum, Trevi, 1994

Bonami, Francesco, 'Maurizio Cattelan', *Flash Art,* No. 178, Milan, 1994

Bonami, Francesco, 'El desierto de los Italianos', *Atlantica,* No. 10, Gran Canaria, 1995

Bonami, Francesco, *Kwangju Biennale,* Kwangju Biennale Press, 1995

Bonami, Francesco, *Campo 6: il villaggio a spirale,* Galleria Civica d'Arte Moderna e Contemporanea, Turin, 1996

Bonami, Francesco, 'Simplicius Simplicissimus, Impossible', *Sculpture Projects in Münster,* 1997

Verlag Gerd Hatje, Ostfildern-Ruit, Germany, 1997

Bonami, Francesco, *Delta,* ARC Musée d'Art Moderne de la Ville de Paris, 1997

Bonami, Francesco, *Fatto in Italia,* Centre d'Art Contemporain de Genève, Geneva; Institute of Contemporary Arts, London; Electa, Milan, 1997

Bonami, Francesco, *Maurizio Cattelan,* Wiener Secession, Vienna, 1997

Bonami, Francesco, *Truce: Echoes of Art in an Age of Endless Conclusions,* SITE Santa Fe, New Mexico, 1997

Bonami, Francesco, *Unfinished History,* Walker Art Center, Minneapolis, 1998

Bonami, Francesco, 'Maurizio Cattelan', *cream: contemporary art in culture,* Phaidon Press, London, 1998

Bonami, Francesco, 'Every Artist can be a Man, The silence of Beuys is understandable', *Pärkett,* No. 59, Zurich, 2000

Bourriaud, Nicolas, 'Pour une esthétique relationnelle', *Documents,* No. 7, Paris, 1995

Bourriaud, Nicolas, *Traffic,* capc Musée d'art Contemporain, Bordeaux, 1996

Bourriaud, Nicolas, 'A Grammar of visual delinquency', *Parkett,* No. 59, Zurich, 2000

Bruschi, Valentina, 'Oggi l'arte sembra nata a Hollywood', *Il Messaggero,* 5 June, 2001

Buchholz, Daniel, *International Index of Multiples from Duchamp to the Present,* Spiral-Wacoal Art Centre, Tokyo; Walter König, Cologne, 1993

Budney, Jen, 'Maurizio Cattelan', *Flash Art,* No. 189, Milan, 1996

Budney, Jen, 'Quasi per gioco', *Flash Art,* No. 159, Milan, 1996

Budney, Jen, 'Cityscape Milan', *Flash Art,* No. 194, Milan, 1997

Canovi, C. C., *Loro,* Castello Visconteo, Trezzo, 1991

Carmagnola, F., 'Arte organizzazione e complessità', *Flash Art,* No. 163, Milan, 1991

Casavecchia, Barbara, 'I Want to Be Famous – Strategies for Successful Living', *Flash Art Italia,* Milan, April–May, 1999

Casadio, Mariuccia, 'The Making of Cattelan's Tyrannosaurus "Felix"', *Vogue Italia,* October, 2001

Casciani, Stefano, *Biologia della Passioni,* Edizioni Essegi, Ravenna, 1989

Casciani, Stefano, *Design in Italia 1950–1990,* Giancarlo Politi Editore, Milan, 1991

Cattelan, Maurizio, *Personale,* Palazzo del diavolo edizioni, Forlì, 1987

Cattelan, Maurizio, 'Face to Face: Interview with Giacinto Di Pietrantonio', *Flash Art Italia,* No. 143, Milan, 1988

Cattelan, Maurizio, 'Pensieri molesti', *Gran Bazaar,* No. 68, Milan, 1989

Cattelan, Maurizio, *Sonsbeek 93,* Snoeck-Ducaju & Zoon, Arnhem, 1993

Cattelan, Maurizio, *Incertaine Identité,* Galerie Analix – B & L Polla, Geneva; Georg Editeur, Geneva, 1994

Cattelan, Maurizio, *Unbuilt Roads: 107 Unrealized Projects,* Cantz Verlag, Ostfildern, 1997

Cattelan, Maurizio, *Maurizio Cattelan,* Centre d'art de Brétigny-sur-Orge; Le Consortium, Dijon; Galerie Emmanuel Perrotin, Paris, 1998

Maurizio Cattelan, 'Interview with Daniel Pinchbeck', *Art Newspaper,* Vol. 10, No. 88, London, January, 1999

Maurizio Cattelan,

'Admit you have a desire to be famous: An exclusive interview with Maurizio Cattelan', *Art-Land,* Vol. 5, No. 1, April, 1999

Maurizio, Cattelan, 'Maurizio Cattelan with Bob Nickas', *index,* New York, September–October, 1999

Cattelan, Maurizio, 'Blown Away – Blown to Pieces', *Material,* No. 2, Migros Museum, Zurich, November, 1999

Cavallari, L., 'Nuovo "styling" richiani dadaisti', *Il resto del Carlino,* Bologna, 6 February, 1988

Celant, Germano, *Future Present Past: XLVII Venice Biennale,* Electa, Milan, 1997

Celant, Germano, *Dall'Italia,* Electa, Milan, 1997

Cerritelli, C., *Biennale giovani,* Palazzo delle Esposizioni, Faenza, 1987

Cherubini, Laura, 'Medialismo', *Flash Art,* No. 166, Milan, 1991

Christov-Bakargiev, Carolyn, *Fatto in Italia,* Centre d'Art Contemporain de Genève, Geneva; Institute of Contemporary Arts, London; Electa, Milan, 1997

Ciavoliello, Giulio, *La mostra non mostra,* Galleria Primo Piano, Milan, 1989

Ciavoliello, Giulio, 'Maurizio Cattelan', *Flash Art Italia,* No. 158, Milan, 1990

Ciavoliello, Giulio, 'Se avessi cento bocche', *Juliet,* No. 61, Trieste, 1992

Coen, Vittoria, 'Maurizio Cattelan', *Flash Art,* No. 151, Milan, 1989

Coen, Vittoria, 'I ragazzi della Via Emilia', *Flash Art Italia,* No. 158, Milan, 1990

Corgnati, Martina, 'Concettuali in città', *Arte,* No. 158, Milan, 1991

Corvi Mora, Tommaso, 'In Italy There Is No

Sport as Popular as Football', *Purple Prose,* No. 3, Paris, 1993

Daolio, Roberto, 'Stagione Neon', *Flash Art,* No. 146, Milan, 1988

Daolio, Roberto, *Strategie,* Edizioni Essegi, Ravenna, 1990

Daolio, Roberto, 'I ragazzi della Via Emilia', *Flash Art Italia,* No. 158, Milan, 1990

Daolio, Roberto, *Anni 90,* Galerie d'Arte Moderna, Bologna, 1991

Daolio, Roberto, 'Presenze', *Flash Art,* No. 180, Milan, 1993

Daolio, Roberto, *Alfabetizzazione,* Castel S. Pietro, Italy, 1996

Daolio, Roberto, 'Maurizio Cattelan', *Artel,* Bologna, June, 1997

de Canchy, Jean-François, *Transit,* École nationale supérieure des beaux-arts, Paris, 1997

De Cecco, Emanuela, 'Maurizio Cattelan', *Flash Art Quotidiano,* Milan, 10–11 July, 1993

De Cecco, Emanuela, 'Maurizio Cattelan', *Flash Art,* No. 163, Milan, 1993

De Cecco, Emanuela, 'Incursioni', *Flash Art Italia,* No. 182, Milan, 1994

Decter, Joshua, *A/drift:Scenes from the Penetrable Culture,* Center for Curatorial Studies, Bard College, Annandale-on-Hudson, New York, 1996

Delaise, Jean, *Connecion implicite,* École nationale supérieure des beaux-arts, Paris, 1997

Di Costa, G., 'Maurizio Cattelan', *Flash Art,* No. 198, Milan, 1996

Di Pietrantonio, Giacinto, 'Face to Face: Interview with Giacinto Di Pietrantonio', *Flash Art Italia,* No. 143, Milan, April–May, 1988

Di Pietrantonio, Giacinto, *Prima Linea,* Flash Art Museum, Trevi, 1994

Di Pietrantonio, Giacinto, 'Uno

spostamento reale', *Flash Art,* No. 182, Milan, 1994

Di Pietrantonio, Giacinto, *Caravonserraglio,* Ex-Aurum, Pescara, 1995

Di Pietrantonio, Giacinto, *Odisseo,* Bari, Italy, 1997

Dissanayake, E., *Campo 6: il villaggio a spirale,* Galleria Civica d'Arte Moderna e Contemporanea, Turin, 1996

Downer, Leslie, 'Artists see Visions of "Apocalypse" Now', *Wall Street Journal,* New York, 3 October, 2000

Elliot, David, *Wounds: Between Democracy and Redemption in Contemporary Art,* Moderna Museet, Stockholm, 1998

Engberg, Juliana, *Melbourne International Biennial,* Melbourne, 1999

Fanelli, Franco, 'Neo-Post-Iper', *Il Giornale dell'Arte,* No. 91, Turin, 1990

Fanelli, Franco, 'Un bambino di nome Adolf', *Vernissage,* October, 2001

Folkersma, Nina, *Crap Shoot,* De Appel, Amsterdam, 1996

Froment, Jean-Louis, *Traffic,* capc Musée d'art Contemporain, Bordeaux, 1996

Gale, David, 'Maurizio Cattelan', *Daily Telegraph,* London, 22 November, 1997

Gandini, Manuela, *Take Over,* Galerie Inga Pin, Milan, 1990

Gandini, Manuela, 'Ma dov'è l'artista? Sta rovistando nella discarica', *Il Giorno,* Milan, 5 February, 1994

Gauville, Hervé, 'Cattelan fait son trou à Dijon', *Libération,* Paris, 13 February, 1997

Gazzola, E., 'Maurizio Cattelan', *Segno,* Pescara, March, 1993

Giacometti, F., 'L'Armando Testa va in Biennale', *Italia Oggi,* Milan, 9 June, 1993

Gibbons, Flachra, 'Sensation's over, now it's Apocalypse', *The Guardian*, London, 3 May, 2000

Gingeras, Alison M., 'A Sociology without truth', *Parkett*, No. 59, Zurich, 2000

Gioni, Massimiliano, 'Maurizio Cattelan', *Flash Art*, Milan, January–February, 2000

Gioni, Massimiliano, 'Maurizio Cattelan', 'Him'', *Flash Art*, Milan, May–June, 2001

Gioni, Massimiliano, 'Maurizio Cattelan, Giu la mashera', *Flash Art*, Milan, April, 2001

Goldsmith, M. C., 'Oggetti meccanrici', *Modo*, No. 101, Milan, 1988

Grant, Simon, 'Maurizio Cattelan', *Art Monthly*, No. 174, London, March, 1994

Grasso, Sebastiano, 'L'arte in cerca di popolarità sposa il calcio', *Córriere della sera*, Milan, 18 May, 1990

Grazioli, Elio, *Documentario*, Spazio Opos, Milan, 1993

Gregotti, Vittorio, *Campo 6: il villaggio a spirale*, Galleria Civica d'Arte Moderna e Contemporanea, Turin, 1996

Grenier, Catherine, *Abracadabra: International Contemporary Art*, Tate Gallery, London, 1999

Guha, Tania, 'Maurizio Cattelan', *Time Out*, No. 1334, London, 1996

Hahn, Clarisse, 'Maurizio Cattelan', *Art Press*, No. 201, Paris, April, 1995

Hoffman, Jens, 'Blown Away – Blown to Pieces', *Material*, No. 2, Migros Museum, Zurich, November, 1999

Hofleitner, Johanna, 'Der Korper – nackt, bekleidet, verkleidet', *Die Presse*, Vienna, 3 February, 1997

Holler, V. C., 'Kanone auf Seide', *Die Furche*, No. 39, Vienna, 1995

Hoptman, Laura, *Projects 65: Maurizio Cattelan*, The Museum of Modern Art, New York, 1998

Hoptman, Laura, *Maurizio Cattelan*, Kunsthalle, Basel, 1999

Huck, B., 'Plötzlich diese Übersicht', *Der Standard*, Vienna, 31 January, 1997

Imhof, Dora, 'Stein fiel vom Himmel – direkt auf den Papst', *Baselllandschaftliche Zeitung*, Liestal, 21 October, 1999

Imhof, Dora, 'Der Stein der Anstosses', *Der Bund*, Bern, 26 October, 1999

Jackson, Tina, 'Snap Shot, Get Stuffed', *The Big Issue*, London, 17 April, 2000

Janus, Elizabeth, 'Maurizio Cattelan', *frieze*, No.34, London, May, 1997

Jeffett, William, 'Maurizio Cattelan', *Artefactum*, No. 52, Antwerp, 1994

Joo, Eungie, 'Let's Entertain: Walker Art Center', *Art Press*, Paris, May, 2000

Kohlmeyer, Agnes, *XLVII Venice Biennale*, Edizioni La Biennale di Venezia, 1999

König, Kasper, 'Was Sie Schon Immer Wissen Wollten ...', *Kunst und der öffentliche Raum*, No. 2, Münster, 1997

Lageira Jacinto, 'Absurdity For All, Belonging to Nobody, Maurizio Cattelan', *Parachute*, No. 109, January, 2003

La Pietra, U., *Design Balneare*, Centro Polivalente, Cattolica, 1990

Leguillon, Pierre, 'Maurizio Cattelan: Museum of Modern Art', *Art Press*, No. 243, Paris, 1998

Leguillon, Pierre, 'Maurizio Cattelan', *Art Press*, Paris, January, 1999

Levin, Kim, 'Maurizio Cattelan at Marian Goodman Gallery', *Village Voice*, June, 2002

Lichtenhahn, Stephan, 'Itallener bringt den Papst zu Fall', *Blick*, Zurich, 16 October, 1999

Lillington, David, 'Maurizio Cattelan', *Time Out*, London, March, 1994

Lindwall, Johan T., 'Kompisarna säger att jag kan få "klipparm"', *Expresen*, 25 October, 2001

Loers, Viet, *Nachtschottengewöchse*, Museum Fridericianum, Kassel, 1993

Luca, E., 'Tanti messaggi colorati di simbolica ironia, *Il Piccolo*, Trieste, 11 February, 1994

Liu, Jenny, 'Trouble in Paradise', *frieze*, London, March–April, 2000

Lyttleton, Celia, 'Maurizio Cattelan: Art Terrorist or Merry Prankster', *Very* 6 March, 2000

Mack, Gerhard, 'Ein Künstler legt den Papst flach', *Cash*, Zurich, 29 October, 1999

MacNeil, W. A., 'Even SITE visited with O'Keeffe Mania', *Albuquerque Journal*, Albuquerque, 17 July, 1997

Maggi, L., 'Oggetti transfigurati', *Casa Vogue*, No. 210, Milan, 1989

Magnani, Gregorio, *Ottovolante*, Galleria d'Arte Moderna e Contemporanea Accademia Carrara, Bergamo, 1992

Magnani, Gregorio, *International Index of Multiples from Duchamp to the Present*, Spiral-Wacoal Art Centre, Tokyo; Walter König, Cologne, 1993

Mantica, C., *Biologia della Passioni*, Edizioni Essegi, Ravenna, 1989

Marcadé, Bernard, *Cet été là ...*, Centre Régional d'Art contemporain Languedoc-Rousillon, Sète, France, 1998

Marogna, G., 'Trash Design', *Casa Vogue*, Milan, September, 1987

Martaix, Ingrid, 'Dossier', *Documents sur l'art*, Dijon, Winter, 1996

Martin Coomer, 'Maurizio Cattelan', *Time Out*, London, 9–16 June, 1999

Martínez, Rosa, *5th Istanbul International Biennial: On Life, Beauty, Translations and Other Difficulties*, Istanbul Foundation for Culture and Arts, 1997

Massimiliano, Gioni, 'Blown Away – Blown to Pieces', *Material*, No. 2, Migros Museum, Zurich, November, 1999

Maurer, Simone, 'Der Papst bestaunt seinen Sturzflug', *Tages – Anzeiger*, Zurich, 27 October, 1999

Mendini, Alessandro, *Biologia della Passioni*, Edizioni Essegi, Ravenna, 1989

Mendini, Alessandro, *Existenz Maximum*, Instituto degli innocenti, Florence, 1990

Meneguzzo, Marco, 'Maurizio Cattelan', *Artforum*, New York, February, 1998

Millet, Catherine, *L'art au corps*, Musées de Marseille, 1996

Myerson, Clifford, 'Cattelan', *Untitled*, No. 5, London, 1994

Nickas, Bob, 'Maurizio Cattelan with Bob Nickas', *index*, New York, September–October, 1999

Notte, R., 'Maurizio Cattelan', *Roma*, Rome, 6 May, 1993

Obrist, Hans Ulrich, 'Interview with Maurizio Cattelan', *Features*, May, 2002

Orengo, Nico, 'Cattelan: Ho messo Hitler in ginocchio', *La Stampa*, 7 October , 2001

Papi, G., 'Peep Show ultimo tango al computer', *L'Unità*, Bologna, 4 April, 1987

Parmesani, Loredana, *Take Over*, Galerie Inga Pin, Milan, 1990

Pasini, Francesca, 'Ecco gli italiani che incantano Parigi', *Il Secolo XIX*, Genova, 12 March, 1994

Pasini, Francesca, *Soggetto, Soggetto: Una nuova relazione nell'arte oggi*, Castello di Rivoli, Museo d'Arte Contemporanea, Turin, 1994

Peretta, Gabriele, 'Medialismi', *Politi*, Milan, 1993

Perreau, David, 'Maurizio Cattelan: Travail de sape', *Omnibus*, No. 22, Paris, 1997

Perreau, David, 'Maurizio Cattelan: The Village Idiot', *Art Press*, No. 233, Paris, March, 1998

Perretta, Gabriele, 'Metessi', Galleria Carrieri, Rome, 1989

Perretta, Gabriele, *Medialismo*, Galleria Vitolo, Rome, 1991

Perretta, Gabriele, 'Maurizio Cattelan', *Flash Art*, No. 163, Milan, 1993

Pesch, Martin, 'Fast nichts/ Almost invisible', *frieze*, No. 32, London, 1997

Pinchbeck, Daniel, 'Interview with Maurizio Cattelan', *Art Newspaper*, Vol. 10, No. 88, London, January, 1999

Pinto, Roberto, 'Maurizio Cattelan: Everyday Outlaw', *Flash Art*, No. 164, Milan, 1991

Pinto, Roberto, 'Ouvertures', *Flash Art*, No. 166, Milan, 1992

Pinto, Roberto, *XLV Venice Biennale*, Edizioni La Biennale di Venezia, 1993

Pinto, Roberto, 'Medialismi', *Politi*, Milan, 1993

Pinto, Roberto, 'Incursioni', *Flash Art Italia*, No. 182, Milan, 1994

Pinto, Roberto, 'Maurizio Cattelan: l'architettura del pensiero', *Linea d'Ombra*, No. 126, Milan, June, 1997

Pluchard, François, *L'art au corps*, Musées de Marseille, 1996

Polla, Barbara, *Incertaine Identité*, Galerie Analix – B & L Polla, Geneva; Georg Editeur, Geneva, 1994

Posca, C., 'Was Sie Schon Immer Wissen Wollten ...', *Kunst und der öffentliche Raum*, No. 2, Münster, 1997

Reschia, C., 'Il calcio balilla fa spettacolo', *La Stampa*, Turin, 11 May, 1991

Rian, Jeff, 'Maurizio Cattelan', *frieze*, No. 23, London, 1995

Rian, Jeff, 'Maurizio Cattelan ... Went Home', *Flash Art*, No. 190, Milan, October, 1996

Rian, Jeff, *Ironic, Museum für Gegenwartskunst*, Zurich, 1998

Shave, Stuart 'The Artful Dodger', *I-D*, London, March, 2000

Smith, Roberta, *New York Times*, 17 March, 2000

Smith, Roberta, 'From the Observatory', *New York Times*, April, 2002

Romano, Gianni, 'Anni Novaenta', *Lapiz*, No. 91, Madrid, 1991

Romano, Gianni, 'Loro', *Lapiz*, No. 78, Madrid, 1991

Romano, Gianni, 'El juego del Arte', *Lapiz*, No. 86, Madrid, 1992

Romano, Gianni, *Twenty Fragile Pieces*, Galerie Analix – B & L Polla, Geneva, 1992

Romano, Gianni, 'Maurizio Cattelan', *Zoom*, No. 124, Italy, 1993

Romano, Gianni, *Incertaine Identité*, Galerie Analix – B & L Polla, Geneva; Georg Editeur, Geneva, 1994

Romano, Gianni, *Prima Linea*, Flash Art Museum, Trevi, 1994

Romano, Gianni, *Rien à signaler*, Galerie Analix – B & L Polla, Geneva, 1994

Romano, Gianni, *Carte Italiano*, Centro d'Arte, Athens, 1996

Rovatti, P. A., *Das Spiel in der Kunst*, Neue Galerie, Graz; Ar/ge Kunst, Bozen, 1995

Russi Kirshner, Judith, 'Palermo Hollywood', *New Art Examiner*, Chicago, September–